# Henri Cartier-Bresson: The Early Work

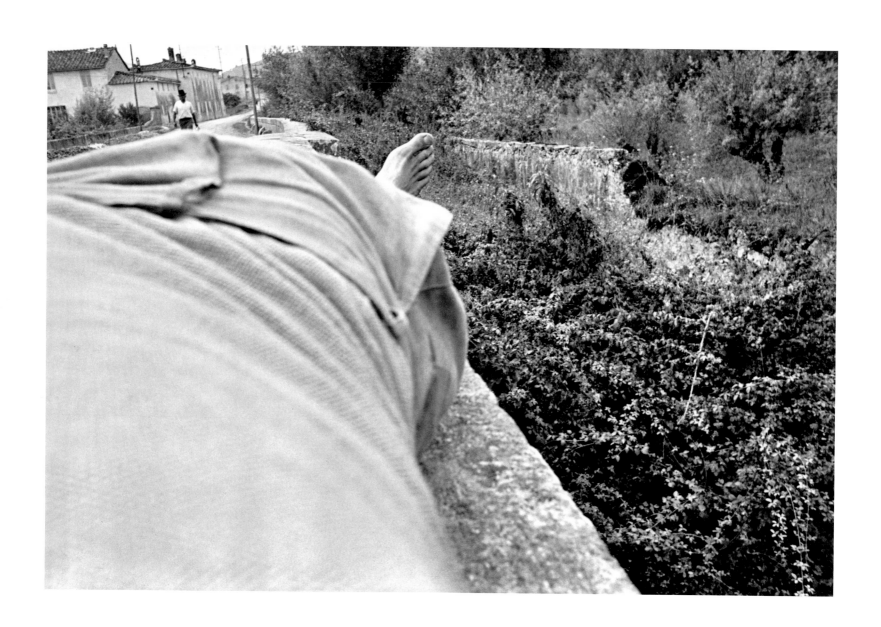

# Henri Cartier-Bresson: The Early Work

Peter Galassi

The Museum of Modern Art, New York

Distributed by New York Graphic Society Books/Little, Brown and Company, Boston

This book and the exhibition it accompanies have been made possible by grants from Champagne Taittinger, as part of its program in support of the arts, and from the International Herald Tribune, in celebration of its 100th Anniversary.

Schedule of the exhibition:

The Museum of Modern Art, New York
September 10–November 29, 1987

The Detroit Institute of Arts
December 15, 1987–February 7, 1988

The Art Institute of Chicago
February 27–April 16, 1988

The Museum of Photographic Arts, San Diego
May 10–June 26, 1988

Danforth Museum of Art, Framingham, Massachusetts
September 25–November 28, 1988

The Museum of Fine Arts, Houston
December 17, 1988–February 26, 1989

National Gallery of Canada, Ottawa
March 31–May 28, 1989

Edited by James Leggio
Designed by Antony Drobinski, Emsworth Studios, New York
Production by Daniel Frank
Halftone photography for plates by Robert J. Hennessey
Type set by Concept Typographic Services, New York
Printed by Franklin Graphics, Providence, Rhode Island
Bound by Sendor Bindery, New York

In all but a few cases, the halftone negatives for the plates in this book were made directly from the original prints. Copy photographs used for the remainder of the plates and for illustrations in the essay have been provided, in the majority of cases, by the owners or custodians of the works, indicated in the captions. The following list applies to photographs for which a separate acknowledgment is due: Cinémathèque française, Paris, fig. 13; Pictorial Service, Paris, courtesy Henri Cartier-Bresson, figs. 7, 11, 12; Robert D. Rubic, New York, fig. 26; E. V. Thaw & Co., Inc., New York, fig. 28.

Distributed outside the United States and Canada by
Thames and Hudson Ltd., London

The Museum of Modern Art
11 West 53 Street
New York, New York 10019

Printed in the United States of America

Frontispiece: *Italy.* 1932

# Contents

# Acknowledgments

On behalf of The Museum of Modern Art and its Trustees, I am pleased to thank Champagne Taittinger and the International Herald Tribune for their generous support of this book and the exhibition it accompanies. The Herald Tribune's contribution helps to mark its one hundredth anniversary. Taittinger's grant extends the company's program in support of the arts from Europe to the United States.

In the course of work on the exhibition and book I depended upon the help of many people. For their recollections and counsel I am grateful to Manuel Alvarez Bravo, Charles Henri Ford, Pierre Gassmann, Leo Hurwitz, Helen Levitt, Ben Maddow, Romeo Martinez, Beaumont Newhall, Leo Sauvage, Marie-Claude Vaillant-Couturier, and Monroe Wheeler.

Thomas Michael Gunther, André and Marie-Thérèse Jammes, Christopher Phillips, Sandra S. Phillips, and David Travis shared with me their expertise on photography of the 1920s and 1930s. Geoffrey Biddle, Genevieve Christy, Christopher Phillips, John Szarkowski, Helen Wright, and Henri Cartier-Bresson each read part or all of the text and offered suggestions that I used. Virtually every page bears the mark of James Leggio, who edited the book with skill and imagination.

The book itself has been produced under the expert supervision of Daniel Frank and Tim McDonough. Catherine Evans organized many of the book's details.

Robert J. Hennessey made the superb halftone negatives from which the plates have been printed. Antony Drobinski created the elegant design of the book.

Many of the prints reproduced here were made by L'Atelier Picto of Pictorial Service, Paris. For this work Henri Cartier-Bresson and the Museum are indebted to Pierre Gassmann, Georges Fèvre, Catherine Guilbaud, Marc Hervé, Marie-Pierre Jorre, and Vojin Mitrovic. Carol Ehlers, Edwynn Houk, and Harry H. Lunn, Jr., helped in tracing prints that are or were on the market. Weston J. Naef of The J. Paul Getty Museum kindly invited me to study prints in the museum's collection. The Getty Museum, The Art Institute of Chicago, and The Metropolitan Museum of Art, New York, have lent rare early prints to the exhibition.

From the very beginning of the project to its very end, Helen Wright, Mr. Cartier-Bresson's agent in the United States, has played an essential role.

I am most grateful, of course, to Henri Cartier-Bresson. Despite the inevitable disruption to his current work, he graciously allowed me to study his archive and spent many hours discussing his early work and life. The wit and intelligence and generosity that he and his wife, Martine Franck, contributed to our work together filled it with pleasure.

P. G.

# Henri Cartier-Bresson: The Early Work

Familiarity breeds inattention, perhaps more often than contempt. Certainly it has done so in the case of Henri Cartier-Bresson's photographs, which have been admired for half a century but have received little sustained critical attention since the 1940s.[1] In the absence of such discussion, our understanding of the work has been encumbered by two simplifying habits of interpretation. On one hand, Cartier-Bresson's photography is celebrated as the expression of an intuitive talent beyond the reach of historical analysis. On the other, it is classified as the exemplar of an anonymous formal principle: the capacity of the small, hand-held camera to seize a telling picture from the flux of life. The title of the American edition of Cartier-Bresson's first book, *The Decisive Moment* (1952), provided a handy label for that function.[2]

Both of these views foreshorten Cartier-Bresson's long and extremely rich career into an undifferentiated whole, a tendency that published surveys of the work have done little to discourage. The most recent survey (1979), sequenced without regard to chronology or variation in style, presents fifty years of work as a compendium of isolated "decisive moments."[3] Critics and historians are far behind photographers, who since the 1930s have studied Cartier-Bresson's work with persistent care.

The interpretive vacuum has been filled by the convenient label "photojournalism." In 1947, nearly twenty years after he had begun to experiment with photography, Cartier-Bresson helped to found the photographers' cooperative Magnum, which soon became a prestigious and influential force in photojournalism. Over the next twenty-five years Cartier-Bresson did perhaps more than any other photographer to enrich the profession's opportunities and goals. His work, widely published in magazines and in a series of superb books, only rarely reported newsworthy events. It provided, rather, a broad description of a place, its people and culture, and the texture of its everyday life. And it helped create the image of the photojournalist as an alert and sympathetic, but also knowing and detached, observer—an image that dovetailed neatly with the notion of the "decisive moment" and in the process limited its meaning.

Under the rubric of photojournalism, the decisive moment is not only a pictorial climax that yields a satisfying photograph but also a narrative climax that reveals a truth about the subject. In recent years Cartier-Bresson has suggested that for him "photojournalism" was little more than a mask, which obviated further explanation of his motives and reassured editors for whom the word "artist" conjured up the image of a self-absorbed fanatic. Nevertheless, we should not discount the seriousness with which Cartier-Bresson pursued the journalistic function of photography, at least under the broad definition he gave it. Much of his best work after World War II may appropriately be read in the descriptive and narrative terms of photojournalism (although this does not mean that the content of the pictures is equivalent to the captions appended to them).

Cartier-Bresson's work in the early thirties, his earliest photographic work, is another matter. Trained as a painter, Cartier-Bresson formed his artistic outlook under the rising star of Surrealism, and within a culture whose aspirations and pressures were very different from those that emerged after the war. His early photographs have virtually nothing to do with photojournalism; indeed they insistently and quite inventively subvert the narrative expectations upon which photojournalism depends. Stylistically, too, the early work is different from the work after the war: blunter, less lyrical, and much more severely focused on a narrow range of subjects.

These distinctions have been blurred by the tendency to regard Cartier-Bresson's entire career as a self-consistent unity, and thus to extend the interpretation of the postwar work retroactively to the work of the early thirties. In other words, the habit of treating the whole work as a piece has robbed the early pictures of some of their force and much of their meaning.

There are of course exceptions to the rule. Last year Van Deren Coke and Diana Du Pont wrote that "there is justification for the opinion that in the early 1930s Cartier-Bresson was the best and most mature of the Surrealist photographers, although his work does not appear in any of the Surrealist periodicals."[4] In 1960 Arthur Goldsmith wrote, "As you go through [Cartier-Bresson's] work in approximate chronological order you can sense a growing

they belong. No artist has worked in a vacuum, least of all in Europe in the years just before and just after 1930, the period to which Cartier-Bresson's early work belongs. In the field of photography, it was an especially fertile and inventive period, in part because of a rich exchange between photography and the other arts. Cartier-Bresson's early work is an exemplary expression of that exchange, a powerful synthesis of diverse impulses and artistic ideas.

concern with content, with human beings, with social and political implications."[5] Nevertheless, these observations—like our understanding of all of Cartier-Bresson's varied achievements—remain undeveloped.

This catalogue and the exhibition it accompanies are designed to isolate the work of 1932 to 1934 and thus to test the thesis that in conception, function, and style it has a distinct identity. The famous pictures of the period are joined by others that are less familiar and by still others that have not been seen since the thirties, or not at all until now.

Another aim of the catalogue is to examine the pictures critically and within the broad pattern of culture to which

The second part of this essay will examine Cartier-Bresson's early photographs in this light.

Like Gustave Flaubert, who late in life stated that "giving the public details about oneself is a bourgeois temptation that I have always resisted,"[6] Cartier-Bresson has always insisted that the artist's life has nothing to do with his work. The claim is of course justified in the fundamental sense that Cartier-Bresson's best pictures would command our attention even if we knew nothing about the circumstances under which they were made, nor even the name of their maker. But in Europe in the thirties the pressure of events impinged upon the individual with unusual weight and urgency. The mark was strongest on

members of Cartier-Bresson's generation, who came of age as the historical crisis deepened and so defined their identities in its terms. For Cartier-Bresson in the thirties the personal, the cultural, and the historical were thoroughly interdependent. This condition, the ground against which the photographs must be understood, is the subject of the first part of this essay.

<center>•         •         •</center>

Henri Cartier-Bresson was born on August 22, 1908, in Chanteloup, near Paris—near the site, he notes with chagrin, of a future Disneyland. His mother was from Normandy, and he has often been described as Norman in spirit. "Norman as the beech tree," wrote his friend André Pieyre de Mandiargues.[7] "From Normandy," wrote Lincoln Kirstein, "comes his frugal elegance and peasant shrewdness, an independent chill or candor, and also a transparent dignity and pride in his own brand of technique."[8] The family lived in Paris, where Henri's father, a native of the capital, directed a well-known textile concern that bore the family name. Cartier-Bresson now recalls that the business was less prosperous than it once had been, but the family was financially comfortable and socially established. They lived on the rue de Lisbonne in the fashionable eighth *arrondissement*.

As a teenager Cartier-Bresson attended classes at the celebrated Lycée Condorcet, and did his homework at the nearby Catholic École Fénelon. He had already begun to turn toward the arts and away from the prospects imposed upon him by his father's position. One afternoon at Fénelon the schoolmaster caught Cartier-Bresson reading Rimbaud. Luck had it that the master in his youth had been a friend of the Symbolist poets and instead of punishing Cartier-Bresson invited him to read every afternoon in his, the master's, office. Over the next year Cartier-Bresson devoured modern literature, from Dostoyevsky and Hardy to Schopenhauer, Marx, and Romain Rolland, from Rimbaud and Mallarmé to Freud, Proust, and Joyce. The master of Fénelon also was interested in painting, and with his encouragement Cartier-Bresson began to visit the Louvre and galleries of modern art, including those of Kahnweiler, Simon, and Rosenberg. He recalls admiring Seurat's *Poseuses* at the Galerie Barbazange.

Cartier-Bresson was already fascinated by painting. In 1974 he remembered:

Painting has been my obsession from the time that my "mythical father," my father's brother, led me into his studio during the Christmas holidays in 1913, when I was five years old. There I lived in the atmosphere of painting; I inhaled the canvases. One of my uncle's friends, a student of Cormon, initiated me into oil painting when I was twelve. My father also drew very well, but he wanted me to make my career in textiles. Thus I was to enter business school. Three times I failed to pass the *baccalauréat* examination, and the ambitions my father had formed for me were soon dissipated.[9]

The painter who first instructed Cartier-Bresson was his uncle Louis's friend Jean Cottenet. In the early twenties, during vacations on the channel coast, Henri also took lessons from Jacques-Émile Blanche in his studio at Offranville. The arts had long offered a path of independence for disaffected bourgeois youth, but there was nothing radical about these teachers. Cottenet had studied at the moribund École des Beaux-Arts and few outside polite society considered Blanche (the principal model for Proust's Elstir) to be more than a society painter. Two surviving studies by Cartier-Bresson from this period, painted in 1924, are accomplished student essays in a style that had ceased to be adventurous decades earlier (figs. 1, 2).

Although unoriginal as a painter, Blanche possessed a lively mind and a sophisticated circle of acquaintance. In the mid-twenties he took Cartier-Bresson under his wing and introduced him to his cultivated world. He took his protégé to the literary salon of Marie-Louise Bousquet and to visit Gertrude Stein, who after looking at the young man's paintings advised him to enter his father's business. It was through Blanche, also, that Cartier-Bresson became friendly with the young Surrealist writer René Crevel. Beginning in about 1925 he also often visited the poet and painter Max Jacob, and through his schoolmate Henri Tracol met Tracol's uncle, the art historian Élie Faure. By the time he turned twenty Cartier-Bresson had acquired, as he puts it, considerable cultural baggage.

In 1927 Cartier-Bresson, freed from the *lycée* at the age of nineteen, entered the studio of André Lhote. Lhote was not a talented painter but he had been an early adherent of Cubism and by the twenties enjoyed a substantial reputation. This depended partly on the broad appeal of his work, which combined simplified Cubist forms and easily recognizable popular subjects, such as landscapes and nudes. More important was his prominence as a teacher, which rested on his pedagogical books as well as on the reputation of the Montparnasse academy where Cartier-Bresson studied.

The central goal of Lhote's teaching and work was to connect advanced art with the noble tradition of French classicism, from Clouet to Poussin, to David and Ingres, to Cézanne. It was a familiar goal of the time.[10] Picasso's neoclassicism of the early twenties, Léger's robust nudes and compact still lifes of the same years, and the Purist movement led by Amédée Ozenfant and Le Corbusier—all expressed a shared longing for order and stability after the heady innovations of the decade before World War I and the trauma of the war itself. Lhote, the modern academician, molded this spirit into a didactic creed, supported by historical examples and by venerable principles of classical design, notably the golden section.

Two surviving paintings by Cartier-Bresson from 1928 are products of this environment. In one, a thoroughly chaste nude reclines in an ambiguous space suggesting a Parisian studio (fig. 3). In the other, painted in England later in the year, a well-dressed couple fit as neatly as bricks into a solid bourgeois interior (fig. 4). Both pictures, which owe as much to Ozenfant as to Lhote, employ the Purist vocabulary of hard-edged flat planes, smooth, pneumatic volumes, and a compressed harmony of grays and browns. Floating in the blank space of the *Nude* is an axonometric cube which, according to Cartier-Bresson's tongue-in-cheek recollection, contains André Lhote. Yet the private joke does little to dispel the mood of decorum, which Cartier-Bresson's photographs of just a few years later would repeatedly violate.

Cartier-Bresson has always recalled Lhote with respect: "He taught me to read and write. His treatises on landscape and the figure are fundamental books. . . . I saw him again shortly before his death [in 1962]. 'Everything comes from your formation as a painter,' he said of my photographs."[11]

Within a decade of his apprenticeship Cartier-Bresson had so far outstripped his master that it would seem pointless if not also unjust to attribute the photographer's talent for geometric clarity to the influence of Lhote's inert style. Nevertheless, Lhote's teaching may have helped to form Cartier-Bresson's concept of discipline, not as the rote application of formal rules but as the definition of a set of precise conditions that clarify an artistic problem and thus release the imagination to work on it. In this sense, Cartier-Bresson's formation as a painter may indeed have played an important role in his photography.

Cartier-Bresson spent the academic year 1928–29 visiting his cousin Louis Le Breton, a student at Magdalene College of Cambridge University. He attended a few lectures and frequented the circle of young aesthetes who modeled themselves on Oscar Wilde, but he did not matriculate. Instead he continued to paint. The portrait of the couple, Cartier-Bresson's landlady and her husband, was painted at Cambridge. The only other known works from this period are two paintings reproduced in the Cambridge student journal *Experiment* in 1929.[12] In one (fig. 5) the pictorial model is no longer Purist Cubism but the recent work of Joan Miró. The shift is significant since Miró, a genuine leader of the avant-garde, was also a favorite of the Surrealists.

Cartier-Bresson recalls that he had been attracted to Surrealism around 1925, only about a year after the movement was inaugurated. At that time his only close friend among the group was Crevel, and he never actively participated in the movement. But with his friends Pierre Josse and André Pieyre de Mandiargues he often attended the conclaves on the place Blanche where André Breton met twice daily with his colleagues to exchange ideas, to plan manifestoes and actions and, as Louis Aragon put it in reference to earlier Dada meetings, "to argue in the heat of some violent crisis which convulsed [the movement] from time to time, when the charge of moderatism was preferred against one of its members."[13] Still in his teens, Cartier-Bresson absorbed Surrealism at the source.

In a recent interview with Gilles Mora, Cartier-Bresson explained: "I was marked, not by Surrealist painting, but by the conceptions of Breton, [which] satisfied me a great deal: the role of spontaneous expression [*jaillissement*] and of intuition and, above all, the attitude of revolt." It was, he added, a revolt "in art but also in life."[14] This is both an apt definition of Surrealism and a key to its influence on the young Cartier-Bresson. Before 1932, when he began to photograph with a Leica, he produced very few pictures (in any medium) that he considered worth preserving. He did, however, pursue a pattern of life that owed a great deal to Surrealism—and which powerfully shaped his work of 1932 to 1934, the work presented here.

Surrealism was not so much an artistic movement as a moral and spiritual crusade aimed, as Breton put it, to provoke a crisis of conscience. Surrealism spawned new artistic techniques, such as automatic writing, and won the strong (if often temporary) allegiance of a series of outstanding artists in a variety of mediums; but it derived its coherence and force less from works of art than from a sustained output of hectoring manifestoes, many of them

the work of Breton. In the "Second Manifesto of Surrealism," published in 1929, five years after the first, Breton's zeal was undiminished: "Everything remains to be done, every means must be worth trying in order to lay waste to the ideas of *family, country, religion*."[15]

One reason Breton was able to seize center stage is that he addressed head-on the moral crisis that had emerged from the debacle of World War I. The war left in its wake a profound mood of moral despair, of disgust with bourgeois institutions, and with it a desire to wipe the slate clean and begin again. Both anarchic Dada (the precursor of Surrealism) and the Purist "call to order" should be understood in this context. "These two movements," explained Ozenfant in 1928, "though apparently in opposition to each other, were equally sickened by the glib and stale productions of art, and sought to restore it to health: the former by ridiculing time-worn formulas, the latter by emphasizing the need for discipline."[16] Although too sweeping to be just, the statement suggests how the young Cartier-Bresson could learn from both Lhote and Breton. It is no less relevant to his early photographs, which express a violent yearning for personal and social liberty through a pictorial language that is almost austere in its formal rigor.

Surrealism was the creation of a tiny elite who made a cult of personal experience and whose efforts, however radical, initially were confined to the arts. Very soon, however, the moral conscience that animated the group drew it into political debate, which inevitably centered on communism. If postwar despair had inspired a desire for renewal, many intellectuals on the left found a recipe for that renewal in the Russian Revolution. André Thirion, a young Surrealist in the late twenties, later recalled in a memoir the seductive appeal of communism: "One can easily imagine my unshakable certainty in 1928. I was part of the cohort destined to change the world according to laws as ineluctable as those of gravity."[17]

By its title alone the house periodical *La Révolution surréaliste*, founded in 1924, associated the movement with the Soviet experiment. The journal's successor in 1929, *Le Surréalisme au service de la révolution*, by reversing the emphasis suggested that the commitment had deepened. In fact in the late twenties a number of Surrealists, including Breton in 1926, had joined the Party. Despite extended efforts at accommodation, however, Breton never submitted to Party discipline. His position fluctuated (as did everyone else's) but—much to the displeasure of Party didacts—he maintained a principled distinction between his sympathy for the goals of international communism and his own intellectual liberty. The contest between the two provoked Surrealism's most impassioned arguments of the late twenties and thirties. The most notorious rupture was between Breton and Louis Aragon, perhaps his closest collaborator of the early twenties, upon Aragon's militant rejection of Surrealism for communism in 1932.

The internal political machinations of Surrealism were more than squabbles among headstrong intellectuals. They reflect the growing pressure of external events, which intensified rapidly after 1930. The twenties, wrote George Orwell,

were the golden age of the *rentier*-intellectual, a period of irresponsibility such as the world had never before seen. The war was over, the new totalitarian states had not yet arisen, moral and religious taboos of all descriptions had vanished and the cash was rolling in. "Disillusionment" was all the fashion. . . . It was an age of eagles and crumpets, facile despairs, backyard Hamlets, cheap return tickets to the end of the night.[18]

In the thirties the moral vacuum so caustically described by Orwell was filled with a bitter dose of reality. The cruel consequences of Europe's economic collapse, and the menace of Hitler and then Franco, added to that of Mussolini, created an atmosphere of crisis from which few felt immune, and which increasingly polarized opinion into fascist and anti-fascist camps. To a far greater degree than before, artists and intellectuals felt compelled to take a stand and were relentlessly pressured by their colleagues to do so; the term "engagement" belongs to this period. Young men of bourgeois families, such as Cartier-Bresson, felt particular pressure to commit themselves against their class lest they be denounced as defenders of it.

This period of deepening political crisis and of growing moral anxiety within the cultural avant-garde coincided with Cartier-Bresson's early maturity and affected him profoundly. When he left Lhote's studio in 1928 at the age of twenty, the Depression was two years away and the most intense political battles, within Surrealism and without, had not yet begun. By the time Cartier-Bresson was thirty, Hitler was on the verge of achieving the Munich Pact, the French Popular Front government had come and gone, and the Spanish Civil War—the great unifying cause of anti-fascist sentiment—had been under way for two years. In the course of these ten years Cartier-Bresson's spirited rejection of his bourgeois upbringing inevitably was

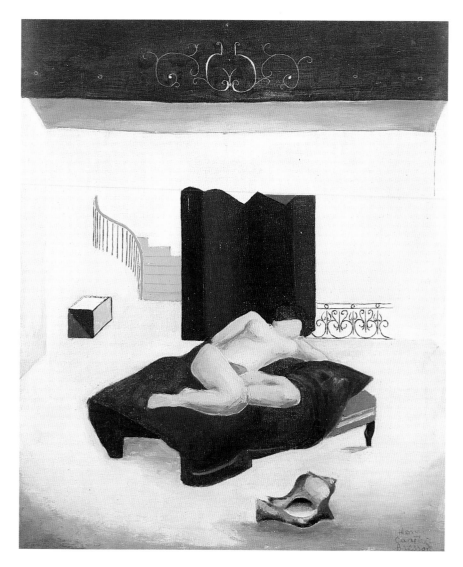

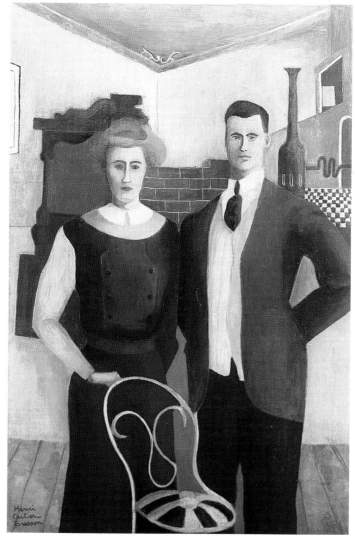

inflected by the growing social and political turmoil. His astonishingly fertile early photographic work was concentrated in the middle of these ten years, between 1932 and 1934.

The years from 1928 to 1931 were a period of personal discovery and liberation. In 1929, after his return to Paris from Cambridge, Cartier-Bresson began the obligatory year of military service, at Le Bourget airfield outside of Paris. As a disciple of Surrealism, Cartier-Bresson must have considered the army anathema. He made no secret of his feelings and gave comic answers to a questionnaire for new recruits. He recalls reporting to duty with his rifle on his shoulder and a copy of *Ulysses* under the other arm, and he often slipped away from the barracks at night to attend raucous parties at the local brothel. Caught on one of these

escapades, and again after playing a practical joke on his superior, Cartier-Bresson was severely punished.

Cartier-Bresson's closest friend in the late twenties and early thirties was André Pieyre de Mandiargues (p. 86), who had not yet begun his career as a poet and novelist. The following passage from an interview published in 1974 concerns Mandiargues's recollections of the late twenties and first year or two of the thirties.

From a family of the Norman *grande bourgeoisie*, a year older than I, [Cartier-Bresson] had parents who were friendly with my mother, and it is not extraordinary that we also were friendly from my sixteenth year [i.e., 1925], or a little bit earlier, since we spent our vacations in the department of Seine-Maritime. What is remarkable, if not extraordinary, is that we discovered at the same time, together or separately, most of the things that

Left: Fig. 3. Henri Cartier-Bresson. *Nude.* 1928. Oil on canvas, 21¼ × 17¾ (54 × 45 cm). Collection the artist

Above: Fig. 4. Henri Cartier-Bresson. *Couple.* 1928. Oil on canvas, 20½ × 13⅜" (52 × 34 cm). Collection the artist

would become essential to us a little bit later: Cubist painting, Negro art, the Surrealist movement, the poetry of Rimbaud and Lautréamont, James Joyce, the poetry of Blake, the philosophy of Hegel, Marx and communism. . . .

. . . . . . . . . . . . . . . . . . . . .

Quite authoritarian, [Cartier-Bresson] often reproached me for certain of my admirations, notably in art, a domain in which he felt himself more assured than I. As much as I have the fault (if you wish) of being too broad in my taste, Henri, at that period,

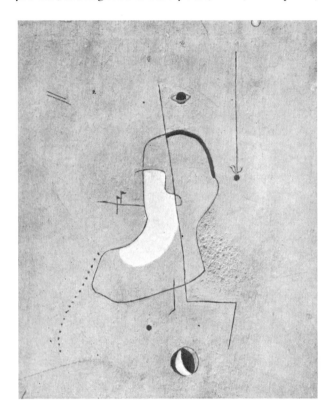

had the fault of being too narrow. But I think that, taken together, what each of us owes the other make two completely equal parts. We feverishly discussed everything that inspired our passion; we passed whole nights, or almost, in the nightclubs of Montparnasse, which were then in their most splendid period, and in certain bars of the rue Pigalle where black musicians came to play for themselves and for a few friends, after the cabarets had closed; the same bars and musicians of which Soupault speaks in the most beautiful of his books, *Le Nègre.* "Memphis Blues," "Saint Louis Blues," "Beale Street Blues," everything that blossomed from the trumpet of Louis Armstrong, we drank it all in through our ears, like the whisky that I do not much like but a whole bottle of which, on one of those nights, I happened to drink on my own. . . . We also went to the Jockey, on the boulevard Montparnasse, to drink with the beautiful Kiki and to listen to her sing with her staggering voice "Les Filles de

Camaeret." . . . I am speaking of the old Jockey, which was just about opposite the current one, which occupies the spot of the old Jungle, another club where the jazz was of such a splendid violence that it wiped out all memory of laws or decorum. It was with Henri, finally, that I went to the Bal antillais on the rue Blomet. . . . Understand me well: What I am sure of and somewhat proud of is that we were not looking for "a little amusement," as I said at the outset. No, what we were seeking, in the course of these sometimes hot nights, was violent emotion, rupture with the disciplines of everyday life as we knew and barely tolerated it, a certain dizziness and a certain convulsion. The notion of amusement is characteristic of the bourgeois spiritual system that we wanted to destroy in ourselves, even if it meant wounding ourselves. Moreover, I was already fascinated by the dream, and I wanted to find places, acts and people who gave me the illusion of a dream. In sum, I asked for reality to become a dream. On occasion reality fulfilled my desire. For example when with Henri Cartier-Bresson I went to follow the lesson of Aragon in the brothels of provincial France, at Rouen or Nancy. In a spirit of burning purity of which most of our more or less well heeled contemporaries would have understood nothing, but which the young people of today would understand right away, since it was a matter of undertaking a kind of "trip" not terribly different from the sort that they look for in hallucinogens. If I tell you all this, it is because I know that the writer that is in me and which interests you was formed there, secretly, while its germ would have been piteously defeated if it had entered as an employee into a publishing house.[19]

The reference to "the lesson of Aragon" is a reminder that Pieyre de Mandiargues and Cartier-Bresson had experienced guides in their search for self-definition. In *Le Paysan de Paris* (1926), Aragon had explained his attraction to brothels in moral terms: "In these retreats I feel delivered from a world of intolerable convention, and at last thrive in the broad daylight of anarchy."[20] Aragon's book and with it Breton's *Nadja*, published two years later, instantly had become manuals of Surrealist behavior. Alone, the Surrealist wanders the streets without destination but with a premeditated alertness for the unexpected detail that will release a marvelous and compelling reality just beneath the banal surface of ordinary experience. His every act is calculated to disrupt the conventional pattern of life, to invite irrational obsession. Breton's delirious affair with Nadja expressed for him

the idea that freedom, acquired here on earth at the price of a thousand—and the most difficult—renunciations, must be enjoyed . . . without pragmatic considerations of any sort, and this because human emancipation . . . remains the only cause

worth serving. Nadja was born to serve it, if only by demonstrating that around oneself each individual must foment a private conspiracy . . . by thrusting one's head, then an arm, out of the jail—thus shattered—of logic, that is, out of the most hateful of prisons.[21]

Breton himself admitted that his idea was an unreachable ideal. Unlike Nadja (who, according to Breton's report, went mad) and unlike his mentor Jacques Vaché and his disciple René Crevel (both suicides), Breton retained what he called "that minimal common sense"[22] that kept him from the precipice. His program of sustained revolt was more demanding than the facile despair described by Orwell and, perhaps partly for this reason, more compelling to young rebels such as Mandiargues and Cartier-Bresson.

In 1930 Cartier-Bresson took a further step in his personal revolt when he embarked for Cameroon and, on the return voyage, jumped ship at the Ivory Coast of Africa, then a French colony. In an interview of 1974 he recalled:

I left [Lhote's] studio because I did not want to enter into that systematic spirit. I wanted to be myself. . . . With Rimbaud, Joyce and Lautréamont in my pocket, I took off on adventure and made my living hunting in Africa, with an acetylene lamp. I made a clean break. What I mean to say is: one thing and then afterwards, finished, no more. To paint and to change the world counted for more than everything in my life.[23]

The trip was no mere jaunt. Cartier-Bresson stayed in Africa for about a year, at first along the coast and then inland, where he hunted at night with a single-barreled shotgun by the light of an acetylene lamp mounted on his head. He dried and sold the meat of the animals he shot, including once a hippopotamus. Cartier-Bresson recalls that the Africa he saw was the Africa of Joseph Conrad's *Heart of Darkness* (1902), and of Louis-Ferdinand Céline's *Journey to the End of the Night*, which appeared in 1932. After about a year in Africa, Cartier-Bresson was stricken with blackwater fever, which left him for several days in a coma. He attributes his survival to the ministrations of a native friend schooled in the medicinal properties of herbs. The illness was severe but it did not rob Cartier-Bresson (or his family) of an arch sense of humor. In a postcard to his grandfather he asked to be buried in Normandy, at the edge of the forest of Eawy, and that Debussy's string quartet be played at the funeral. The response, dictated by an uncle, was succinct: "Your grand-

father finds that too expensive. It would be preferable that you return first."[24]

He did return and gradually recovered, but he had lost his taste for the polite art of easel painting. Although far less cynical than Céline's Bardamu, Cartier-Bresson like him acquired in Africa a healthy measure of disgust for the fictions and abuses of civilized convention. With perhaps only a minimum of memory's retrospective clarity he states, "The adventurer in me felt obliged to testify with a quicker instrument than a brush to the scars of the world." Within a year or so of his return to France he had begun to devote most of his energy to photography.

In a general way Cartier-Bresson's African journey belongs to a long tradition of French artists (including Delacroix, Flaubert, and Matisse) who had gone to Africa for initiation into the exotic and unknown. More important were the examples of Arthur Rimbaud and André Gide, whose journeys were more extensive and much deeper into the continent. Rimbaud had been a hero for Cartier-Bresson since his school days, and the poet's flight to Africa in the 1870s had acquired an almost mythic status as a violent rejection of bourgeois life and art. Less dramatic but more immediate was the example of Gide, who had first visited Africa in the 1890s and whose *Travels in the Congo* (1927) documented his most recent trip, in 1925. Cartier-Bresson had not read the book but he could not have remained untouched by Gide's influence over the generation of young rebels to which Cartier-Bresson belonged. Shortly before Cartier-Bresson left for Africa, Gide's acolyte Paul Morand had advised him, "Go to Patagonia. You will see beautiful storms there."[25]

In 1893 at the age of twenty-four (two years older than Cartier-Bresson would be at the time of his trip) Gide wrote in his journal: "Africa! I repeated this mysterious word; I swelled it with alluring horrors, with anticipation; and my eyes plunged desperately into the hot night towards a promise, impressive and enveloped in flashes of lightning."[26] This passage found many echoes in Gide's writing, notably in *The Fruits of the Earth*, published in 1897 but not widely read until it was reissued in the twenties, when independently minded youth (including Mandiargues) adopted it, and Gide, as a spiritual guide.[27]

With Gide on his trip to the Congo in 1925 was his young companion Marc Allégret, who made a film and still photographs of the trip. Several of the photographs, including one as the frontispiece, appeared in Ozenfant's *Foundations of Modern Art* in 1928. Perhaps with Allégret's

pictures in mind, Cartier-Bresson acquired in Africa a small, second-hand roll-film camera, made by the German firm Krauss. The film he shot there, not developed until later in France, was ruined by humidity.

Cartier-Bresson's trip to Africa belongs to a broad stream of primitivism, which was especially strong in the Paris avant-garde of the twenties and thirties.[28] Primitivism—the idea that Western civilization has repressed

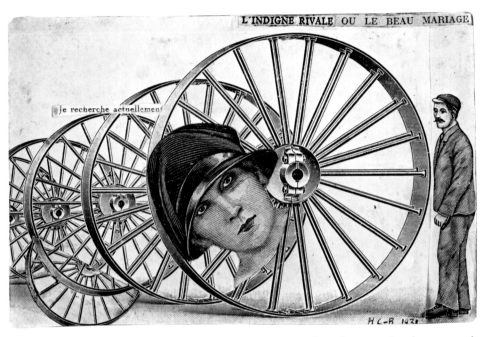

L'INDIGNE RIVALE OU LE BEAU MARIAGE

Je recherche actuellement

HC-B 1931

Fig. 6. Henri Cartier-Bresson. *Pour l'amour et contre le travail industriel (For Love and Against Industrial Work)*. 1931. Paper collage, 3½ × 5½" (8.9 × 13.9 cm). Collection the artist

an original vitality that can be rediscovered and recaptured in so-called primitive cultures—is as old as Western civilization itself. In modern art it became a central force in both aesthetic and intellectual terms. But for Cartier-Bresson, primitivism was first and foremost a personal ideal; it focused and directed his urge to escape the industrial, bourgeois society into which he had been born, not only on his trip to Africa but also on a series of extensive if less exotic journeys over the next four years. Here is the relevance of Rimbaud and Gide, for whom the essentially primitive lay not in African objects but in the place and its people.

Gide's example is telling in another respect as well. His trip to the Congo in 1925 had inspired in him a powerful revulsion to French colonialism. In his journal and after his return to France he lent his influential voice to the growing anti-colonial movement, which the Surrealists also soon joined. "Henceforth an immense cry inhabits me," Gide wrote. "I know things I cannot accept. What

demon pushed me into Africa? What shall I seek in this country? I am calm. Now I know: I must speak."[29]

Gide's earlier romantic primitivism had transformed itself into political commitment, which deepened through the early thirties. The interdependence of personal and sexual self-liberation, of artistic ambition, and of political commitment was not specific to Gide nor, of course, to his era. But in France in the thirties that interdependence was felt with unusual urgency, a fact that gives added weight to Cartier-Bresson's otherwise quite ordinary recollection that "to paint and to change the world counted for more than everything in my life."

In Africa Cartier-Bresson made a collage in the style of his friend Max Ernst, pasted together on a postcard with the sap of a rubber tree (fig. 6). The title of the collage explains its message: *Pour l'amour et contre le travail industriel (For Love and Against Industrial Work)*. Recently, after rereading Mandiargues's recollections of their youth together, Cartier-Bresson elaborated:

André de Mandiargues makes clear our total uninterest in "pursuing a career." He and I were and still are libertarians (in an old tradition that includes Élisée Reclus, Pissarro, and Élie Faure, to name only a few French intellectuals). For us every human being is potentially an artist; but in our societies of high technical specialization, amateurism is considered a creation of the second order. There is a polarity, the "hobby" opposed to professionalism; man is impinged upon by industrialization and a certain professionalism (this is the meaning of my collage of 1931); technology levels individuals. Amateurs find themselves solitary, unrecognized; professionals enter into the law of the jungle. One might almost say that now only children are still able to express themselves spontaneously. . . .[30]

Primitivism incorporates an essential contradiction: only the non-primitive can admire the primitive. This contradiction expressed itself in the polarity of Cartier-Bresson's life in the early thirties. In Paris he was a familiar if reserved figure in the sophisticated circles defined by the intersection of wealth and avant-garde culture. His presence there, however, was often interrupted by extended solitary or near-solitary wanderings, first to Eastern Europe, then to Italy, Spain, and Spanish Morocco, and finally to Mexico. None of these places was as exotic as Africa, but in them Cartier-Bresson sought out the most backward areas and the poorest neighborhoods, whose rough street life and open sensuality provided the gritty vitality of the primitive.

Earlier, before his trip to Africa, and then increasingly

after his return, Cartier-Bresson enjoyed a broad acquaintance among advanced artists and writers, Surrealist and otherwise. Mandiargues recalls, apparently in reference to the years just before the African journey, "Henri already knew Max Ernst, whom I was not to know until much later; he was more advanced, more 'civilized' than I and I believe that he owed that 'civilization,' a good part of it, to the couple of Harry Crosby, the American poet, and Caresse, whom he saw or had seen frequently."[31]

Wealthy Boston blue bloods, the Crosbys since 1922 had lived in Paris, where they wrote poetry, published their own and others' work under the imprint of the Black Sun Press, and pursued a wild, extravagant life that exemplifies the hedonistic extreme of American expatriate experience in the 1920s.[32] The whirlwind came to an abrupt end in December 1929 when, in a friend's apartment in New York, Harry shot and killed himself and one of his mistresses, a young Boston socialite.

In the summer of 1928 the Crosbys had taken a long-term lease on an old mill at the edge of the Forest of Ermenonville, near Paris, on the estate of their friend Armand de La Rochefoucauld. They christened the place "Le Moulin du Soleil" (The Mill of the Sun) and instituted a policy of elaborate weekend parties. Among the regular visitors were André Breton, René Crevel, Max Ernst, Salvador Dali, and Eugene and Maria Jolas, publishers of the journal *transition*. "Every weekend we went to the Moulin du Soleil," Dali wrote later.

We ate in the horse-stable, filled with tiger skins and stuffed parrots. There was a sensational library on the second floor, and also an enormous quantity of champagne cooling, with sprigs of mint, in all the corners, and many friends, a mixture of surrealists and society people who came there because they sensed from afar that it was in this Moulin du Soleil that "things were happening."[33]

Cartier-Bresson had met Harry Crosby in 1927 or 1928 through a mutual friend at Lhote's academy. He soon became intimate with the Crosbys and with their friends Gretchen and Peter Powel, American expatriates whose amateur enthusiasms included photography. The friendship was the occasion of Cartier-Bresson's first serious, although still far from exclusive, pursuit of photography.

After Harry Crosby's suicide, Caresse continued and expanded the work of the Black Sun Press. (In the early thirties the press published works by Hart Crane, Pound, Hemingway, and Faulkner, among others.) She also main-

tained the tradition of extravagant entertainment at the Mill, to which Cartier-Bresson resumed his visits upon his return from Africa in 1931.

History has made well-known figures of many of the people Cartier-Bresson met at the Mill and in Paris, thus opening to familiarity what was at the time a small, rather closed circle. Accepted into it at an early age (he was not yet twenty when he met Harry Crosby), Cartier-Bresson

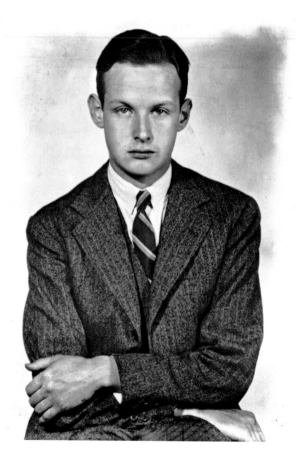

Fig. 7. Gretchen Powel. *Henri Cartier-Bresson.* 1929

had immediate access to the works and ideas of the avant-garde and also to its network of acquaintance, patronage, and mutual support. Among those he met at the Mill, for example, was the young American art dealer Julien Levy, whose New York gallery in 1932 established itself as the leading Surrealist outpost in the United States, and whose fall season of 1933 opened with a show of Cartier-Bresson's photographs.[34] A similar encounter led to his exhibition at the Club Atheneo in Madrid in 1934, which was organized by Guillermo de Torre and Ignacio Sanchez Mejias.

In the late twenties, through Max Jacob, Cartier-

Bresson had become friendly with Julien Levy's associate and Parisian counterpart Pierre Colle and Colle's associate, the young Christian Dior. Colle's gallery, like Levy's, exhibited both the Surrealists and the Neo-Romantics: Pavel Tchelitchew, Christian Bérard (p. 79), Eugène and Léonide Berman, and Kristians Tonny. Balthus, who also exhibited at the gallery, painted a portrait in which Colle, in suit coat and bow tie, projects a pensive stare.[35] Cartier-Bresson's portrait of Colle provides an intimate glimpse of another side of his life (p. 75). The young art dealer, topsy-turvy in his disheveled bed, veteran perhaps of another wild night, will soon compose himself and put on the proper, expensive shoes that await him at the bottom of the picture. In 1931 or 1932 Cartier-Bresson also met the young Greek-born art critic Tériade, who in 1933 became the editor of the Surrealist journal *Minotaure*, then in 1936 established his own luxurious magazine *Verve*, which published several of Cartier-Bresson's photographs.[36] In the mid-thirties Tériade conceived the idea of publishing an album of photographs by Brassaï, Bill Brandt, Eli Lotar, and Cartier-Bresson. The idea—a very original one at the time—was scuttled by the war, but it may have provided the germ for *Images à la sauvette*, which Tériade's Éditions Verve published in 1952 and which appeared simultaneously in the United States as *The Decisive Moment*. Another young publisher whom Cartier-Bresson met in the early thirties was Monroe Wheeler, who later, as Director of Publications at The Museum of Modern Art, oversaw the publication of Cartier-Bresson's first exhibition catalogue there in 1947.

Despite the range of Cartier-Bresson's acquaintance in the early thirties, the first-hand accounts and memoirs of the period rarely mention him, perhaps partly because he was still so young and had only just begun to produce original work of his own. In an article published in Madrid in January 1934, Guillermo de Torre mentioned Cartier-Bresson's "contacts with Dali" and his current collaboration with Jean Cocteau on the illustrations for a book, which never appeared and which Cartier-Bresson does not recall.[37] The reference is an exception; it seems likely that in the early thirties Cartier-Bresson was not so much a participant in the scene as an attentive observer. His reserved behavior, reinforced by his boyish appearance, was often taken for shyness. Caresse Crosby later recalled that he "looked like a fledgling, shy and frail, and mild as whey."[38] Julien Levy reported that upon their first meeting Cartier-Bresson was "damp with shyness and

fussily mothered by Gretchen [Powel]."[39]

There is reason to suppose that behind Cartier-Bresson's placid, boyish exterior was an intense appetite for experience and a deep-seated if still unformed artistic ambition. Ralph Steiner, who knew Cartier-Bresson in New York in 1935, remembered him this way:

About this time I met a beautiful, angelic-looking, very young man who had come from France. . . . I had a talk with him about film making versus still-photograph making. He was a serious listener and questioner. When he finished talking he said most solemnly that whichever he did, it would be special and superb work. In all my life I have never heard anyone say a thing like that about himself without seeming immodest. But his simple, unaggressive seriousness impressed—even awed—me.[40]

By the time he met Steiner, Cartier-Bresson had accomplished more than enough to justify his self-confidence. His work of 1932, 1933, and 1934 is one of the great, concentrated episodes in modern art. On the eve of it, in 1931, Cartier-Bresson's ambition, if intense, was still unfocused. He still thought and for some time would continue to think of himself vaguely as a painter, but he regularly destroyed his work. Art still counted for less than adventure, in which Cartier-Bresson continued to be guided by Surrealism and his own brand of primitivism.

In 1931, not long after his return from Africa, Cartier-Bresson began to travel again, frequently in the company of Mandiargues, who had recently received an inheritance which helped to finance the trips. In 1931 the two wandered extensively in Eastern Europe: Germany, Poland, Austria, Czechoslovakia, and Hungary. Cartier-Bresson took with him the wooden view-camera he had used as early as 1929 and the small roll-film camera he had bought in Africa. Nevertheless, photography still remained at the margin of the adventure.

By 1932, judging from the pictures, this condition had changed. Only a few pictures from 1931 have passed the test of time (and of Cartier-Bresson's own judgment) but from 1932 there are two dozen or more that not only passed the test but changed its rules. Cartier-Bresson's raw enthusiasm for life transformed itself into a powerful, unforeseen artistic talent. Mandiargues again is the best witness:

Whenever I see Henri Cartier-Bresson today, I am always reminded of 1930, 1931 and the years that followed, when, in the course of car journeys all over Europe, and strolls in Paris, I witnessed the emergence of the greatest photographer of mod-

ern times through a spontaneous activity which, rather like a game at first, forced itself on the young painter as poetry may force itself on other young people. Not with any thought of making a profitable career out of it: in fact, *petits-bourgeois* that we were, barely out of adolescence and trying with difficulty to get away from the rules of polite society, the words "career" and even "craft" merely turned our stomachs—as our families, with some disquiet, were beginning to realize.[41]

The achievement of the pictures leaves little doubt that Cartier-Bresson recognized, at least intuitively, that his talent matched his ambition. The recognition may have come at Marseille in 1932, where Cartier-Bresson acquired a Leica to replace the more cumbersome hand-held camera he had used in 1930 and 1931. He never abandoned the Leica and so thoroughly identified the instrument with his artistic personality that he henceforth consigned his earlier work to the realm of juvenilia. Beginning in 1932 and for the next three years he pursued photography voraciously; photography, which had grown out of traveling, now fueled it.

A small minority of the best pictures were made in Paris. The remainder of the work of 1932 and 1933 was made elsewhere in France and, mainly, in Spain and Italy. On his journeys Cartier-Bresson was often accompanied by Mandiargues and sometimes also by the young painter Léonor Fini (fig. 8), whose flamboyant personality Paul Éluard later aptly characterized in the pun, "Quand c'est Fini, ça commence."[42] Cartier-Bresson also occasionally visited other artists and writers such as the poet Rafael Alberti in Spain and the black American writer Claude McKay, at whose house in Spanish Morocco Cartier-Bresson met the young American poet Charles Henri Ford, later the editor of the New York Surrealist journal *View*.[43] Nor did traveling mean absolute separation from the sophisticated Paris art world. But while Cartier-Bresson's artistic ideas grew directly from his contacts with avant-garde circles, the work itself flourished in a wholly separate realm of poor neighborhoods, ruined buildings, brothels, back alleys, and open-air markets. Cartier-Bresson's flight from convention and propriety propelled him into the world of the dispossessed, the marginal, and the illicit, which he embraced as his own.

In early 1934 Cartier-Bresson left Europe for Mexico, where he stayed for about a year and where his photographic work continued along the path he had already established. Culturally and politically, ancient and contemporary Mexico were of intense interest at the time to

the European avant-garde. Sergei Eisenstein had recently traveled to Mexico to work on the ill-fated *Qué viva México!* and a few years later Antonin Artaud and André Breton each made a pilgrimage to the country. This atmosphere doubtless contributed to the decision of Cartier-Bresson, who previously had joined nothing, to sign up as photographer on an expedition to Mexico composed of about ten people and led by an Argentine, Dr. Julio

Fig. 8. Henri Cartier-Bresson. *Léonor Fini.* 1932–33. Gelatin-silver print, 14 × 9⅜" (35.5 × 23.9 cm). The Museum of Modern Art, New York. Gift of the photographer

Brandan. Cartier-Bresson recalls that the expedition, to be funded by the Mexican government, was intended to trace a route for a proposed Pan-American highway. It also had the blessing, if not the official support, of the Trocadéro Museum in Paris, and thus presumably was to gather ethnographic material for the museum. In any case the project almost immediately collapsed. After stopping briefly at Cuba, where Cartier-Bresson made the picture reproduced on page 122, the expedition disembarked at Veracruz only to discover that its financial support had

evaporated. The members disbanded, each going his own way. With the painter Antonio Salazar (p. 77), Cartier-Bresson left for Mexico City, where he continued to live and work much as he had in the previous two years.

During part of his stay in Mexico City Cartier-Bresson lived with the American Langston Hughes and the Mexican Andrés Henestrosa, both poets, and the Mexican painter Ignacio Aguirre. Among his other friends were

Fig. 9. Manuel Alvarez Bravo and Henri Cartier-Bresson at the time of their joint exhibition at the Palacio de Bellas Artes, Mexico City, March 1935. Photographer unknown

Lupe Marin, the estranged wife of Diego Rivera, and the young photographer Manuel Alvarez Bravo, whose work already had taken a turn parallel to Cartier-Bresson's. In March 1935 the Palacio de Bellas Artes in Mexico City organized a joint exhibition of the work of the two photographers (see fig. 9).[44]

Langston Hughes, who had come to Mexico to settle his father's estate and decided to stay for a while, remembered the period in his autobiography:

Henri declared his father in Paris—whom rumor had was a wealthy industrialist—could keep his money. He, Henri, would get along. . . . With a photographer and a poet as roommates, and none of us with any money to speak of, I recall no period in my life when I've had more fun with less cash. . . . Andres was courting a beautiful and much-photographed Indian girl, dark brown in complexion, whom he later married. And Cartier was in love with another Indian beauty from Tehuantepec who went barefooted. My favorite girl was a tortilla maker's daughter

named Aurora. All three of us in the Lagunilla flat were interested in the folk dances, songs and nightlife of the Mexican capital. When our daytime work was done, if there were no parties to which we were invited, we would often seek out the little bars and clubs where the *mariachis* played their guitars and wailed their *corridos* and *huapangos*. Once I went with Cartier to the hot springs on a picture-taking trip.[45]

The lodgings of the group, writes Juan Rulfo, were "in one of the most sordid quarters of the capital, near the Candelaria de los Patos, the Cuadrante de la Soledad, and not far from the chaotic Mercado de la Merced and the Calle Cuauhtemoctzin and the Calle Chimalpopoca, a zone reserved for the underworld, prostitution, and the *teporochos*, those alcoholics who live on filth and die miserably from it."[46] The great majority of Cartier-Bresson's work was done in this neighborhood or far from the city in Juchitán, near Tehuantepec. These neighboring towns on the coast in the southern province of Oaxaca, enclaves of the Zapotec Indian culture, had become a favorite gathering place of advanced Mexican artists and writers. The Indians called the blond, blue-eyed photographer by a name that meant "beautiful-man-with-face-the-color-of-shrimp."[47] Among the Mexican painters, Cartier-Bresson was most attracted, personally and artistically, to José Clemente Orozco. He reserved his highest admiration, however, for the violent prints of José Guadalupe Posada.

In early 1935 Cartier-Bresson left Mexico for New York City, where again he stayed for about a year. The immediate occasion for the trip may have been a second exhibition of his work (together with the photographs of Walker Evans and Alvarez Bravo) at Julien Levy's gallery in April 1935. Besides Levy, Cartier-Bresson had other friends in New York, including Pavel Tchelitchew, Charles Henri Ford, and the composer Nicolas Nabokov, whom Cartier-Bresson had met in Paris through Pierre Colle. He stayed for a time with both Ford and Nabokov. Another friend whom he rediscovered in New York was Elena Mumm, a former fellow student in Lhote's studio (and the future wife of Edmund Wilson). Among the new friends he made in New York were the critic and impresario Lincoln Kirstein and the young photographer Helen Levitt.

Nabokov's studio apartment on East Thirty-ninth Street contained two pots of tropical creepers, whose vines covered a good part of the walls and ceiling. Shortly before Cartier-Bresson moved into this jungle bohemia it had served as the venue for an exhibition, organized by Tchelitchew, of photographs by Cecil Beaton, Hoyningen-

Huene, Horst, and Carl Van Vechten. About this time both Hoyningen-Huene and George Platt Lynes, another master of the elegant celebrity image, each made a series of portraits of Cartier-Bresson (see fig. 10). These pictures suggest that through his exhibitions at Levy's gallery and through the grapevine of the fashionable avant-garde, Cartier-Bresson had acquired a degree of prominence as an artist. As Nabokov's memoir records, however, Cartier-Bresson's artistic status did nothing to alter his bohemian habits:

Cartier-Bresson loved to eat apple pie *à la mode*. He found it to be the cheapest and most nourishing dish. I ate skimpy drugstore hamburgers, and both of us consumed a huge amount of fruit.

Cartier-Bresson was enamored of Harlem. He spent days, evenings, and nights there. Sometimes I would accompany him. We would trudge from club to club and listen to marvelous bands. Some of Cartier-Bresson's friends belonged to Harlem's radical elite. They were extraordinarily bright and educated people, and nearly all of them immensely open and hospitable.

But with some of Cartier-Bresson's intellectual black friends I used to get into scraps about the Bolshevik Revolution. To them, Lenin was a hero and a saint whose role in history was not supposed to be challenged. . . .

Henri was carefree, gay, and immensely companionable. He was, like me, totally unconcerned with America's main profession—money-making. He spent his time going for long walks, snapping photographs, but, except for our small circle of friends, no one saw them or seemed to be interested in them. . . .

We had long talks mostly on morals and politics. I suppose that both of us were radicals. But to Cartier-Bresson the Communist movement was the bearer of history, of mankind's future—especially in those years, when Hitler had saddled Germany and when a civil war was about to explode in Spain. . . .

Fortunately, Henri Cartier-Bresson was never dogmatic or didactic about his beliefs or his leanings.[48]

Cartier-Bresson's arrival in New York in early 1935 marks the close of the marvelous early episode that is the principal subject here. In the first half of the thirties, although obviously influenced by the ideas and works of others, he had single-mindedly followed the dictates of his own intuitions. Those intuitions were prompted by an uncommon thirst for experience and—inseparable from it—a volatile impulse that in retrospect may be called artistic ambition, but which at the time only gradually and unpredictably developed such a clearly defined form. Certainly, as Mandiargues has observed, Cartier-Bresson had nothing but disgust for the idea of a career in photography or anything else. Indeed the primacy that Cartier-Bresson gave to personal adventure, his openness to the untested and undefined in both experience and art, made possible his seduction by photography, which his sophisticated friends regarded as more of a curiosity than an art. Arriving in New York in 1935, after accomplishing the great body of work shown here, Cartier-Bresson still had no settled plan for the future. After 1935, the same spirit that had led him to make this work now led him away from it.

During the year Cartier-Bresson spent in New York he all but ceased making photographs. He moved about the city, visiting friends from lower Manhattan to Harlem, leading a bohemian life whose spirit is suggested by an anecdote told by Ben Maddow.[49] While living in a rooming house on Fourteenth Street, Cartier-Bresson at night would tie a string to his toe and lower the other end out of his fourth-floor window, so that Maddow could wake him in the morning without disturbing others. (Neither man remembers what the two then did together.)

They had met through Nykino, a filmmaking group whose name suggests its members' admiration for Soviet film.[50] Under a loose apprenticeship to Paul Strand, a leader of the group, Cartier-Bresson learned the rudiments of film direction. Cartier-Bresson was only slightly younger than the cinema; in his teens he had been enthralled by the great silent films of the 1920s.[51] Like a number of other talented still photographers of his generation, he was eager to try his hand at filmmaking. Toward the end of 1935 he applied unsuccessfully for a chance as assistant director, first to G. W. Pabst then to Luis Buñuel, whom he had met earlier in Paris. Upon returning to Paris at the end of 1935 or in January 1936, Cartier-Bresson offered his services to Jean Renoir. After looking at the young man's photographs, Renoir took him on.

From early 1936 until the outbreak of World War II in September 1939, Cartier-Bresson devoted a great deal of his time and energy to filmmaking. But lest it be supposed that he had in mind from the beginning a clear plan for a career in film, the following episode should be recorded. In 1935, shortly before he left New York, Carmel Snow at *Harper's Bazaar* invited him to make some fashion photographs for the magazine. "You photograph garbage so well and we are a bit tired of the style of the other fashion photographers," is the gist of what she told him. Cartier-Bresson accepted the assignment and soon after returning to Paris reported to the magazine's studio, where several

beautiful models awaited his instructions. Understanding that he could not, as he wished, simply invite the models out for a drink, he deployed them at random on the studio floor and photographed them from above. Mrs. Snow, after reviewing the proofs in New York, wrote tactfully to Cartier-Bresson that she felt they were not his best work and that she looked forward to meeting him again soon. He is still grateful to Mrs. Snow for saving him the time he

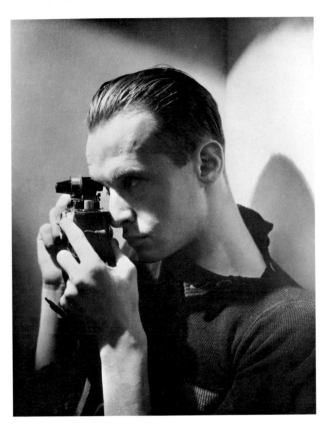

might have wasted trying to master the business of fashion photography.

A month or two before taking on Cartier-Bresson as an assistant, Renoir had agreed to supervise a propaganda film for the French Communist Party. *La Vie est à nous (Life Is Ours)* was made in February and March 1936 for the elections of May 3, which brought the Popular Front government to power.[52] Cartier-Bresson was one of five assistant directors. Many of the participants, including Renoir, Jacques Becker, and Cartier-Bresson, were not communists but the language of the film is strong. One section, denouncing the privileges of wealth and class, is explicitly directed at "the 200 families," of which Cartier-Bresson's family was one.

When he returned to Paris and began work with Renoir, Cartier-Bresson had been away from France for nearly two years, and he recalls being struck by how greatly conditions had changed. The sense of impending crisis had deepened considerably. In October 1935 Mussolini's troops had invaded Ethiopia; only nine months later, in July 1936, the Spanish Civil War began. With Franco now added to the menace of Hitler and Mussolini, the citizens of pacifist France were justifiably alarmed. By the summer of 1936, the drift of French artists and intellectuals toward political commitment had become a tidal wave.[53]

Roger Shattuck has analyzed this process in a brilliant article on the First International Congress of Writers for the Defense of Culture, in Paris in June 1935, which consolidated intellectual support for Popular Front ideology.[54] According to Shattuck the communists managed to seize the high moral ground and from it attempted, with considerable success, to bully intellectuals of conscience into silence or conformity. In general outline this doubtless was the case, and Shattuck's analysis provides an essential context here; nevertheless, the shape of a particular individual's experience rarely is precisely congruent with the general outline.

In late 1937 Cartier-Bresson, assisted by Herbert Kline, directed *Victoire de la vie (Return to Life)* under the auspices of Frontier Films, a production company that had grown out of Nykino.[55] A documentary on medical relief for Republican Spain, the film was designed to raise money for the relief program and thus, like *La Vie est à nous*, may be classified as propaganda. But the remainder of Cartier-Bresson's film work of the late thirties, for Renoir, was free of the ideological urgency so widely felt in those years. Immediately after the completion of *La Vie est à nous*, Cartier-Bresson served Renoir again, in the summer of 1936, as a second assistant director of *Une Partie de campagne (A Day in the Country)*.[56] The story, taken from de Maupassant, was neither contemporary nor, except in the most oblique sense, political. Cartier-Bresson appeared briefly in the film (fig. 11), as he did again in *La Règle du jeu (Rules of the Game)*, the third and last film on which he assisted Renoir, in 1939. *Rules of the Game* serves up an acute critique of class hierarchy, and Renoir intended it in part as a cautionary premonition of war. But its ideological implications, like the conclusions to be drawn from its drama of human folly and passion, are far from unambiguous.

Renoir, who must be counted among the most humane

23

of great artists, had become a new mentor for Cartier-Bresson. Like his father the painter, Renoir was a populist in spirit and, especially in the thirties, he was sympathetic to the left. But, preferring observation to judgment, he always resisted both the certainties and the abstractions of politics. Unsentimental sympathy for the individual—any individual—is the hallmark of his work. His outlook provided an alternative to the teaching of Cartier-Bresson's earlier mentors, to the rule-laden aesthetic of Lhote and the preaching of Breton. Renoir: "I am against great themes and great subjects. . . . You can't film an idea. The camera is an instrument for recording physical impact."[57] Cartier-Bresson: "I want to prove nothing, demonstrate nothing. Things and beings speak sufficiently."[58]

In early 1937 Cartier-Bresson married Ratna Mohini, an accomplished Javanese dancer, and for the first time in his life set up housekeeping, in a small apartment-cum-studio on the rue Danielle Casanova, across the street from houses where Joséphine de Beauharnais and Stendhal had lived. Earlier he had from time to time received small sums from his family, but he now required a regular income and could not be confident of earning it as an assistant to Renoir. The director, whose fierce independence and frequent commercial failure had alienated established producers, often did not himself know where, or whether, he would find the money for his next film. Perhaps also at this time Cartier-Bresson began to recognize that his best talents, rooted in direct observation of ordinary life, were alien to the inventions of dramatic film.

These are the circumstances, in Cartier-Bresson's recollection, that led him to take a position as staff photographer for *Ce Soir*, the communist evening daily founded in March 1937 and edited by Aragon. His pictures also appeared frequently in the communist illustrated weekly *Regards*, but his daily assignments came from the 9:00 A.M. editorial meetings at *Ce Soir*. The film had to be delivered for processing by 11:00 A.M. Periodically he worked on important picture stories, such as the coronation of King George VI in May 1937, which he covered with the writer Paul Nizan, and which yielded a splendid series of pictures of spectators along the parade route. Much of his work, however, was considerably less glamorous. "I photographed *chiens écrasés* [run-over dogs] on a regular basis," he recalls, using photographer's slang for the most banal of news events. The daily routine could hardly have provided a more extreme contrast with Cartier-Bresson's life and work of the early thirties.[59]

Although *Ce Soir* employed a number of photographers under a variety of arrangements, Cartier-Bresson, Robert Capa, and David Seymour ("Chim") enjoyed a degree of liberty and privilege that the others did not. Cartier-Bresson had met the other two before his trip to Mexico in 1934, but the close bond among the three, each so different in character and ability, was forged during their years together at *Ce Soir*, from 1937 to 1939.[60] In addition

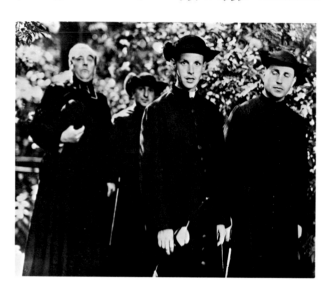

Fig. 11. Still for Jean Renoir's film *A Day in the Country*. 1936. The young curate at center (Cartier-Bresson) is dazzled by the sight of Henriette Dufour (Sylvia Bataille); at right, Georges Bataille; at left, rear, Pierre Lestringuez. Photograph by Eli Lotar

to working for the paper, the three often submitted their pictures for potential distribution to Maria Eisner, who ran a picture agency called Alliance Photo. The relationship eventually led to the founding of Magnum in 1947.

Like his film work, Cartier-Bresson's newspaper work of the late thirties led him away from the intensely private enterprise that he had so avidly pursued in the early thirties. The young vagabond, possessed by Surrealist ideals of absolute personal and artistic freedom, now enlisted his talent in collective work and turned his attention to social concerns. Jean Renoir, who wrote a weekly column for *Ce Soir* from March 1937 until October 1938,[61] later recalled his own participation in the Popular Front:

I believed that every honest man owed it to himself to resist Nazism. I am a filmmaker, and this was the only way in which I could play a part in the battle. But I over-estimated the power of the cinema. *La Grande Illusion*, for all its success, did not prevent the Second World War. I tell myself, however, that many "great illusions," many newspaper articles, books and demonstrations, may yet have some effect. . . . Thanks to [*La Vie est à nous* and *La Marseillaise* (1938)] I breathed the exalted air of the

Popular Front. For a short time the French really believed that they could love one another. One felt oneself borne on a wave of warm-heartedness.[62]

Cartier-Bresson has used similar terms to describe his own experience of the period. The threat of fascism was so palpable and immediate that only an emotional and intellectual nullity could have remained untouched by it. The cultural environment that had nourished if not indeed fostered Cartier-Bresson's earlier personal revolt, and the work that grew from it, had been transformed into an atmosphere of turmoil and urgency, in which private artistic experiment took second place. Cartier-Bresson's attraction to the collective art of filmmaking, his apprenticeship to Renoir, and the challenge and responsibility of newspaper photography had begun to change his outlook and his work. The political and social climate of the late thirties further distanced him from the spirit of his early pictures.

So, too, did Cartier-Bresson's experience of World War II. At the outbreak of war between Germany and France in September 1939, he joined the army at the rank of corporal and soon after was captured. The Pétain armistice of June 1940 only aggravated the predicament of French prisoners of war, most of whom continued to be held by Germany, in effect as hostages. Soldiers below the rank of officer, such as Cartier-Bresson, fared the worst, since in addition to harsh treatment they endured a series of terms of forced work under the unsympathetic supervision of private German enterprise. Cartier-Bresson recalls the precise and unpleasant details of the thirty-two different kinds of hard manual labor that he did, as slowly and as poorly as possible, during thirty-five months of captivity. The routine was interrupted only by periods of solitary confinement following two failed attempts to escape. Cartier-Bresson succeeded on the third attempt and made his way to a safe farm near Tours and then to Paris, where he joined a section of the underground comprised of, and devoted to aiding, escaped prisoners of war.

Cartier-Bresson recalled recently that right after the war, "I felt close again to André Breton and to his attitude: 'First of all, life!' It was later that I became a photographic reporter. . . ."[63] Indeed, he soon began a series of far-flung journeys that recall his wanderings of the early thirties. In 1946 he realized his earlier plan of traveling across the United States, to which he had returned to prepare an exhibition of his work at The Museum of Modern Art.

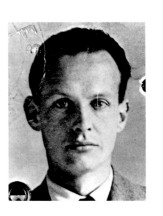

Fig. 12. Passport photograph of Henri Cartier-Bresson. c. 1938

Cartier-Bresson intended to publish the pictures from the trip in a book, with a text by his traveling companion John Malcolm Brinnin, but the project fell through.[64] The few who took photography seriously had recognized Cartier-Bresson's achievement before the war; the exhibition at the Museum in 1947, like the publication of *The Decisive Moment* in 1952, gave delayed public expression to that recognition. Beaumont and Nancy Newhall had begun work on the exhibition during the war, before it was known that Cartier-Bresson had survived; thus the photographer had the rare opportunity of participating in his own "posthumous" exhibition. In 1947, after collaborating in the founding of Magnum, he set off again for parts unknown as he had so often done in the early thirties. This time his destination was the Far East, where he traveled for three years.

Cartier-Bresson was still very young and (as he would prove for decades to come) still uncommonly eager for life and work. But his outlook had been tempered by a demoralizing political struggle, by the brutality of his long captivity, and, not least, by the personal and artistic maturity he had earned. He recalls now that the war marked a break in his life, as indeed it did for many other artists and writers, especially those on the left who had shared the enthusiasms and defeats of the mid- and late thirties. Jean Guéhenno, a veteran of the intellectual left, remembered the bitterness of his mood after the war: "I felt myself in violent opposition to literary modes, to dilettantism, to the narcissism that sets so many young men on their own little paths, teaching them to love, to adore themselves."[65] There is, perhaps, more than a hint of this sentiment in the following remark from Cartier-Bresson's introduction to *The Decisive Moment* in 1952: "I regard myself still as an amateur, though I am no longer a dilettante."[66]

Except perhaps briefly in his teens, Cartier-Bresson had never been a dilettante. But his newspaper work of the late thirties and then his freelance reporting after the war had become far more responsive to social as opposed to personal concerns. Compared to this new work, his photographs of the early thirties in retrospect might indeed have seemed hermetic or even self-indulgent. He implied as much when in 1946 Dorothy Norman asked him if his experience of the war had changed his approach to photography:

Most certainly. I became less interested in what one might call an

"abstract" approach to photography. Not only did I become more and more interested in human and plastic values, but I believe I can say that a new spirit arose among photographers in general; in their relationships not only to people, but to one another.[67]

In 1947, at the time of Cartier-Bresson's exhibition at The Museum of Modern Art, Capa warned him, "Watch out for labels. They are reassuring. But people will attach one to you that you will not be able to remove. That of little Surrealist photographer. You will be lost, you will become precious and mannered." Cartier-Bresson recalls, "Capa was right, and he added, 'Instead of Surrealist take the label of photojournalist, and keep the rest, in your heart of hearts.' And I followed his advice."[68] In fact, before the war Cartier-Bresson had already worked extensively as a photo-reporter, in the company of Capa and Chim. When the three founded Magnum in 1947, Cartier-Bresson formally accepted not only the label but also the challenge of photojournalism, which nourished his work for years to come and to which his independent spirit brought an essential vitality.

By the end of the war, at the age of thirty-six, Cartier-Bresson had experienced a lifetime of enthusiasms, accomplishments, and defeats. It is not remarkable that his work since then has been different from the early work presented here, made by a man in his mid-twenties. Nor is it remarkable, given the independence and talent that Cartier-Bresson has displayed since his early youth, that his work since the war has been so inventive and so rich. Discounting the role of talent, Cartier-Bresson stresses the role of independence, explaining that throughout his life he has tried, as he expresses it, always to put himself in question.

•          •          •

Henri Cartier-Bresson became familiar at an early age with advanced culture, with the still fresh innovations of the recent past and the vital ideas behind them. His work of the early thirties is a maddeningly rich synthesis of this diverse cultural baggage. So completely had he absorbed the lessons of the avant-garde that he spoke its languages with a single clear voice, his own.

The coherence of his early work reflects the enthusiasm with which he embraced the ideal—dear to his Surrealist mentors but also to modern culture as a whole—that art and life should be continuous if not in fact indistinguishable. Cartier-Bresson allowed artistic discipline to impinge

upon personal adventure only when he discovered the instrument—the hand-held Leica—that made it unnecessary to separate the two. His early work is hardly a diary, but it does focus narrowly on the special world to which his sense of adventure had drawn him. A recapitulation of his early travels will introduce his subjects.

Beginning with his journey to Africa in 1930, Cartier-Bresson had transformed primitivism into a personal credo. Equating civilization with repression, both individual and social, he identified with civilization's outsiders. In respect to his own milieu, almost all of Cartier-Bresson's early subjects are marginal: peasants, workers, prostitutes, bums, and beggars. There are also many pictures of children, whose acrobatic antics provided both a metaphor for liberty and a model for Cartier-Bresson's method of making pictures.

Cartier-Bresson recalls that upon returning from Africa he felt compelled to testify to "the scars of the world." After recuperating from blackwater fever he began to do just that. In 1931, on a tour through Eastern Europe with Mandiargues, Cartier-Bresson used the Krauss camera he had bought second-hand in Africa, photographing flea markets and poor street fairs, the Jewish ghetto in Warsaw, run-down shops, laborers, the dispossessed and unemployed. In the several dozen negatives that survive, no sign of wealth or comfort or untouched nature appears. The camera was more cumbersome than the Leica Cartier-Bresson would soon acquire, and light leaked into it. Only a few pictures, direct and simple, are better than awkward documents, but Cartier-Bresson had defined his essential subject (pp. 60, 61).

In 1932, soon after returning from his travels in Eastern Europe with Mandiargues, Cartier-Bresson left Paris again, for Marseille (where Rimbaud had gone to recover from his African illness). Geographically, as well as ethnically and in spirit, Marseille with its immigrant population and port life is the French city closest to Africa. By his own account and by the evidence of the pictures, at Marseille Cartier-Bresson's talent, his conception of his subject, and the capabilities of his new Leica camera first fell into step together. There is no reason, however, to consider separately the pictures made in and around Marseille. Cartier-Bresson matured so rapidly that these pictures form a continuous whole with the work done over the next three years elsewhere in France and in Italy, Spain, and Mexico.

At the center of this work is an unblinking stare at mean

poverty. The photographer's attitude is sympathetic but unsentimental, not unlike the concerned expression of a woman in one picture, evidently not much better off than the man she looks at, sprawled on the street in the poor Paris suburb of La Villette (p. 59). In all of Cartier-Bresson's early work, excepting portraits of friends, only a few figures from the world of comfort and authority intrude. The proper Parisian gentleman seated alone

behind the glass façade of a sidewalk café is physically and emotionally inert, a symbol of the life Cartier-Bresson had rejected (p. 67). In another picture a policeman is rendered ridiculous as he stoops comically behind a midget doorman, whose frank self-presentation wins the viewer's affection (p. 72). Another cop, anonymous, his back turned to us, inspires the derision of striking workers, whom Cartier-Bresson describes not as a crowd but as individuals (p. 64).

This last picture is the only one that, by virtue of the specific incident it describes, has an explicit political aspect. But more than a few others imply social criticism. Certainly the viewer's sympathy is aroused by the sight of the young boy standing among the squalid shacks of Aubervilliers (p. 65), a suburb like La Villette, and by the terrified stare of the Spanish man seated against a stone wall with his child in his arms (p. 128). Some viewers (including André Breton) have mistaken the latter picture, or the famous photographs of children playing among ruins in Seville (pp. 108, 109), as documents of the devastation of the Spanish Civil War, which did not begin until three years later. The error, however, is merely technical,

for the pictures—like Luis Buñuel's harrowing film *Land Without Bread* (1932; fig. 13)—do express the grim circumstances that already prevailed in Spain in the years before the war. And not only in Spain: by 1932 the economic crisis precipitated by the New York stock-market crash of 1929 had become severe throughout Europe.

Those of Cartier-Bresson's photographs that bluntly point to individuals in trouble are unquestionably documents of the Depression. Nevertheless, the very bluntness of the pictures, the absence of narrative incident or explanatory details, shifts their weight from the political to the personal. By insisting upon immediate contact between the viewer and a particular individual, these pictures describe not so much the plight of the early thirties as the one that had always existed.

If the hard reality of these pictures casts Cartier-Bresson in the role of outside observer, no matter how sympathetic, many others involve him as a participant. Often the subjects are aware of the photographer, and even when they do not clown or perform for him it is clear that he has won their collaboration. As much as Cartier-Bresson deplored the hard circumstances of his subjects he admired their spirit, and entered into it.

Cartier-Bresson's affection for his subjects is expressed physically, in the way he describes not just their faces but their whole bodies. Everyday gestures of work or play or contemplation or, perhaps most often, of fatigue, express an open sensuality no less potent than in the few pictures explicitly concerned with sex. One picture, of a young girl and boy, encapsulates what then was not yet called the male-chauvinist ethos of Latin countries (p. 115). The girl, nude, looks at the (male) photographer, projecting with her face and body a perfect balance between shy innocence and impish coquettishness. The boy, pants on, sizes her up with cynical macho confidence. The position of the girl's arms in this picture is repeated by her mature counterpart in another, a mother for whom the posture now expresses both resignation and protectiveness of her child (p. 114).

As the comparison of these two pictures suggests, Cartier-Bresson responded to the diversity of his subjects. His early pictures present a full range of types, from the plain to the mysterious, the exuberant to the defeated, the comic to the sinister. Each is acutely described. Above the beautiful sleeping black in Marseille, his sensuous repose worthy of a sculpture by Michelangelo, floats an unsavory character whose shabby elegance of dress matches the devilishness of his pose (p. 70). Elsewhere in Marseille, on

a sidewalk that might have been designed for a macabre Expressionist film, a caped assassin pauses on his way to (or from?) work (p. 89). In Alicante, Spain, three prostitutes (one male?) improvise a magic dance with the aplomb and practiced ease of trained performers (p. 133).

Despite the narrowness of its social boundaries, the world of the early photographs suggests a full working

monplace. In the early thirties it was still new, at least to photography. As an artistic idea it was not new and indeed had been explored extensively by realist artists of the nineteenth century. Among those most relevant to Cartier-Bresson are Manet, Degas, and other painters of their generation, who deliberately constructed their pictures of contemporary life as if they were momentary perceptions of a passing observer (fig. 14). By the 1890s, however, the

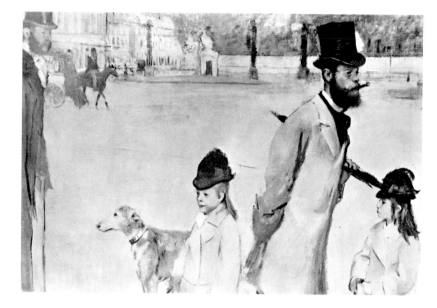

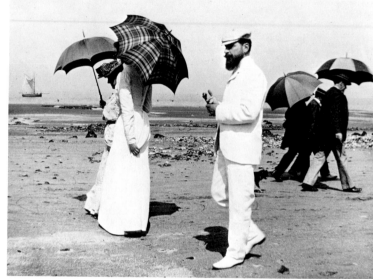

theater with a complete cast of players, each the master of his or her role. Not all are admirable but none is boring.

Yet such an approach to Cartier-Bresson's work is severely limited: it treats the photographer's relationship to his subjects as if the photograph were merely a transparent window between them. The remainder of this essay will attempt to correct this faulty approach by demonstrating the aesthetic sophistication with which the pictures are constructed. Nevertheless, the fault is instructive, for it points at two fundamental axioms underlying the new conception of photography that Cartier-Bresson's work helped to create. First, that the photograph need be nothing more than a record of a particular fact or set of facts, chosen without regard to an established hierarchy of value and described without interference from any prior standard of pictorial elegance or beauty. Second, that a collection of such pictures, accumulated without plan, can express a personal artistic vision.

Over the last half-century this conception of photography has been so fruitful that it has become a com-

mainstream of advanced painting had departed from this path of inquiry, which remained abandoned until advanced photographers took it up again in the 1920s and 1930s. When they did so, their work was inflected by two intervening developments. The first of these was the proliferation and rapid improvement of small hand-held cameras, which invited photographers to approach their work in a spirit of improvisation. The second development was the revolution of early twentieth-century painting, whose formal and philosophical innovations provided photographers with a rich resource for their own work.

For most of the nineteenth century photography had been a matter of manipulating a heavy, cumbersome box mounted on a tripod. The photographer could make only one picture at a time, usually with delays of several minutes between exposures, and the length of the exposures themselves made it impossible to arrest motion. These conditions not only limited the range of subjects available to the photographer; they also obliged him to plan his picture carefully in advance. The advent of small cameras

Left: Fig. 14. Edgar Degas. *Place de la Concorde (Vicomte Lepic and His Daughters)*. 1875–76. Oil on canvas, 31¾ × 47⅜" (80.6 × 120.3 cm). Formerly collection Gerstenberg, Berlin. Believed destroyed

Above: Fig. 15. Jacques-Henri Lartigue. *The Beach at Villerville*. 1908. Gelatin-silver print, 10½ × 13¾" (26.7 × 35 cm). The Museum of Modern Art, New York. Purchase

and fast exposures removed this straightjacket.

André Kertész, Cartier-Bresson, and others who were born within a decade before or after 1900, so imaginatively exploited the hand camera that it is easy to forget it had been available a generation earlier. When Cartier-Bresson was still an infant Jacques-Henri Lartigue, himself still a child, gleefully compiled albums of pictures that outline the new opportunities of the small camera (fig. 15).

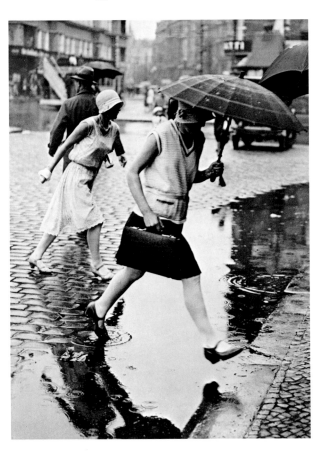

His photographs, however, were not known outside his family circle until the 1960s. At the turn of the century the pride and inertia of professionals and the defensive arrogance of photographic aesthetes consigned the small camera to the status of a toy, whose proper use was limited to amateurs (in the pejorative sense) and to children, such as Lartigue. Snapshots proliferated—Lartigue is exceptional only for his fortunate circumstances and his talent—but until the 1920s (slightly earlier in America) the small camera had no place in the arsenal of the ambitious photographer, and its products received little considered attention.

Beginning in the 1920s, a new generation of European photographers brought the small camera from the margins of photography to the center. Their delight in the new freedom spawned a whole class of pictures that celebrate instantaneity for its own sake. A favorite subject is illustrated here by Friedrich Seidenstucker's *Puddle-Jumpers* (fig. 16). By 1932, when Cartier-Bresson made his version (p. 101), the subject had become or was about to become a cliché. This instance introduces a characteristic of several of Cartier-Bresson's early pictures: his puddle-jumper is distinguished not by the originality of the idea but by the perfection of its execution. Compared to Seidenstucker's picture of 1925, quite satisfying in itself, Cartier-Bresson's photograph is at once more precise—excruciatingly perfect—in its timing, more powerful in its graphic design, and far richer in its atmosphere and details. The poster-like simplicity of the picture's central incident emerges from the agreeably seedy vicinity of Monet's Gare St.-Lazare—a complete picture in itself, as rich in dramatic implications as a scene from a film by Jean Renoir. Unaccountably, a real poster in the background of Cartier-Bresson's photograph mimics the man's leap; a fragment of a name on another poster comically elaborates "rail" into "railowsky" (the pun also works in French); and the discarded circular bands lying in the water anticipate the ripples of the imminent splash. Add to this the well-known fact that to make the picture Cartier-Bresson wedged his camera into a narrow gap in a fence, and it is clear why other photographers have a sober respect for his luck.

Too much often is made of instantaneity itself, impoverishing Cartier-Bresson's notion of the "decisive moment." The small camera not only made it possible to stop the motion of the subject; it also made it possible for the photographer himself to move. Liberated from the tripod, the photographer could now pursue the action as it unfolded, as one potential subject transformed itself by almost imperceptible stages into another. Thus the small camera not only gave photographers access to previously unavailable subjects, but also fundamentally changed the way in which the subject was defined. It was now possible to discover in the process of working the kinds of pictures that Degas had so laboriously designed to appear as if they had been discovered. The pursuit of this opportunity forms one of the central traditions of twentieth-century photography.

A pioneer in this endeavor, perhaps *the* pioneer, was the Hungarian-born photographer André Kertész, who

moved from Budapest to Paris in 1925. Kertész's work and small-camera photography of the twenties generally are bound up with another technical improvement, which through a series of now arcane steps had at last made it practical to reproduce photographs as illustrations in the cheap press. New publications designed to exploit this opportunity originated in Germany in the 1920s and soon spread to the rest of Europe and the United States. This

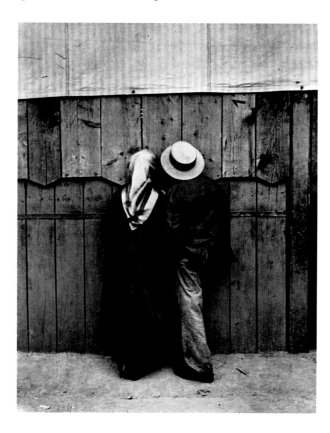

development brought small-camera pictures out of the family album and before a mass audience; it created a new class of professional photographers; and it applied the versatility of the small camera to a bewildering variety of new subjects, from the momentous to the trivial. For the editors of the new illustrated publications soon realized that the kind of photograph that we now classify under "human interest"—or even casual observations whose interest was hard to define and harder to defend—contributed as much to sales as did records of important events.

Photojournalism did not become the profession we now know until somewhat later. The rigid concept of the picture story, the subservience of photographer to editor, and narrow areas of specialization had yet to be estab-

lished. For Kertész and others the loose arrangement was perfect. It provided the photographer with an income without turning him into an employee, and it enriched his opportunities without forcing a sharp distinction between reporting and art. Sandra S. Phillips's extensive research into Kertész's work in Paris from 1925 to 1936 has demonstrated the continuity among those pictures Kertész made on assignment, those he made hoping to sell to the magazines, and those he made for himself.[69]

Kertész had a brilliant eye for the small dramas and affecting details of ordinary life. Within a few years of his arrival in Paris, this talent had earned him a substantial reputation as a photojournalist and artist. Because of this reputation and the broad influence that went with it, it is difficult to separate what was original in Kertész's work from what belonged generally to the new photography of the twenties. For Cartier-Bresson, Kertész's work seems to have been most useful as a catalogue of potentially fruitful subjects or circumstances. One example among many is Kertész's *Circus* (fig. 17), which, like one of Cartier-Bresson's earliest Leica pictures (p. 73), places the viewer in the agreeable trap of seeing everything but what the subjects of the picture are most eager to see.

Kertész's choice of subjects and his manner of describing them betray, as John Szarkowski has observed, "a taste for the slightly strange: distortion saved from the macabre by sweet good humor."[70] This taste, made blunter and less polite, also marks Cartier-Bresson's early work. The question of influence, however, is rendered moot by the prevalence of this taste in the cultural milieu to which both photographers belonged. Consider, for example, Kertész's slightly disquieting *Meudon* (fig. 18). The street has become the stage on which unfolds a mysterious plot, in which the link between the passing train and the man and his package is all the more compelling for being unexplained. A number of Cartier-Bresson's early photographs may be described in similar terms. The affinity between the two photographers, however, is only one thread in the complex tapestry of modern imagery, photographic and otherwise. For example, by the 1920s the pictorial theater of Giorgio de Chirico (fig. 19) had become common property, as Kertész's *Meudon* and several of Cartier-Bresson's early photographs attest (for example, pp. 90, 91, and 102). To make matters more complex, ordinary vernacular photographs had anticipated (and perhaps also contributed to) aspects of de Chirico's (and Kertész's) sensibility and style (fig. 20).[71]

Left: Fig. 17. André Kertész. *Circus*. 1920. Gelatin-silver print, 14⅜ × 12¾" (36.5 × 32.3 cm). The Museum of Modern Art, New York. Gift of the photographer

Below: Fig. 18. André Kertész. *Meudon*. 1928. Gelatin-silver print, 16⁷⁄₁₆ × 12½" (41.7 × 31.7 cm). The Museum of Modern Art, New York. Gift of the photographer

Right: Fig. 19. Giorgio de Chirico. *Gare Montparnasse (The Melancholy of Departure)*. 1914. Oil on canvas, 55⅛ × 72⅝" (140 × 184.5 cm). The Museum of Modern Art, New York. Gift of James Thrall Soby

Right: Fig. 20. Charles J. Van Schaick. *Special Car of Traveling Minstrel Show*. c. 1905. Gelatin-silver print, 7⅝ × 9⁹⁄₁₆" (19.2 × 24.3 cm). The Museum of Modern Art, New York. Courtesy of the State Historical Society of Wisconsin

It is not difficult to recognize that the new photography of the twenties and thirties owed an enormous debt to modern painting. In addition to its formal innovations, modern art lent to photography its devotion to innovation as an end in itself; its view of art as an experimental process in which the medium became a subject; its identification of art with personal experience; its combative opposition to received ideas; and its responsiveness to the symbolic

power of ordinary fact. Not least among these debts was a new open attitude toward photography, with the result that modern photographers saw photography's traditions and possibilities not from a narrow professional viewpoint but through the eyes of modern culture as a whole.

This assertion may apply more fully to Cartier-Bresson than to any other photographer of the period, with the possible exception of those, such as László Moholy-Nagy and Man Ray, who worked simultaneously in photography and other mediums. For all of its affinities with modern painting, Kertész's mature work can be understood as a natural extension of the amateur snapshots he had made in his late teens. But although Cartier-Bresson also made snapshots as a child, his mature interest in photography

and his sense of its opportunities did not grow out of his boyhood pastime. Rather they grew from the sophisticated enthusiasms of the artistic avant-garde.

The advanced painters and poets whom Cartier-Bresson admired as he turned twenty, and whose ranks he was eager to join, had nothing but disdain for the Whistlerian pieties of photographic high art of the turn of the century. Instead they embraced the vast, chaotic mass of photography which the aesthetic movement had rejected as too mechanical, too awkward, too banal—too incoherent— to be art. Like other kinds of vernacular imagery and like so-called primitive art, photography appealed to the modernist eye precisely because it lay outside the conventional boundaries of art and thus provided a welcome provocation and a resource for invention.

The aesthetic movement had arisen just as technical advances were making photography much faster, easier, and cheaper than before, and much easier to reproduce. These developments opened photography to an enormous range of new functions, both professional and amateur, and to a much broader and more varied audience. The high-minded rhetoric of the aesthetic movement may be interpreted as a defensive response to this flood of new imagery, from snapshots to medical illustrations—an effort to draw the wagons around an ever narrower definition of art.[72] The modernist taste for photographs swept that barrier away, opening up to advanced photographers photography's own fecund present and past.

A case in point is the Surrealist appropriation of Eugène Atget, to which we owe Cartier-Bresson's first successful photographs, of 1929–31 (pp. 54, 55).[73] The fullness of Atget's work and the nature of his ambitions are not at issue here, for they did not concern the Surrealists. Indeed, for Man Ray and his colleagues, it was indispensable that Atget remain a naïf, a passive conduit for photography's automatic operation which demonstrated that the real and the surreal, the ordinary and the fantastic, are one in the same thing. Thus one category of Atget's work that the Surrealists admired was his photographs of mannequins, in which the inanimate figures come half to life, revealing a still drama, comic or eerie or both (fig. 21). Like many other early emulations of Atget, but far more successfully than most, Cartier-Bresson's early glass-plate pictures abstract this special quality from the complex whole of his work.

The Surrealists knew Atget's name and perhaps regarded him as first among equals, but the emphasis was

Fig. 21. Eugène Atget. *Avenue des Gobelins, Paris.* 1927. Albumen-silver printing-out-paper print, 9⁷⁄₁₆ × 7⅛" (24 × 18 cm). The Museum of Modern Art, New York. Abbott-Levy Collection; Partial gift of Shirley C. Burden

on the latter term, on the great anonymous mass of ordinary photography. They loved the idea of photography because it was purely mechanical and automatic. The more banal and straightforward the picture, the more fully it seemed to offer a direct avenue between the psyche and reality, free from the habits of consciousness and from the hated conventions of aesthetics. A character in one of Pierre Courthion's fictional episodes of café chit-chat,

usual and unusual, the bizarre in the banal. It was an aggressively inclusive aesthetic, from which only the conventionally artistic was barred. The Surrealists recognized in plain photographic fact an essential quality that had been excluded from prior theories of photographic realism. They saw that ordinary photographs, especially when uprooted from their practical functions, contain a wealth of unintended, unpredictable meanings. The attempt to

Above: Fig. 22. Photographer unknown. *Mechanical Advances: Protection of Men.* Page from *Variétés* (Brussels), January 1930

Right: Fig. 23. Photographer unknown. *Aix-les-Bains at the Time of Félix Faure.* c. 1895. Formerly collection Brassaï. Published in *Bifur* (Paris), no. 7 (1931)

published serially in *Variétés*, explained the vogue for Atget and for plain photography generally as an antidote to "the disgust for all that gratuitous painting."[74] In an essay in *La Révolution surréaliste*, Pierre Naville elaborated on the theme:

I have no tastes except distaste. . . . Everyone knows that there is no *surrealist painting* . . .
But there are *spectacles.*
Memory and the pleasure of the eyes: that is the whole aesthetic. . . .

. . . . . . . . . . . . . . . . . . . .

The cinema, not because it is life, but the marvellous, chance grouping of elements.
The street, kiosks, automobiles, screeching doors, lamps bursting in the sky.
Photographs . . .[75]

The Surrealists approached photography in the same way that Aragon and Breton, in their guidebook novels, approached the street: with a voracious appetite for the

harness this centrifugal, obstreperous force forms a central tradition of modern photography.

By the late twenties, vernacular photographs of all sorts had become a staple of avant-garde periodicals, Surrealist and otherwise.[76] The criteria of selection were catholic, but favored either the very ordinary or the extraordinary, thus challenging the reader's assumptions about the distinction between the two (figs. 22, 23). The pictures were presented matter-of-factly, often interspersed with paintings and modernist photographs, and rarely with any clue to whether the editors were interested in the photograph as a picture or only in its subject. On occasion cryptic captions or unexpected juxtapositions deliberately diverted attention from the pictures' original functions. The

spirit of presentation is explicit in the following caption below a photograph in a 1921 issue of *L'Esprit nouveau*: "This photograph (the clockwork at Strasbourg Cathedral) has no connection with any article. It is here only to give pleasure to the eyes and to make you think."[77]

Partly because of their incessant breast-beating, partly out of simple convenience, the Surrealists have been credited with more than one idea or practice that was neither original nor exclusive to them. The taste for vernacular photography is one of these. Certainly by 1930 it had become the common property of modernist culture at large, a fact suggested by the reproductions in such non-Surrealist books as Moholy-Nagy's *Painting, Photography, Film* (1925), Werner Gräff's *Here Comes the New Photographer!* (1929), and Ozenfant's *Foundations of Modern Art* (1928).[78] John Szarkowski has observed that Ozenfant's book is "illustrated largely by photographs that are so uniformly diverting, so divergent in their original functions (photographs of news events, tribal customs, street scenes, scientific apparatus, plant forms, buildings, aerial views, battleships, colleagues, etc.) and so elliptically related to the subjects of the text, that this aggregation is clearly the work of a twentieth-century painter."[79]

In the 1920s Surrealism with a capital "S" was more fruitful and varied as a strategy for looking at photographs than for creating them. Photographs made by or expressly for the group may be divided into two unequal categories.[80] The smaller is comprised of pseudo-vernacular documents, which are often less provocative than the real ones. The second category, numerically larger but conceptually narrow, is comprised of tableaux (often incorporating a female nude) devised for the camera. The talented Maurice Tabard and many others followed the lead of Man Ray, who brought what little he needed into his studio and rarely left it.

In 1931, after he returned from Africa and before he discovered the Leica, Cartier-Bresson experimented briefly in this vein. Only one picture survives from the episode, a fantastic, distorted face created when Léonor Fini put a silk stocking over her head and invited Cartier-Bresson to record her pose (p. 57). Shortly thereafter, with the Krauss camera in Eastern Europe and then with the Leica in 1932, Cartier-Bresson definitively abandoned studio Surrealism and, like Breton and Aragon, gave himself up to the surprises of the street. The corresponding shift, from hyperbolic fantasy to gritty realism, has an exact contemporary parallel in the early films of Luis Buñuel, whose

passage from the arch, Freudian symbolism of *L'Age d'or* (1930) to the hard facts of *Land Without Bread* (1932) occurred in the same years. In an interview of 1974, Buñuel stated, "I made [*Land Without Bread*] because I had a Surrealist outlook, and because I was interested in the problem of man. I saw reality differently than I had before Surrealism. I was sure of that...."[81]

In his small-camera work of the early thirties Cartier-

Bresson brought together, with highly original results, two previously separate elements of the Surrealist aesthetic. One was its sensitivity to the unpredictable psychic force of straight photography. The other was its vision of the street as an arena of adventure and fantasy only thinly disguised by the veneer of daily routine. The small camera provided the link between the two, by making it possible to record and preserve the most ephemeral Surrealist epiphany. Other photographers, notably Kertész (whose sensibility was a little surreal before Surrealism was invented), had made intermittent forays into this territory. Cartier-Bresson occupied it with a single-minded intensity that accounts for the unusual coherence of his early work. This quality of coherence is what separates Cartier-Bresson

Fig. 24. Manuel Alvarez Bravo. *The Crouched Ones*. c. 1934. Gelatin-silver print, 7 × 9⅜" (17.7 × 23.8 cm). The Museum of Modern Art, New York. Purchase

from Kertész or Germaine Krull, or other small-camera photographers of the period, whose far more varied work reflects the variety of their commissions, their interests, and their artistic contacts. An exception is Manuel Alvarez Bravo, who like Cartier-Bresson did not earn his living from photography, and who learned similar lessons from Surrealist ideas and Atget's pictures. Just how much he had learned before meeting Cartier-Bresson is a fascinat-

ing question, since their early work is so closely related, and an insoluble problem, since Alvarez Bravo's work of the thirties can be only approximately dated (fig. 24).[82]

If Surrealism aimed to eliminate the distinction between art and life, no one achieved this goal more thoroughly than Cartier-Bresson in the early thirties. The tools of his art—a few rolls of film, the small camera held in the hand—required no distinction between living and working. There was no studio, no need to separate art from the rest of experience. And despite the high intelligence that lies behind the work, Cartier-Bresson is justified in describing it as a purely visceral act: "I prowled the streets all day, feeling very strung-up and ready to pounce, determined to 'trap' life—to preserve life in the act of living. Above all, I craved to seize the whole essence, in the confines of a single photograph, of some situation that was

in the process of unrolling itself before my eyes."[83]

No one is likely to improve upon those two sentences. But since the talent itself is beyond explanation, it is worth considering the underlying intelligence and the artistic ideas that helped to shape it. A number of Cartier-Bresson's early pictures, for example, treat subjects or themes made familiar by Surrealism: objects bound or wrapped; bodies without heads; extremes of sexuality; and the grotesque or repellent, such as the animal hide at the slaughterhouse of La Villette (p. 84). The last picture evidently was inspired by Eli Lotar's photographs of the slaughterhouse, published in 1929 as illustrations to an entry in Georges Bataille's episodic dictionary in *Documents* (fig. 25). The entry reads in part:

The slaughterhouse evokes religion in the sense that temples of far-off epochs (not to mention present-day Hindu temples) had a double function, serving at the same time prayer and carnage. As a result without a doubt (as one may judge from the chaotic appearance of today's slaughterhouses) there is a staggering coincidence between mythological mysteries and the lugubrious grandeur characteristic of places where blood is spilled.... Nevertheless in our time the slaughterhouse is damned and put in quarantine like a boat carrying cholera.[84]

The virtually total disappearance of Lotar's work, sad in itself, has removed a potentially important link between Cartier-Bresson's enthusiasm for Surrealism and his realization of its goals. The handful of pictures by Lotar that survive, in the original or in reproduction, suggest that he was one of the few photographers before Cartier-Bresson to apply Surrealist principles in the street, and with a similar talent for graphic compression.[85]

Surrealist objects aside, Cartier-Bresson employed Surrealist strategies with great wit and skill. The first of these—in the academic lingo, *dépaysement*—is to uproot an ordinary fact or incident from its expected spatial or narrative context, thus releasing a hidden poetic force. In a sense all photographs are details, framed and dismembered from the world at large. But Cartier-Bresson applied the principle with radical concision, often denying the viewer the bare minimum of clues necessary for a plausible reconstruction of the broad scene from which the cryptic detail had been snatched. How could one know, for example, without being told, that the child in *Valencia* (1933; p. 107) is merely playing a game, arching his back to catch sight of a ball he has tossed in the air, out of the frame? Cartier-Bresson's visceral intuition, the Surrealist principle of dislocation, and the instantaneity of the Leica, have

come together to transform the ordinary incident into an image of rapture. The realist interpretation of the "decisive moment" has no room for such a transformation, which may be why Ben Maddow's perceptive description of the picture has not (to my knowledge) been repeated or extended since he wrote it in 1947:

The ball itself, the ordinary cause, is not seen; in fact it can hardly be guessed. Because now the child has been enlarged into

a legendary figure. The wall behind him, with the whitewash coming off, is inscribed with fabulous organic shapes. The child is bending back, but as if stabbed, and suffering not pain but ecstasy. The slice of time has become enormous in importance, and its hidden meaning is now perfectly plain, though so complex that it can hardly be written down.[86]

As Maddow's description suggests, Cartier-Bresson's picture is precise enough to demonstrate the validity of Georges Bataille's theory linking eroticism and death[87]—

and rich enough to escape the dull role of illustrating an idea.

The close cousin of dislocation is the Surrealist strategy of juxtaposition: two or more incongruous fragments of reality, uprooted and then grafted together, create a new reality. The Surrealists regarded this new reality as the true one and adduced its improbable meanings as proof that the logic of ordinary meaning is false. In *La Peinture au défi*

(*Painting Challenged,* 1930), Aragon placed collage—the favored technique of juxtaposition—at the center of the Surrealist aesthetic.[88] The hero of the piece is Max Ernst, who in his earlier Dada incarnation, then as a leading Surrealist, was a master of the technique. His work of the early twenties and Surrealist collages generally are frankly two-dimensional aggregates.[89] Composed of fragments of photographs and other prosaic printed materials, freely deployed on a flat ground, they instantly foreclose any possibility of reading them as conventional pictures in depth. In the late twenties, however, Ernst experimented with just that possibility, creating bizarre dramatic episodes within the unaltered realist space of the Victorian illustrations he used as raw material (fig. 26).[90] Hence the affinity between these collages and several early photographs by Cartier-Bresson, which exploit the principle of Surrealist collage within the bounds of the integral camera

Left: Fig. 26. Max Ernst. Collage from *The Hundred Headless Woman* (Paris, 1929). Spencer Collection, The New York Public Library; Astor, Lenox and Tilden Foundations

Above: Fig. 27. René Magritte. *Le Symbole dissimulé.* 1928. Oil on canvas, 21¼ × 28¾" (54 × 73 cm). Selma and Nesuhi Ertegun Collection

image (for example, pp. 86, 92, and 131).

Photographs of course collapse three dimensions into two, with the common result that elements of foreground and background, distinct from each other in reality, are compressed in the picture. This phenomenon, ordinarily regarded as a liability, became an asset for Cartier-Bresson. Instead of avoiding its effects he sought them, thus incorporating the artificial technique of collage into the realist

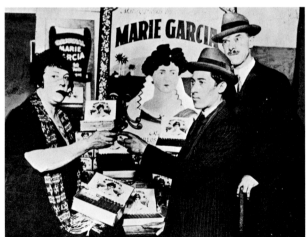

vocabulary of straight photography. The most surprising of the pictures Cartier-Bresson constructed with this new vocabulary was made in a seedy square in the town of Martigues, near Marseille (p. 87). Against the ready-made collage of posters on the sides of the buildings Cartier-Bresson discovered an outrageous visual pun. Although hidden to all but the photographer, an irreverent political joke lurks in this pun—a joke that is worthy of the collagist John Heartfield and which secretly expresses Cartier-Bresson's distaste for French colonial policy. For

the suddenly potent boy in the foreground is part of a monument to the first governor general of French Indo-China.

Cartier-Bresson usually found his collages, but at least twice, in Mexico, he helped to create them. One of the pictures is among the most powerful he ever made (p. 141).[91] Exploring a hacienda with his friend Ignacio Aguirre, Cartier-Bresson noticed an open cabinet whose two shelves contained an assortment of second-hand shoes. This collection—six pairs whose varied positions comprise an abbreviated catalogue of sexual permutations—was made up of elegant, ladies' white heels and one male intruder, a pair of dark, heavy boots. Amid the chaos of this Pandora's box, Cartier-Bresson noticed a heart formed by the blank space between two of the ladies' shoes lying sole to sole. Without reflection he asked his friend to pose with arms crossed beside the box, and photographed the resulting tableau head-on and close-to. Formally, the picture's taut frame and geometric compartments, each neatly enclosing its contents, recall an early series of paintings by Magritte, which reduce the principles of dislocation and juxtaposition to their enigmatic essentials (fig. 27). But here the similarity ends, for Cartier-Bresson has replaced Magritte's artificially banal illustrator's style with the blunt, exacting realism of photography. Applying Surrealism's calculating strategies to the world at large, he transformed his tawdry materials into an erotic ritual at its precarious height.[92]

Collage was not a Surrealist property. As a device of high art it had been invented in 1912 by Picasso and Braque, when they began to introduce into their pictures pieces of newspaper, photographic reproductions, and other printed materials. One effect of this procedure was to enrich and redirect the Cubist dialogue between art and reality; the elements of collage, themselves fragments of reality, were also, as reproductions, false. The relevance of this conundrum to the ambiguities of photographic description did not escape Ozenfant, who mischievously compared a Picasso collage to an unintentionally Picassoid photograph (figs. 28, 29).

The invention of collage broke the impasse that Picasso and Braque had reached in their ever more refined analysis of pictorial representation (hence "Analytic Cubism"). The materials of collage by their nature suggested a new method of constructing pictures in broad planes and simple outlines, a style now called Synthetic Cubism. It was this new vocabulary of bold, flat planes—and the far

more varied content it expressed—that Cartier-Bresson inherited in the 1920s.[93]

Just as a few of Cartier-Bresson's early pictures may be described as Surrealist subjects rediscovered in the street, a few others instantly evoke his Cubist training. One of the latter is a virtual diagram of the golden-section proportions so dear to André Lhote—a picture saved from inert abstraction by the velvet delicacy of its tones and the

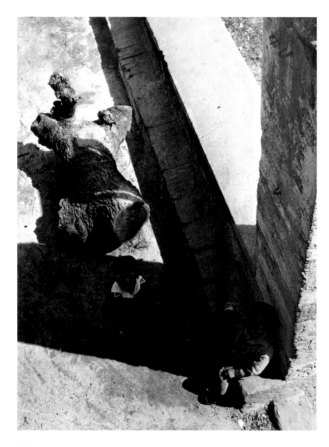

fidelity with which they suggest the hot light and cool shadows, and the human scale, of Italy's old streets and squares (p. 95).

Cartier-Bresson's debt to Lhote's neoclassical ideals and to Purist Cubism generally is easy to exaggerate, or rather, to distort. His talent for pictorial balance and clarity, his demand that even the most eccentric fragment cohere as a picture, are misconstrued as a taste for neatness. In his art the classical elements work in tandem with the anti-classical—the extreme, the incomplete, the abruptly arrested. The new style of photography that Cartier-Bresson invented was a way of giving clarity to flux; the coherence of the picture expresses the intensity and self-

sufficiency of the fleeting experience it describes. Thus the picture's graphic concision is not merely a solution to a problem of design. Nor is Cartier-Bresson's adherence to the unaltered 35-mm frame a rote allegiance to an ideal proportion. The frame, internalized through work, comes to be identified with experience; if the frame is cropped, the experience is compromised. As for many painters, Cartier-Bresson's Cubist inheritance was not a restriction but a liberation.

Like Surrealism, Cubism came to Cartier-Bresson enriched by a photographic component. By the mid-twenties photographers had learned that by shooting at odd angles, or from very close or very far away, or by eccentric framing, or by exploiting designs of light and shadow or accidents of arrested motion, they could achieve surprising, Cubist-like graphic patterns without interfering with the photographic process. This new approach derived in part from the mobility of the hand camera and from the moving images and abrupt editing of films, but the vocabulary of Cubism was an essential resource.[94]

Perhaps the most enthusiastic and influential practitioner of the new photography was László Moholy-Nagy. Both Moholy's own work and his choice of vernacular pictures for reproduction in his books treat photography as an experimental process, whose mechanical objectivity was a tool for uncovering new aspects of experience. Because mechanical, the camera presented a means to escape aesthetic habit; because objective, the photograph—no matter how unexpected—was not arbitrary but true. The originality and fecundity of this approach have been buried beneath the flood of superficial imitations its products soon inspired. In March 1931 a French critic complained in the popular journal *Le Crapouillot*:

But perhaps one may reproach "young photography" for submitting too directly to the influences of cinema and painting. Simply because a studio camera can catch a person or an object from all angles, it does not necessarily follow that a cathedral is more beautiful when foreshortened by a photographer lying on the ground, or that a person is more moving because seen in plunging perspective from the seventh floor. This pursuit of "arrested cinema," just like the photographic transposition of Cézanne's still lifes, has become a veritable cliché.[95]

At its worst the new style descended into mere pattern-making in which the subject, drained of reality, served as the pretext for a counterfeit Cubist design. But at its best the new photography engendered a fascinating and unresolved contest between three and two dimensions, and

thus also between the picture's nominal subject and the new, unfamiliar subject that struggles to displace it. In other words, the best Cubist photographs are psychologically as well as spatially disorienting. Moholy-Nagy recognized and exploited this fact, with the effect that his photographs (like his photocollages) are often richer and more inventive than his pure, abstract paintings. A caption he wrote for one of his photographs in *Painting,*

merely a library of weird or disturbing subjects. Nor, for his best early work, is it possible to analyze the pictures into Cubist and Surrealist components; in his work the two artistic systems operated as one. Cartier-Bresson points out, moreover, that his familiarity with recent art dovetailed with his admiration for early Renaissance masters, especially Paolo Uccello, Piero della Francesca, Masaccio, and Jan van Eyck.

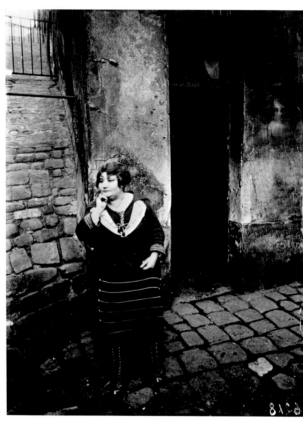

*Photography, Film* needs only slight alteration to fit the similar picture reproduced here (fig. 30): "The organisation of the light and shade removes the [children and the tree stump] into the realm of the fantastic."[96]

The intersection of Cubist and Surrealist conceptions of photography marks the spot where Cartier-Bresson took them up. For him Cubism was not a template of abstract forms to be superimposed on reality, nor was Surrealism

The range of precedent—Cubist, Surrealist, and otherwise—that Cartier-Bresson absorbed into the artistic synthesis of his early work may be suggested by his photograph of two prostitutes in Mexico City who appear in the narrow apertures prescribed for them by law (p. 130). Compare this picture to two others, neither Surrealist in origin, both icons of Surrealist taste in the twenties. Thesis: Picasso's *Les Demoiselles d'Avignon*, in which the aggressive formal invention expresses the violence of sexual attraction and the fear it inspires (fig. 31). Antithesis: Atget's picture of a prostitute in front of her doorway in La Villette, in which the plainness of photographic fact meshes with the sterility of disillusion (fig. 32). At first it

might seem that Cartier-Bresson simply grafted these divergent images together, as in a diptych. One prostitute, barely emerging from her window on the right, confronts the photographer with chilling matter-of-factness; the other, her face a painted mask, projects her body outward, transforming herself into a phantasm of desire. But the black line that separates the two is overridden by the yawning space of the whole. Slightly deflecting his camera from the flat plane of the door, Cartier-Bresson has joined the two women together in the warped plane of the picture, which simultaneously attracts and repels. What more concise description can there be of the real dream of the false business?

The inspection of Cartier-Bresson's artistic inheritance —the ideas and motifs, principles and strategies of modern art and photography—risks missing the forest for the trees. In the street this sophisticated inheritance was subordinate to—incorporated within—Cartier-Bresson's animal intuition. Nonetheless, this does not mean that our minds must accept what our eyes tell us: that the pictures dispense with art in favor of life. It means that for an instant, made permanent, there was no difference between the two.

This equation is so perfectly balanced that either of its terms, isolated for analysis, leads directly to the other. Consider as an instance Cartier-Bresson's acknowledged debt to Martin Munkacsi's photograph of three black youths running into the surf (fig. 33).[97] The picture is at once a deft exercise in the Cubist game of figure and ground, a model of small-camera instantaneity, and— since it figured in a reportage on the Congo—an example of early photojournalism. Cartier-Bresson has frequently stated that when he saw the picture (presumably in 1931)[98] it impressed him enormously and more than any other suggested to him what he might accomplish with a camera. It is possible that Cartier-Bresson was responding to the subject as well as the picture, for he had himself just returned from Africa. In any case he rapidly mastered the lesson of Munkacsi's photograph. Within two or three years he had far surpassed it, notably in his pictures of children playing in ruined buildings in Seville (pp. 108, 109). Each of them is more lively as a graphic pattern, more complex in its tension between plane and depth, and more compelling as a description of real people in a real place. In Munkacsi's picture the organizing impulse of art has, perhaps too easily, defeated the chaos of life. Cartier-

Bresson's pictures instead respect both combatants, describing the struggle between them.

His impartiality was not absolute. Each of the pictures, made within moments (or at most minutes) of the other, slightly favors one side of the contest. In one (p. 108) the flat design is less prominent and slightly less complete than in the other; the children, absorbed in their game, are more independent of the photographer's presence and his

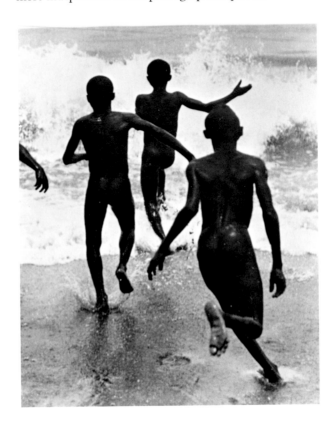

art. Cartier-Bresson prefers this one, but he was not wrong when he printed the other, more than once. The two pictures comprise one of several instances in Cartier-Bresson's early work where close variants provoke a Solomon's choice; another is the pair made in a bullring at Valencia (figs. 34, 35). If proof were needed, these pairs prove that calculation, far more than chance, created this work.

The pairs also provide a clue to Cartier-Bresson's working method—the practical habits that link artistic intelligence to physical talent. In theory the small-camera photographer may work without preconception. In practice every photographer carries a memory of circumstances that have proved fruitful in the past and, from mistakes

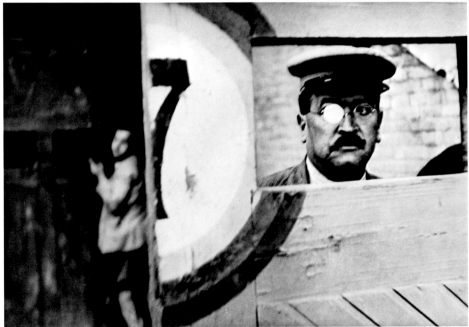

exposure or a dozen, each an attempt to realize a pictorial idea whose essentials he had recognized before beginning to shoot.

The textbook example of this method is the famous picture of a bicycle rider passing below a spiral stairway in the town of Hyères, near Marseille (p. 100)—a coiled vector of pictorial force that is as simple and as lively as the diagrams in Paul Klee's *Pedagogical Sketchbook*. Here, perhaps, Cartier-Bresson required only one exposure to catch the rider in the set trap. Elsewhere, however, he made use of a now familiar but then still new advantage of the roll-film camera—the opportunity to make a series of exposures without pausing to reload.

With few exceptions Cartier-Bresson's early pictures can be described as permutations of a single, simple, pictorial idea. It begins with a shallow space, closed off by a pictorial curtain (often in fact a wall), generally parallel or nearly parallel to the picture plane. On the narrow stage thus created, the figures are deployed as on an architectural frieze. The advantages of this scheme were three. Practically, it made it easier to follow and anticipate the unfolding action, by reducing its complexity. Formally, it established the picture plane as a flat ground against which the figures became elements in a collage. Narratively, it uprooted the figures from the course of everyday experience, transforming them into actors in a Surrealist theater.

Each of these advantages is exploited to the full in the great picture titled *Madrid* (1933; p. 111). The looming white wall, animated by erratic black windows, is a random collage by Jean Arp, enlarged and exported to Spain. Half a dozen surviving frames preceding the best one show that Cartier-Bresson recognized from the start that, by matching the bottom edge of his frame to the base of the wall, he could flatten against it the dark shapes of the children; near or far they all belong to the same irregular silhouette at the base of the picture. In the early frames the picture plane is oblique to the wall. By steps the two become almost parallel, compressing the picture, even as the photographer moved back to include more. (Almost but not quite: the thin triangle of sky in the upper left corner rescues the picture from neatness and abstraction, returning it to life.) As Cartier-Bresson worked, the children began to collaborate, gathering near him and contributing their expressions as well as their shapes to the vivid concoction. These preliminaries were accomplished just in time for the surprise entrance of a fat man from central casting, who crosses the stage in cartoon profile, his

and near misses, an intuition of circumstances that might prove useful in the future. The close variants suggest that Cartier-Bresson's nose for pictorial opportunity was highly developed. Instead of making single stabs at a variety of prey, he focused narrowly on a particular species. Depending on the complexity of the opportunity, he made one

squarish hat rhyming with the dancing black squares.

The complexity of a picture is not a function of the number of its elements. No less complex and mysterious than *Madrid* is another photograph made the same year at Córdoba (p. 131). The latter is economical to the point of austerity: the head, hand, and torso of a woman are flattened against a wall bearing a painted advertisement for corsets, itself bearing (and defaced by) two commercial labels. That is all. From this banal material Cartier-Bresson has fashioned a collage whose strangely affecting chemistry is a chain reaction set off by its two principal elements. The corset girl, like Atget's mannequins, has come to life, mimicking the gesture of the woman and establishing with her a dialogue concerning the relationship between youth and age, fantasy and fact, art and life, thought and vision. So fascinating is this pictorial conversation that the viewer enters into it, suspending his awareness that the photograph in fact describes nothing more than a woman standing in front of a wall, squinting against the light at the photographer. This puzzled squint belongs both to the picture, where it echoes the blinded expression of the girl, and to the woman herself, who now directs it not at the photographer but at us.[99]

Because its mystery is composed of so little, this picture exemplifies and clarifies the most original element in Cartier-Bresson's early work. Discovering that the link between photograph and photographed is highly elastic, Cartier-Bresson experimented, seeing how far it would stretch without breaking. Every amateur snapshooter knows that photographs rarely turn out as expected. Cartier-Bresson learned to anticipate and exploit this transformation, with an intelligence and talent that are, quite simply, astonishing. Like the awkward failures of the snapshooter, his pictures depart from transparent description. But unlike those discarded mistakes, Cartier-Bresson's best photographs arrive at a new, unforeseen destination—at the flamboyant theater of *Madrid* or the inexhaustible riddle of *Córdoba*. In theory this artifice must be accomplished at the expense of reality, and indeed so it is in most Surrealist art. Cartier-Bresson has disproven this theory. The more radically his photographs transform his subjects, the more decisively they transpose to the pictorial invention the unreconstructed vitality of the world it describes.

Beginning in the late thirties Cartier-Bresson's attitude toward his work began to change, and with it his style. In

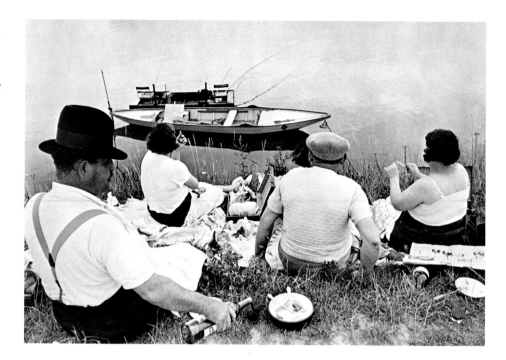

Top: Fig. 36. Henri Cartier-Bresson. *The Banks of the Marne.* 1936–37. Gelatin-silver print, 9⅛ × 13¹¹⁄₁₆" (23.3 × 34.8 cm). The Museum of Modern Art, New York. Gift of the photographer

Above: Fig. 37. Gustave Caillebotte. *Paris, a Rainy Day.* 1877. Oil on canvas, 6'11½" × 9'3¾" (212.2 × 276.2 cm). The Art Institute of Chicago. Charles H. and Mary F. S. Worcester Fund Income

broad terms the shift in attitude may be described as a greater openness to worldly or social as opposed to personal and artistic concerns. The corresponding shift in style may be described as follows. In the new work the depth of the picture, although still not vast, has become less constricted. The frame more often appears to coincide with the boundaries of a subject that preexisted and survived the photographer's intervention, and whose iden-

tity thus is more easily defined without reference to the picture. Like the frame, the chosen moment no longer dislocates the picture from the course of action but suggests an ongoing narrative. Finally, the range of subjects becomes much broader than before, implying a less intensely personal, more neutral or familiar view of the world. And with this broadening of subject matter comes a further evolution of style, since the sensuousness of Cartier-Bresson's aesthetic, no longer qualified by the grittiness of his early subjects, often produces more openly lyrical or even voluptuous pictures.

These over-simple distinctions are inadequate to describe such a rich body of work; nor is it reasonable to illustrate the complex evolution of Cartier-Bresson's style

by referring to a single picture. Nevertheless, the general direction of change may be suggested by the famous *Banks of the Marne* (fig. 36), made within a year or two of Cartier-Bresson's return to France from the United States, in the winter of 1935–36. Perhaps more than any other single picture, this one corresponds to the unexamined but not entirely untrue image of Cartier-Bresson's photography as a lyrical document of everyday social behavior, acutely and often sympathetically observed. It is this quality in Cartier-Bresson's later work, and his talent for discovering order within the ostensibly random course of experience, that inspires comparison with Degas, for example, or (when the formal configuration is more prominent) Seurat. Between the two neighboring sensibilities of Degas and Seurat is Gustave Caillebotte's *Paris, a Rainy Day* (fig. 37). Here (as often in Cartier-Bresson's pictures) the quality of order suspended in time seems, in Kirk Varnedoe's words, "to emanate from beneath the lovingly rendered surfaces of an apparently casual reality."[100] When, in the mid-1960s, Cartier-Bresson noticed a small newsprint reproduction of Caillebotte's painting pinned to the wall of John Szarkowski's office, he at first thought it was a reproduction of a photograph. So similar was the picture to his own work that he momentarily mistook his artistic ancestor for an imitator.

As Varnedoe's study of Caillebotte has shown, Impressionism, its satellites, and the larger tradition to which they belong are far from one-dimensional. Thoughtful students of nineteenth-century realism have always recognized that its sometimes simplistic rhetoric disguised a complex, experimental program. Another aspect of that program—as close to Cartier-Bresson's early work as the familiar image of Impressionism is to the later—may be suggested by Manet's marvelous painting of 1873, *The Railroad* (fig. 38).

The nominal subject of the picture is relatively simple. A woman (a governess?) and a young girl pass time in a garden overlooking the tracks of the Gare St.-Lazare. The girl, like the couple in Kertész's *Circus*, is absorbed in something (a passing train?) that we cannot see. The woman, like her counterpart in Cartier-Bresson's *Córdoba*, looks up at the artist, at us. Superficially the picture is simply another Impressionist slice of contemporary bourgeois life. But a list of the picture's contents hardly begins to define its meaning. For as John House has observed, this and related pictures "brought into sharp focus [Manet's] refusal to follow the conventions of genre paint-

ing and to give his paintings a legible plot."[101]

Failing to add up to a coherent plot, the picture's details challenge the viewer to interpret them: the two books in the woman's lap that at first look like one; the sash of the girl's dress, tied in a bow that forms the shape of another, smaller dress. So powerful is the momentum of interpretation, accumulated over a long tradition of reading pictures, that the viewer's expectations, when deflected, are not defeated but inflamed. Denied the comfort of a familiar explanation, the viewer is all the more sensitive to the faintly sinister, prison-like bars that stand out against the steam, or to the enigma of the girl's hidden expression, or to the tension between the direction of the girl's gaze and the woman's. As in Cartier-Bresson's *Córdoba*, the woman's gaze underlines the artificiality of the ostensibly neutral representation, for it signals the artist's intervention in the scene, and implicates the viewer in its mystery.

Manet's *Railroad*, Cartier-Bresson's *Córdoba*, and other pictures by both artists that rely on the same principle, exploit a crack in the realist conception of the picture as a transparent window on the world. The effect of transparency depends not only on descriptive fidelity to vision but also on conceptual fidelity to inherited definitions of a coherent subject. By simultaneously adhering to the former and violating the latter, Manet and Cartier-Bresson uncovered an unfamiliar and compelling reality beneath the surface of the familiar. If this formulation evokes the rhetoric of Surrealism, perhaps it suggests a connection between Surrealism's calculated disruptions and the experimental program of both realist painting and modern photography.

In their early work of the thirties Cartier-Bresson, Walker Evans (fig. 39), Brassaï (fig. 40), and Bill Brandt (fig. 41)—each a student of Atget, none a stranger to the Parisian avant-garde—created a new opportunity for photography. Their collective innovation is inadequately described as the discovery (or rediscovery) of the symbolic and poetic qualities of plain fact. For this discovery depended on the high artifice by which the photographers displaced an inherited image of reality with a new, more persuasive one. Nowhere is this more evident than in the radical inventions of Cartier-Bresson's early work.

In the 1930s and 1940s, as Cartier-Bresson's work became known, viewers were quicker to recognize its vitality than its artifice. Especially in the United States, where the appreciation and interpretation of Cartier-

Bresson's work began, the established standards of photographic craft required antiseptic clarity of detail and strict organization of form. The purist innovations of the twenties had inspired a mania for "texture" and "composition." To adherents of this standard the apparent casualness or even crudeness of Cartier-Bresson's craft masked the rigor of his style.

Anticipating such a response, Julien Levy, writing a

Fig. 39. Walker Evans. *Torn Movie Poster*. 1930. Gelatin-silver print, 6⅜ × 4⅜" (16.2 × 11.2 cm). The Museum of Modern Art, New York. Purchase

brief essay on Cartier-Bresson's work in 1933, labeled it "Anti-Graphic Photography." Contrasting Cartier-Bresson to "the great S's of American photography"—Stieglitz, Steichen, Strand, Sheeler—Levy compared his style to the "crude motion and crude chiaroscuro" of Chaplin's films: "'bad' photography in protest against the banal excesses of the latest Hollywood films."[102] A decade later James Thrall Soby explained: "What this phrase was intended to mean was that Cartier-Bresson's prints disregarded formal composition and technical display in favor of a spon-

taneous, unposed recording of reality's persistent and sometimes haunting disorder."[103] This sentence in turn requires an explanation. Soby (like Levy) presumably meant that Cartier-Bresson had disregarded one style for another; but to many it seemed that he had disregarded art for reality.

Few young artists have been as lucky in their first promoters and interpreters as Cartier-Bresson was in Levy,

echo the rhetoric that had been forming since the thirties to promote and explain the idea of documentary photography.

Against the background of turn-of-the-century pictorialism and its sharp-focused descendant, no less artificial because less blurry, the conviction that a photograph could be and thus should be straightforward, unmannered, true—a document—achieved the status of

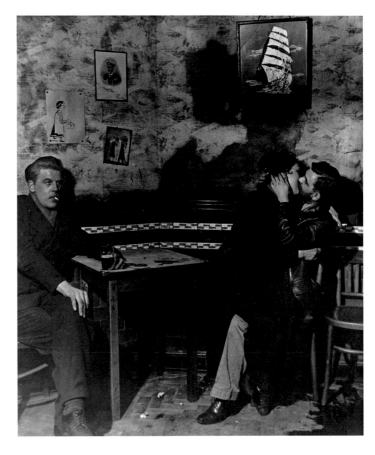

Right: Fig. 40. Brassaï. *Kiki Singing in a Montparnasse Cabaret.* 1933. Gelatin-silver print, 15⅝ × 11¾" (39.7 × 29.8 cm). The Museum of Modern Art, New York. David H. McAlpin Fund

Far right: Fig. 41. Bill Brandt. *At Charlie Brown's, London.* c. 1935. Gelatin-silver print, 12¾ × 10¹¹⁄₁₆" (32.3 × 27.2 cm). The Museum of Modern Art, New York. Gift of the photographer

Soby, Tériade, Beaumont Newhall, and especially Lincoln Kirstein. Soby's and Kirstein's early essays on Cartier-Bresson possess the vitality of fresh perceptions not yet fully resolved. Kirstein's brilliant, dense, complex introduction for the 1947 Museum of Modern Art catalogue is a masterpiece of criticism.[104] Kirstein's essay of 1963 is less successful, in part because it occasionally succumbs to a didactic absolute that the earlier essay had resisted: "[Cartier-Bresson's] clarity of purpose and direct simplicity of vision does much to distinguish an identity for the camera's unique employment." And further, "He is not making art but taking life."[105] These two sentences

a creed. This doctrine soon absorbed, and in the process distorted, Cartier-Bresson's early work. In 1938 a critic for *Time* magazine introduced a review of Walker Evans's *American Photographs* this way:

There are perhaps half-a-dozen living photographers who are seriously and solely engaged in making the camera tell what concentrated truth they can find for it. One, the oldest, is Alfred Stieglitz. Another is a Hungarian war photographer, Robert Capa.... A third, one of the most adventurous, is a 29-year-old vagabond Frenchman named Cartier-Bresson, whose abilities sober critics have called "magical." Apparently carefree but quick on the trigger, Cartier-Bresson has snapped unforgettable, reve-

latory pictures of commonplace and sub-commonplace scenes, from bare French café tables to Mexicans with their pants down. Closest to him among U.S. photographers is . . . Walker Evans.[106]

Notwithstanding the obligatory nod at Stieglitz, this is an alert triangulation of the new documentary styles. Especially perceptive is the recognition of a close affinity between Cartier-Bresson and Evans beneath the superficial dissimilarity of their technique. Yet the inclusion of the journalist Capa—the only one of the four who was not first and foremost an artist—suggests the confusion that was developing between the role of the documentary style as an artistic strategy and its status as a reliable report, to be disseminated in the press. In the reception of Cartier-Bresson's work, this confusion was complicated by the evolution of the work itself.

Compared to the cryptic force of the early work, the greater narrative legibility of later pictures, beginning with *The Banks of the Marne*, is much easier to tally with the aesthetic of journalism. It should be added that the challenge of professional journalism surely enriched not only the raw material but also the artistic content of Cartier-Bresson's work. Nevertheless, as much as they might wish to claim him for the profession, Cartier-Bresson's journalist colleagues doubtless would be the first to admit the justice of John Szarkowski's statement, at the time of an exhibition of Cartier-Bresson's recent photographs, in 1968: "Beginning in the latter thirties, Cartier-Bresson attempted to enroll his own kind of photography in the service of journalism. . . . Notwithstanding his spirited and sophisticated advocacy of the photo-journalist's role, however, the pictures shown here would suggest that journalism has been the occasion, not the motive force, for his own best work."[107]

Consider in this light a picture made in Mexico in 1963, nearly thirty years after Cartier-Bresson's first visit to that country (fig. 42). Compared to the earlier pictures, this one is closer to comedy than tragedy, more witty than enigmatic, more lyrical and less blunt. But like many of the best later pictures—far more than is commonly acknowledged—this one shares with the early work a

lively independence from the conventions of narrative logic and the pat explanations of the caption writer. The picture also provides an occasion to observe that the adjective "later"—used here as a convenient way of separating the vast majority of Cartier-Bresson's work from the brief episode of the early thirties—masks the complexity and richness of an achievement that still awaits study.

If burdened by the unexamined assumptions that sur-

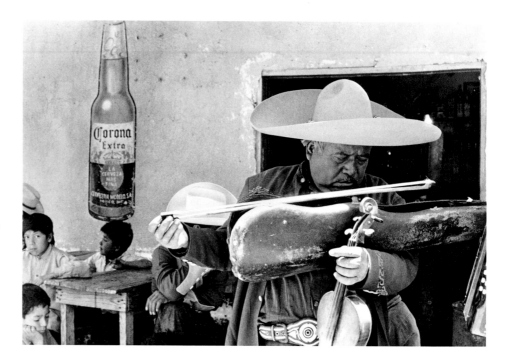

Fig. 42. Henri Cartier-Bresson. *Los Remedios, Mexico.* 1963. Gelatin-silver print, 13¾₆ × 19⅝″ (33.5 × 50 cm). The Museum of Modern Art, New York. Gift of the photographer

round the later work, the early work is misread and thus diminished. But if seen from the viewpoint of the early work—if interpreted as an artful invention—the later work is enriched. To the extent that these assertions are valid, the reason is this: to accept the documentary fiction that the photograph is an authoritative surrogate for reality reduces not only the picture but reality too, by imposing on reality the viewer's dulling expectations. The value of Cartier-Bresson's best work lies in its fierce resistance to such expectations—its view of experience as an incomplete and compelling adventure that is happening right here and right now.

# Notes

The essay draws extensively upon conversations between Henri Cartier-Bresson and the author in May 1986 and February 1987. References to Cartier-Bresson's recollections and to details of his life and work for which no other source is cited derive from these conversations. Excerpts quoted from these conversations, as well as from other, previously published remarks, have been edited by the artist. Translations are by the present author, unless otherwise noted.

1. Essays published in the 1940s by James Thrall Soby, Lincoln Kirstein, and Beaumont Newhall, followed by Cartier-Bresson's own Introduction to *The Decisive Moment* (1952), established the basis for virtually all later interpretations of the photographer's work. The articles by Soby are "The Art of Poetic Accident: The Photographs of Cartier-Bresson and Helen Levitt," *Minicam* (New York), 6 (March 1943), pp. 28–31, 95; and "A New Vision in Photography," *The Saturday Review* (New York), April 5, 1947, pp. 32–34. The essays by Kirstein and Newhall are, respectively, "Henri Cartier-Bresson, Documentary Humanist," and "Cartier-Bresson's Photographic Technique," both in *The Photographs of Henri Cartier-Bresson*, exhibition catalogue (New York: The Museum of Modern Art, 1947).

2. Henri Cartier-Bresson, *The Decisive Moment* (New York: Simon & Schuster, 1952), published simultaneously in France as *Images à la sauvette* (Paris: Éditions Verve, 1952).

3. *Henri Cartier-Bresson, Photographer*, Foreword by Yves Bonnefoy (Boston: Little, Brown, 1979).

4. Van Deren Coke with Diana C. Du Pont, *Photography: A Facet of Modernism* (New York: Hudson Hills Press in association with the San Francisco Museum of Modern Art, 1986), p. 76.

5. Arthur Goldsmith, "Henri Cartier-Bresson Revisited" (1960), in Goldsmith, *The Photography Game: What It Is and How to Play It* (New York: Viking, 1971), p. 112.

6. Quoted in *The New York Review of Books*, November 20, 1986, p. 18.

7. The phrase is a line in the poem "Violon mémorable," which is quoted in André Pieyre de Mandiargues, *Le Désordre de la mémoire: Entretiens avec Francine Mallet* (Paris: Gallimard, 1975), p. 72.

8. Kirstein, "Henri Cartier-Bresson, Documentary Humanist," p. 9.

9. Quoted in Yves Bourde, "Un Entretien avec Henri Cartier-Bresson," *Le Monde* (Paris), September 5, 1974, p. 13.

10. See Kenneth E. Silver, "Esprit de corps: The Great War and French Art, 1914–1925" (Ph.D. dissertation, Yale University, 1981).

11. Bourde, "Un Entretien avec Henri Cartier-Bresson," p. 13. Cartier-Bresson was referring to Lhote's *Traité du paysage* (1939; 4th ed., Paris: Floury, 1948) and *Traité de la figure* (Paris: Floury, 1950).

12. *Experiment* (Cambridge, England), February 1929, p. 17 (*Portrait*) and p. 32 (*Composition*). I am indebted to Beaumont Newhall for this reference.

13. Louis Aragon, *Le Paysan de Paris* (1926); I have used the edition titled *Nightwalker*, trans. Frederick Brown (Englewood Cliffs, N.J.: Prentice-Hall, 1970), p. 59.

14. "Henri Cartier-Bresson, Gilles Mora: Conversation," in Gilles Mora, ed., *Henri Cartier-Bresson*, special issue of *Les Cahiers de la photographie* (Paris), no. 18 (1986), p. 117.

15. André Breton, "Second Manifesto of Surrealism" (1929), in *Manifestoes of Surrealism*, trans. Richard Seaver and Helen R. Lane (Ann Arbor, Mich.: University of Michigan Press, 1969), p. 128.

16. Amédée Ozenfant, *Foundations of Modern Art*, trans. John Rodker (1928; rev. ed., New York: Dover, 1952), p. 116.

17. André Thirion, *Revolutionaries Without Revolution*, trans. Joachim Neugroschel (New York: Macmillan, 1975), pp. 158–59.

18. George Orwell, "Inside the Whale" (1940), in Orwell, *Collected Essays* (London: Secker & Warburg, 1961), p. 138.

19. Pieyre de Mandiargues, *Le Désordre de la mémoire*, pp. 67–70.

20. Aragon, *Nightwalker*, p. 86.

21. André Breton, *Nadja* (1928), trans. Richard Howard (New York: Grove Press, 1960), pp. 142–43.

22. *Ibid.*, p. 143.

23. Quoted in Bourde, "Un Entretien avec Henri Cartier-Bresson," p. 13. In addition to the books mentioned here, Cartier-Bresson took with him Blaise Cendrars's *Anthologie nègre* (Paris, 1927).

24. Quoted in Patrick Roegiers, "Cartier-Bresson, gentleman-caméléon," *Le Monde aujourd'hui* (Paris), March 16, 1986, p. 12.

25. *Ibid.* Morand had recently published a chapter on Gide's travels in Africa, "André Gide, voyageur," in his *André Gide* (Paris: Éditions du capitole, 1928).

26. Quoted in Jacqueline M. Chadourne, *André Gide et l'Afrique* (Paris: A. G. Nizet, 1968), p. 10.

27. In the novel, which celebrates the same spirit of wanderlust that animated Mandiargues and Cartier-Bresson in the early thirties, the character Ménalque, based on Gide, declares: "I hated the family, the home, all places where men think they can rest.... Each new thing must find us always and utterly unattached." Quoted in translation in George D. Painter, *André Gide: A Critical Biography* (New York: Atheneum, 1968), p. 31.

28. See William Rubin, ed., *"Primitivism" in 20th Century Art: Affinity of the Tribal and the Modern,* exhibition catalogue, 2 vols. (New York: The Museum of Modern Art, 1984).

29. Quoted in Chadourne, *André Gide et l'Afrique*, p. 197.

30. Henri Cartier-Bresson, letter to the author, March 1987.

31. Pieyre de Mandiargues, *Le Désordre de la mémoire*, pp. 67–68.

32. See Geoffrey Wolff, *Black Sun: The Brief Transit and Violent Eclipse of Harry Crosby* (New York: Vintage, 1977); Caresse Crosby, *The Passionate Years* (New York: Dial Press, 1953); and Hugh Ford, *Published in Paris: American and British Writers, Printers, and Publishers in Paris, 1920–1939* (Yonkers, N.Y.: Pushcart Press, 1975), pp. 168–230, 407–10.

33. Salvador Dali, *The Secret Life of Salvador Dali*, trans. Haakon M. Chevalier (New York: Dial Press, 1942), p. 327.

34. See Julien Levy, *Surrealism* (New York: Black Sun Press, 1936); Julien Levy, *Memoir of an Art Gallery* (New York: G. P. Putnam's Sons, 1977); David Travis, *Photographs from the Julien Levy Collection, Starting with Atget*, exhibition catalogue (Chicago: The Art Institute of Chicago, 1976); and *Photographs from the Julien Levy Collection*, exhibition catalogue (New York: The Witkin Gallery, 1977).

35. Reproduced in *Les Réalismes, 1919–1939*, exhibition catalogue (Paris: Centre Georges Pompidou, 1980), p. 227.

36. Photographs by Cartier-Bresson were reproduced in the following issues of *Verve*: December 1937, three photographs; Spring 1938, two photographs; and July–October 1939, one photograph.

37. Guillermo de Torre, "El nuevo arte de la cámara o la fotografía animista," *Luz* (Madrid), January 2, 1934.

38. Crosby, *The Passionate Years*, p. 245.

39. Levy, *Memoir of an Art Gallery*, p. 131.

40. Ralph Steiner, *A Point of View* (Middletown, Conn.: Wesleyan University Press, 1978), p. 9.

41. André Pieyre de Mandiargues, Preface to *Henri Cartier-Bresson: Photoportraits*, trans. Paula Clifford (London and New York: Thames & Hudson, 1985), pp. 6–7.

42. Quoted in Levy, *Memoir of an Art Gallery*, p. 168.

43. The episode is reported, rather unsympathetically, in Claude McKay, *A Long Way from Home* (1937; rpt., New York: Harcourt, Brace & World, 1970), pp. 335–37.

44. The printed announcement for the exhibition (which was on view March 11–20, 1935) contains a one-page essay on Cartier-Bresson by Julio Torri.

45. Langston Hughes, *I Wonder as I Wander: An Autobiographical Journey* (New York: Hill & Wang, 1956), p. 293–95.

46. Juan Rulfo, "Le Mexique des années 30 vu par Henri Cartier-Bresson," in *Henri Cartier-Bresson: Carnet de notes sur le Mexique*, exhibition catalogue (Paris: Centre culturel du Mexique, 1984), n.p.

47. Ben Maddow, letter to the author, June 1986.

48. Nicolas Nabokov, *Bagázh: Memoirs of a Russian Cosmopolitan* (New York: Atheneum, 1975), pp. 200–01.

49. Ben Maddow, letter to the author, June 1986.

50. See William Alexander, *Film on the Left: American Documentary Film from 1931 to 1942* (Princeton, N.J.: Princeton University Press, 1981), especially pp. 65–112; and Russell Campbell, *Cinema Strikes Back: Radical Filmmaking in the United States, 1930–1942* (Ann Arbor, Mich.: UMI Research Press, 1982).

51. In the Introduction to *The Decisive Moment* (1952), Cartier-Bresson wrote: "From some of the great films, I learned to look and to see. 'Mysteries of New York,' with Pearl White; the great films of D. W. Griffith—'Broken Blossoms'; the first films of Stroheim—'Greed'; Eisenstein's 'Potemkin,' and Dreyer's 'Jeanne d'Arc'—these were some of the things that impressed me deeply" (n.p.).

52. See Pascal Bonitzer et al., "'La Vie est à nous,' film militant," *Cahiers du cinéma* (Paris), March 1970, pp. 45–51; Alexander Sesonske, *Jean Renoir: The French Films, 1924–1939* (Cambridge, Mass.: Harvard University Press, 1980), pp. 221–33; and Geneviève Guillaume-Grimaud, *Le Cinéma du Front populaire* (Paris: Lherminier, 1986).

53. The literature on the subject is enormous. I have relied upon Henri Dubief, *Le Déclin de la Troisième République, 1929–1938*, Nouvelle histoire de la France contemporaine, 13 (Paris: Éditions du Seuil, 1976); David Caute, *Communism and the French Intellectuals, 1914–1960* (New York: André Deutsch, 1964); and Herbert R. Lottmann, *The Left Bank: Writers, Artists, and Politics from the Popular Front to the Cold War* (Boston: Houghton Mifflin, 1982).

54. Roger Shattuck, "Having Congress: The Shame of the Thirties," in Shattuck, *The Innocent Eye: On Modern Literature and the Arts* (New York: Farrar Strauss Giroux, 1984), pp. 3–31.

55. On *Return to Life*, see Alexander, *Film on the Left*, pp. 186–90; and Campbell, *Cinema Strikes Back*, pp. 169 ff.

56. See Sesonske, *Jean Renoir*, pp. 234–56; and Célia Bertin, *Jean Renoir* (Paris: Librairie académique Perrin, 1986), pp. 161–67.

57. Quoted in Penelope Gilliatt, *Jean Renoir: Essays, Conversations, Reviews* (New York: McGraw-Hill, 1975), p. 9.

58. Quoted in *France Soir* (Paris), April 1, 1974.

59. Cartier-Bresson has occasionally mentioned that his photographs were first reproduced in the illustrated weekly *Vu* (Paris) in 1933. Sandra S. Phillips has kindly called my attention to two issues of *Vu* in November 1933 in which photographs by Cartier-Bresson illustrate articles on contemporary Spain. Four others appeared in *New Theatre* (New York), 2 (September 1935), p. 9. Despite these isolated exceptions, it is clear that in the thirties Cartier-Bresson worked almost exclusively for himself.

60. See Richard Whelan, *Robert Capa: A Biography* (New York: Knopf, 1985); Cornell Capa, ed., *David Seymour—"Chim," 1911–1956* (New York: Grossman, 1974); and Robert Capa and David Seymour "Chim," *Front populaire*, text by Georgette Elgey (Paris: Chêne/Magnum, 1976).

61. See Bertin, *Jean Renoir*, pp. 180–92.

62. Jean Renoir, *My Life and My Films*, trans. Norman Denny (New York: Atheneum, 1974), pp. 125–27.

63. "Henri Cartier-Bresson, Gilles Mora," p. 119.

64. See John Malcolm Brinnin, *Sextet: T. S. Eliot, Truman Capote, and Others* (New York: Delacorte Press, 1981), pp. 99–162.

65. Jean Guéhenno, *Carnets du vieil écrivain* (Paris: Grasset, 1971), p. 202.

66. Cartier-Bresson, Introduction to *The Decisive Moment*, n.p.

67. Quoted in Dorothy Norman, "A Visitor Falls in Love—with Hudson and East Rivers," *The New York Post*, August 26, 1946.

68. "Henri Cartier-Bresson, Gilles Mora," p. 122.

69. Sandra S. Phillips, "The Photographic Work of André Kertész in France, 1925–1936: A Critical Essay and Catalogue" (Ph.D. dis-

sertation, The City University of New York, 1985).

70. John Szarkowski, *André Kertész, Photographer*, exhibition catalogue (New York: The Museum of Modern Art, 1964), p. 4.

71. This phenomenon was the subject of an exhibition, "Photographs Before Surrealism," organized by Bruce K. MacDonald at The Museum of Modern Art, New York, in 1968. The photograph by Van Schaick reproduced here appeared in the exhibition.

72. An original argument in support of such an interpretation is provided in Mary Panzer, *Philadelphia Naturalistic Photography, 1865–1906*, exhibition catalogue (New Haven, Conn.: Yale University Art Gallery, 1982).

73. See John Szarkowski, "Understandings of Atget," in John Szarkowski and Maria Morris Hambourg, *The Work of Atget*, vol. 4: *Modern Times*, exhibition catalogue (New York: The Museum of Modern Art, 1985), pp. 9–29.

74. Pierre Courthion, "Bar du Dôme," *Variétés* (Brussels), August 15, 1929, p. 275.

75. Pierre Naville, "Beaux-Arts," *La Révolution surréaliste*, April 15, 1925, p. 27; quoted in translation in Dawn Ades, *Dada and Surrealism Reviewed*, exhibition catalogue (London: Arts Council of Great Britain, 1978), p. 199.

76. See Alain Mousseigne, "Situation de la photographie dans les revues des mouvements d'avant-garde artistique en France entre 1918 et 1939," (Mémoire de Maîtrise, Université de Toulouse–Le Mirail, 1974–75); and Dawn Ades, "Photography and the Surrealist Text," in Rosalind Krauss and Jane Livingston, eds., *L'Amour fou: Photography and Surrealism*, exhibition catalogue (Washington, D.C.: The Corcoran Gallery of Art; New York: Abbeville Press, 1985), pp. 153–89.

77. *L'Esprit nouveau*, no. 9 (1921), p. 996.

78. The two books not previously cited here are László Moholy-Nagy, *Painting, Photography, Film*, Bauhaus Books, 8 (1925; rpt., Cambridge, Mass.: The MIT Press, 1969); and Werner Gräff, *Es kommt der neue Fotograf!* (Berlin: H. Reckendorf, 1929).

79. Szarkowski, "Understandings of Atget," p. 23.

80. Both are represented in Krauss and Livingston, *L'Amour fou*. See also Nancy Hall-Duncan, *Photographic Surrealism*, exhibition catalogue (Cleveland: The New Gallery of Contemporary Art, 1979); and Édouard Jaguer, *Les Mystères de la chambre noire: Le Surréalisme et la photographie* (Paris: Flammarion, 1982).

81. André Bazin, "Entretien avec Luis Buñuel," *Cahiers du cinéma* (Paris), 6 (June 1954), p. 4. See also Pierre Kast, "Une Fonction de constat: Notes sur l'oeuvre de Buñuel," *Cahiers du cinéma* (Paris), 2 (December 1951), pp. 6–16.

82. Alvarez Bravo (born 1902) began to photograph in 1924. There is no doubt that he established his own artistic identity before meeting Cartier-Bresson in early 1934. But many of the photographs by Alvarez Bravo that are closest to Cartier-Bresson's work, although most often dated before 1934, are sometimes dated 1934 or later. See Jane Livingston, *M. Alvarez Bravo*, exhibition catalogue (Washington, D.C.: The Corcoran Gallery of Art; Boston: Godine, 1978); Nissan N. Perez, *Dreams—Visions—Metaphors: The Photographs of Manuel Alvarez Bravo*, exhibition catalogue (Jerusalem: The Israel Museum, 1983); and *Manuel Alvarez Bravo: 303 Photographies, 1920–1986*, exhibition catalogue (Paris:

Musée d'art moderne de la Ville de Paris; Paris-Audiovisuel, 1986).

83. Cartier-Bresson, Introduction to *The Decisive Moment*, n.p.

84. Georges Bataille, "Abattoir," in "Dictionnaire," *Documents* (Paris), November 1929, p. 329. Lotar's photographs appear on pages 328 and 330.

85. Lotar's photographs appeared regularly in *Variétés* from the fall of 1928 to the spring of 1930. A number also were published in *Bifur* in 1929 and 1930. On his photographic work, see Jean Gallotti, "Eli Lotar," *L'Art vivant* (Paris), August 1, 1929, p. 605; and David Travis, *Photographs from the Julien Levy Collection, Starting with Atget*, exhibition catalogue (Chicago: The Art Institute of Chicago, 1976), p. 49.

86. Ben Maddow, "Surgeon, Poet, Provocateur" (review of Cartier-Bresson's 1947 exhibition at The Museum of Modern Art), *Photo League Bulletin* (New York), April 1947, p. 2.

87. See Georges Bataille, *L'Érotisme* (Paris: Les Éditions de Minuit, 1957).

88. [Louis] Aragon, *La Peinture au défi*, catalogue of an "Exposition de collages" (Paris: Galerie Goemans, March 1930). The text and an essay of 1923 on Max Ernst are reprinted in Aragon, *Les Collages* (Paris: Hermann, 1965).

89. See Herta Wescher, *Collage* (New York: Abrams [c. 1971]); and Dawn Ades, *Photomontage* (London: Thames & Hudson, 1976).

90. I refer principally to two collage novels: *La Femme 100 têtes* (1929) and *Rêve d'une petite fille qui voulait entrer au Carmel* (1930). They have been reprinted as, respectively, *The Hundred Headless Woman* (New York: Braziller, 1981) and *A Little Girl Dreams of Taking the Veil* (New York: Braziller, 1982).

91. The other photograph is reproduced on page 140.

92. This interpretation is based on my article, "An Early Cartier-Bresson," *MoMA* (New York), Winter 1975–76, n.p.

93. The best general account is Robert Rosenblum, *Cubism and Twentieth-Century Art* (New York: Abrams, 1960).

94. Just as the use of the small camera appeared earlier in advanced American photography, so too did the influence of Cubism. See John Pultz and Catherine B. Scallen, *Cubism and American Photography, 1910–1930*, exhibition catalogue (Williamstown, Mass.: Sterling and Francine Clark Art Institute, 1981).

95. "La Jeune Photographie," in Jean Galtier-Boissière and Claude Blanchard, *Voyage à Paris*, special issue of *Le Crapouillot* (Paris, 1931), p. 34.

96. Moholy-Nagy, *Painting, Photography, Film*, p. 28. The picture Moholy-Nagy reproduced included not children but a doll. The caption reads, "The organisation of the light and shade, the criss-crossing of the shadows removes the toy into the realm of the fantastic." The picture reproduced here is discussed in John Szarkowski, *Looking at Photographs: 100 Pictures from the Collection of The Museum of Modern Art* (New York: The Museum of Modern Art, 1973), p. 88. The other and the series to which it belongs are discussed in Coke, *Photography: A Facet of Modernism*, p. 70.

97. For example in Sheila Turner Seed, "Henri Cartier-Bresson: Interview," *Popular Photography* (New York), 74 (May 1974), p. 117.

98. The picture was reproduced on page 87 of the 1931 edition of the annual *Photographie*, published in Paris beginning in 1930 by the

journal *Arts et métiers graphiques*. Photographs by Cartier-Bresson appeared in the editions of 1932 (p. 36) and 1933–34 (pp. 4, 34).

99. This interpretation is based in part on Szarkowski, *Looking at Photographs*, p. 112.

100. J. Kirk T. Varnedoe et al., *Gustave Caillebotte: A Retrospective Exhibition*, exhibition catalogue (Houston: The Museum of Fine Arts, 1976), p. 112. A revised edition of the book will be published later this year by Yale University Press.

101. John House, "Manet's *Naïveté*," in Juliet Wilson Bareau, *The Hidden Face of Manet: An Investigation of the Artist's Working Processes* (London: The Burlington Magazine, 1986), p. 13. The present interpretation of the picture draws upon my lecture "Manet and Photography" and Kirk Varnedoe's lecture "Manet's *Chemin de fer* and the Symbolism of Genre," delivered at The Metropolitan Museum of Art, New York, October 4 and 22, 1983, respectively.

102. Letter by Peter Lloyd [pseudonym for Julien Levy], printed on an announcement for the exhibition "Photographs by Henri Cartier-Bresson and an Exhibition of Anti-Graphic Photography" at the Julien Levy Gallery, New York, in 1933. The "letter" is reprinted in Levy, *Surrealism*.

103. Soby, "A New Vision in Photography," p. 33. In the same article Soby suggested a link between Cartier-Bresson's debts to Degas and to the Surrealists.

104. Kirstein, "Henri Cartier-Bresson, Documentary Humanist" (see note 1).

105. Lincoln Kirstein, "Henri Cartier-Bresson," in *Photographs by Cartier-Bresson* (New York: Grossman, 1963), n.p.

106. "Recorded Time," *Time* (New York), October 3, 1938, p. 43. William Hooper of *Time*, who kindly looked into the archives, states that the author of the unsigned article was probably Robert Fitzgerald.

107. John Szarkowski, "Cartier-Bresson: Recent Photographs," gallery text-panel for the exhibition of the same title at The Museum of Modern Art, New York, in 1968.

# Plates

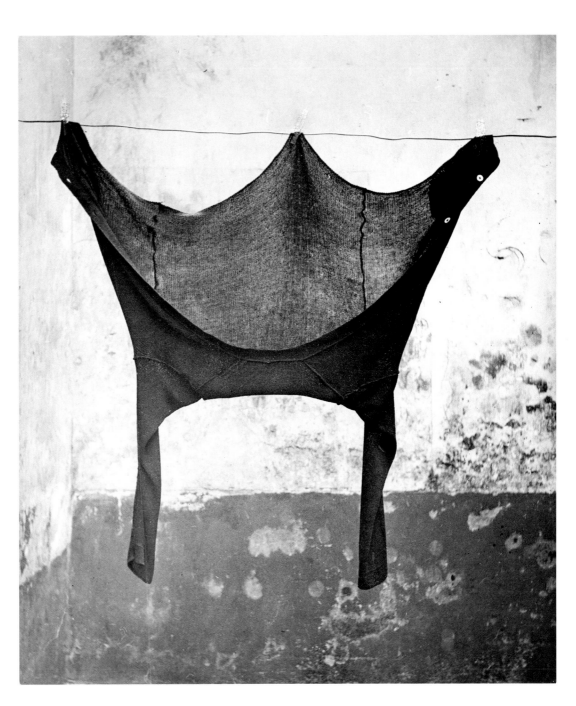

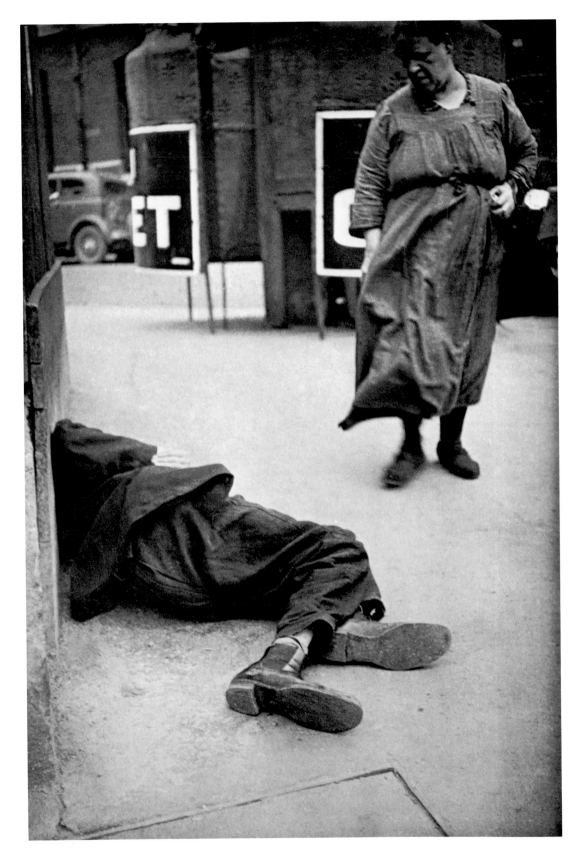

La Villette, near Paris. 1932

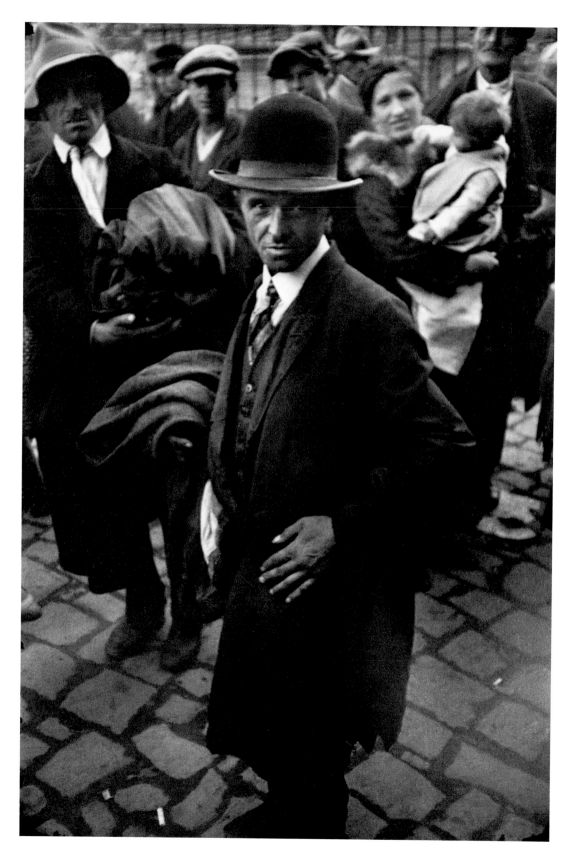

Warsaw. 1931

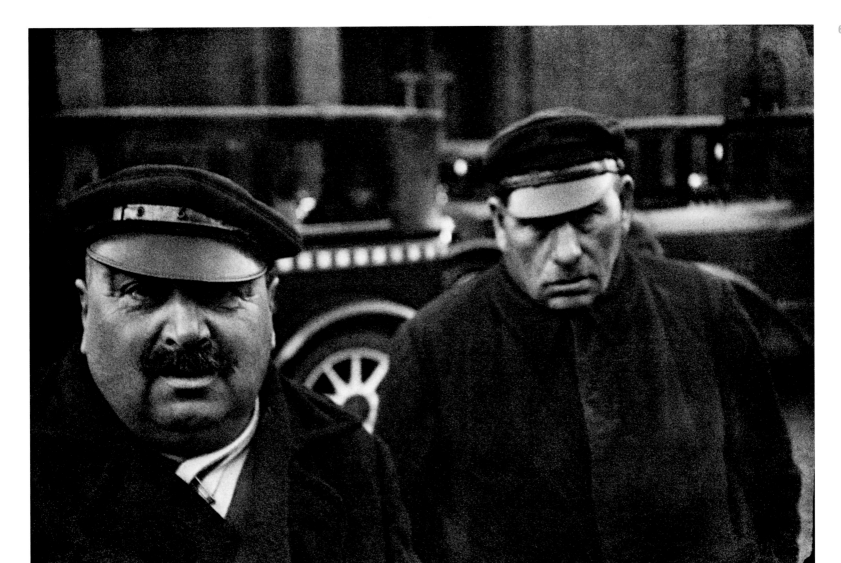

62

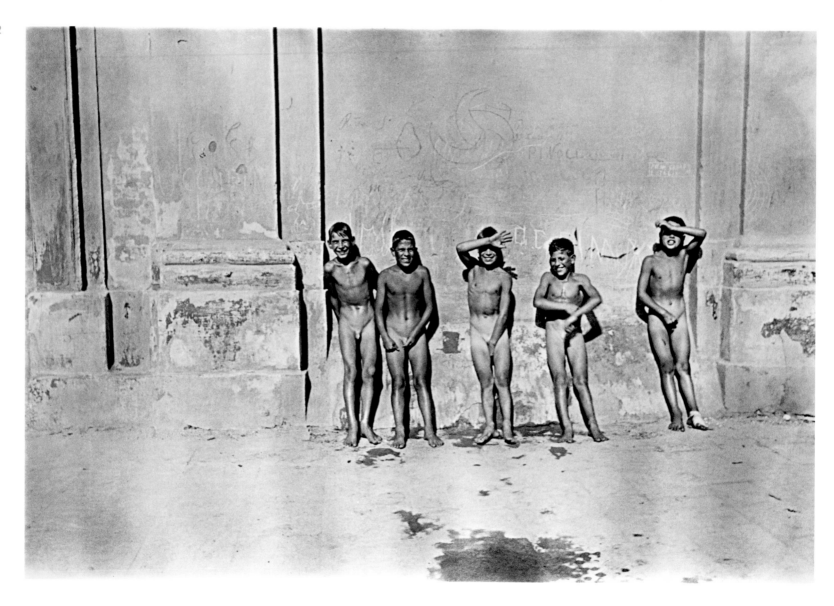

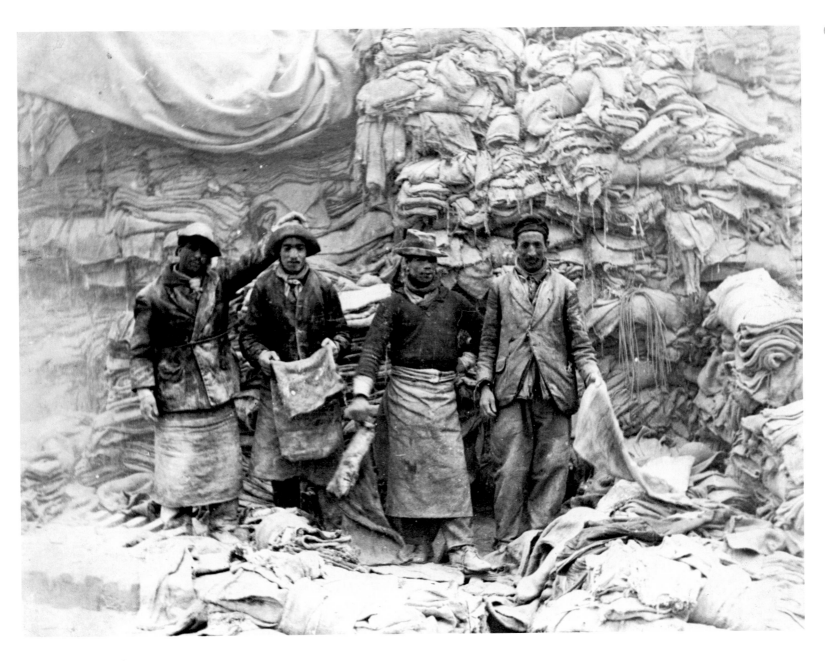

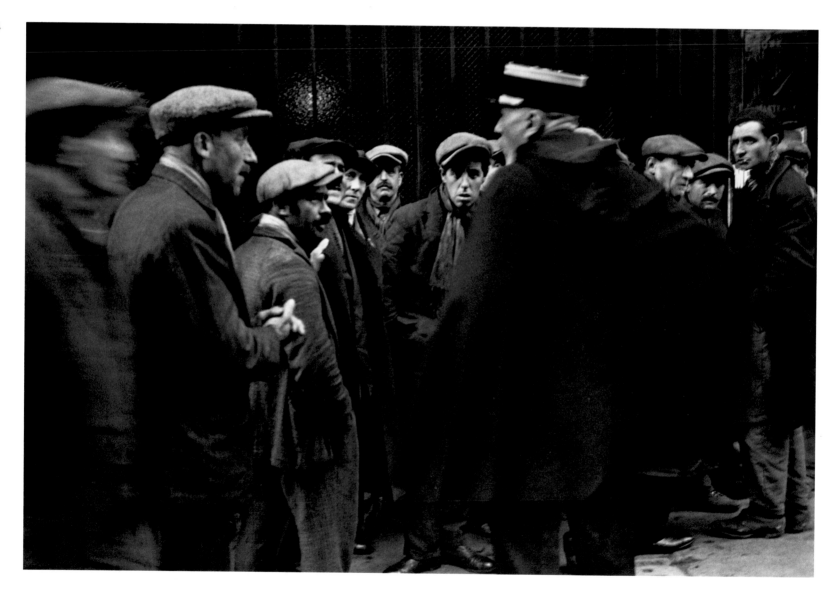

Aubervilliers, near Paris. 1932

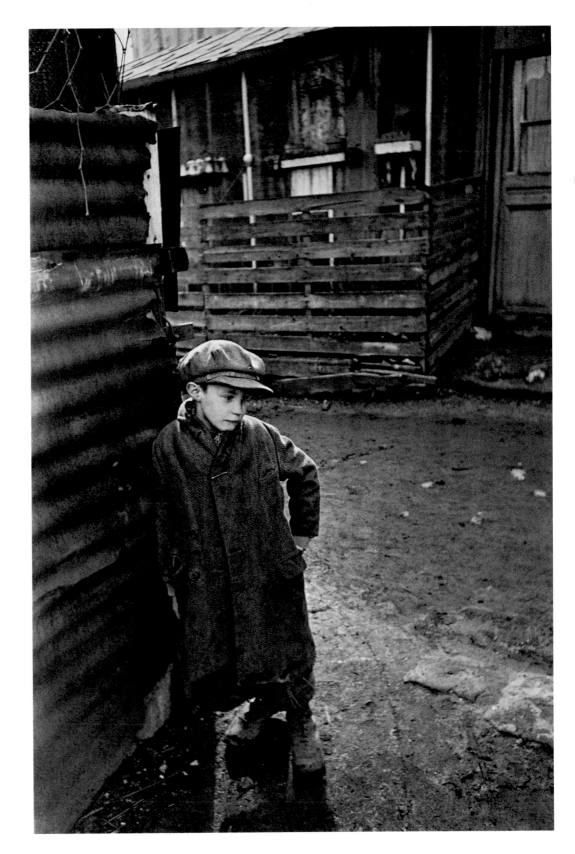

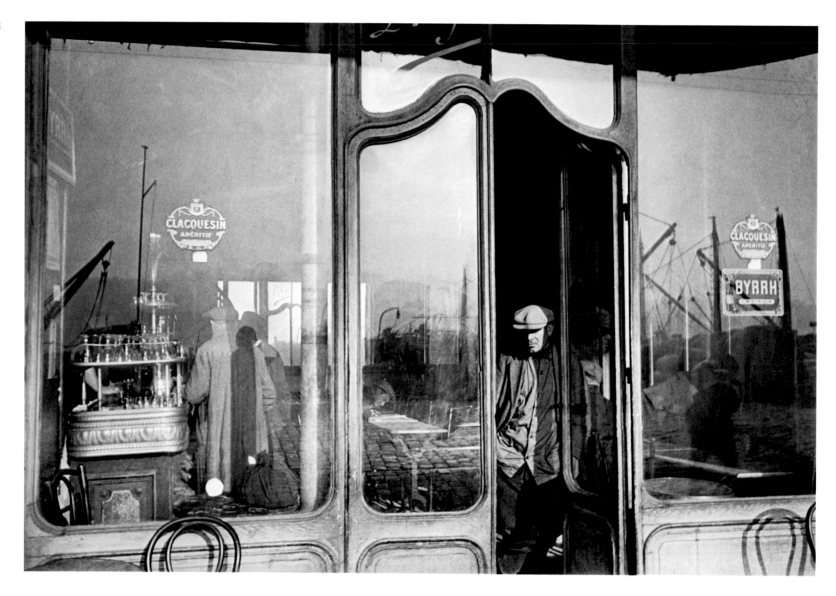

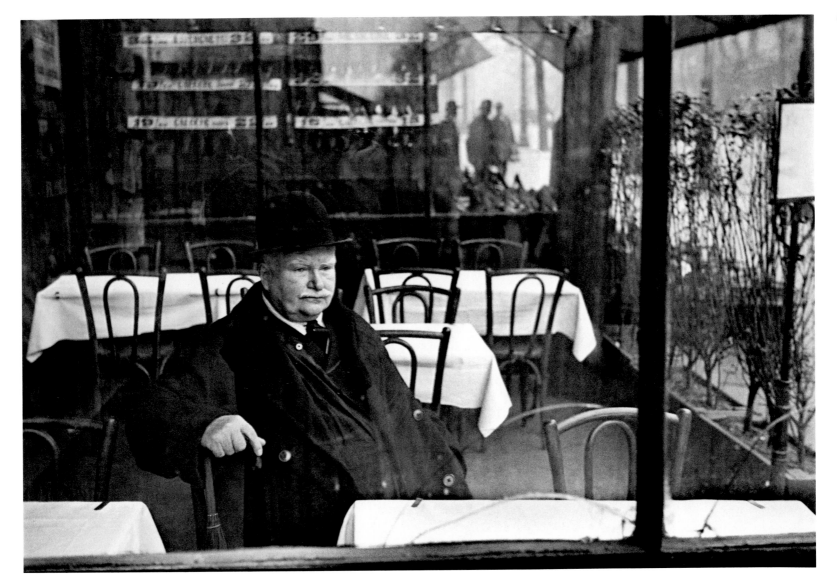

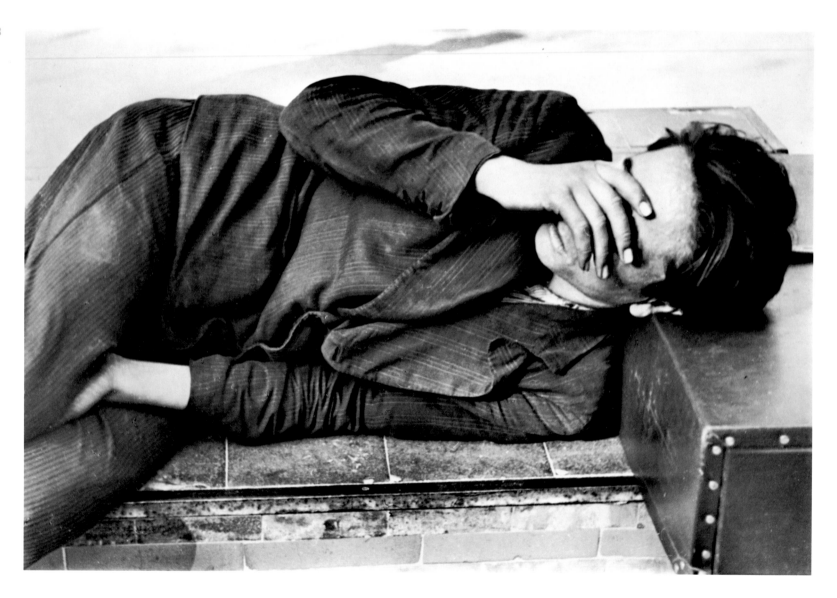

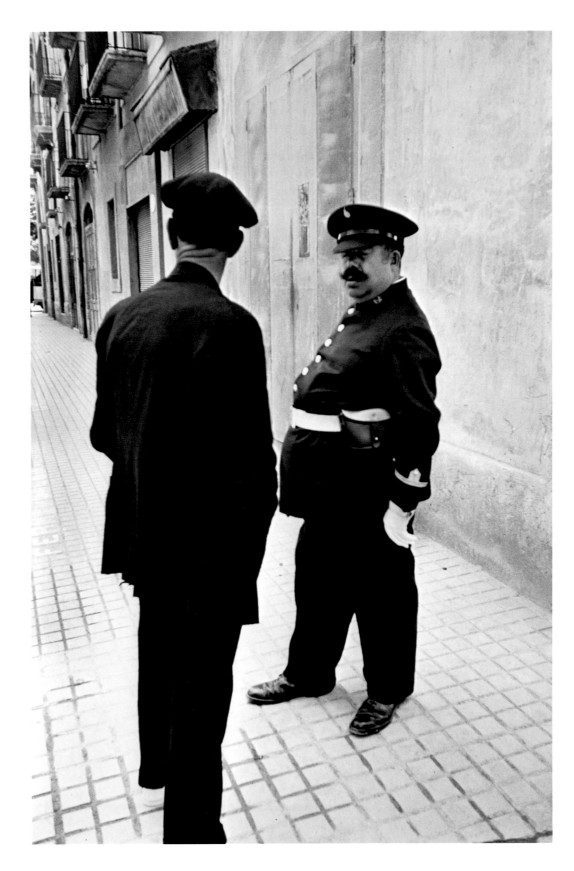

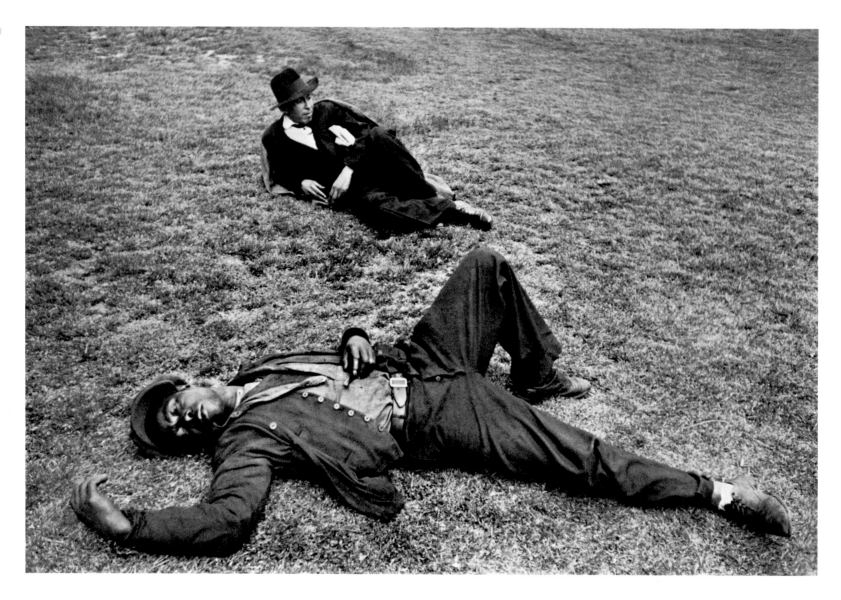

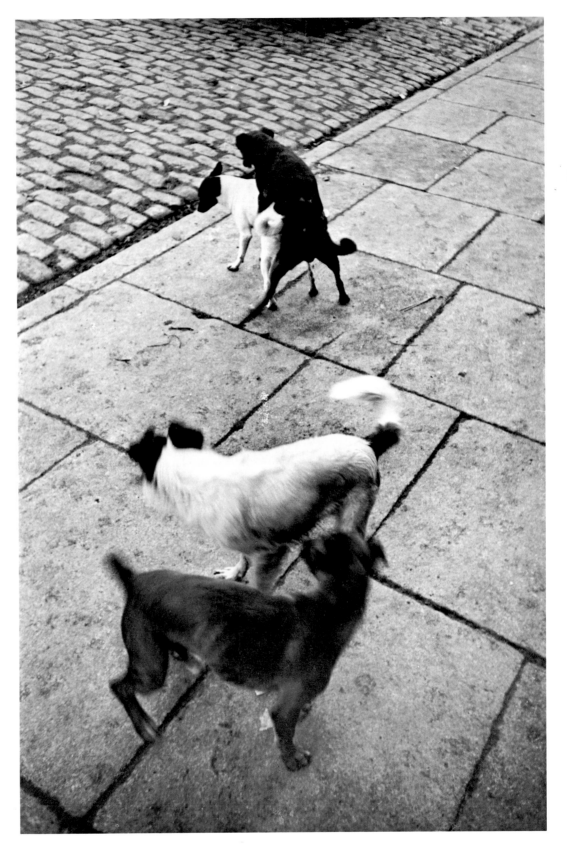

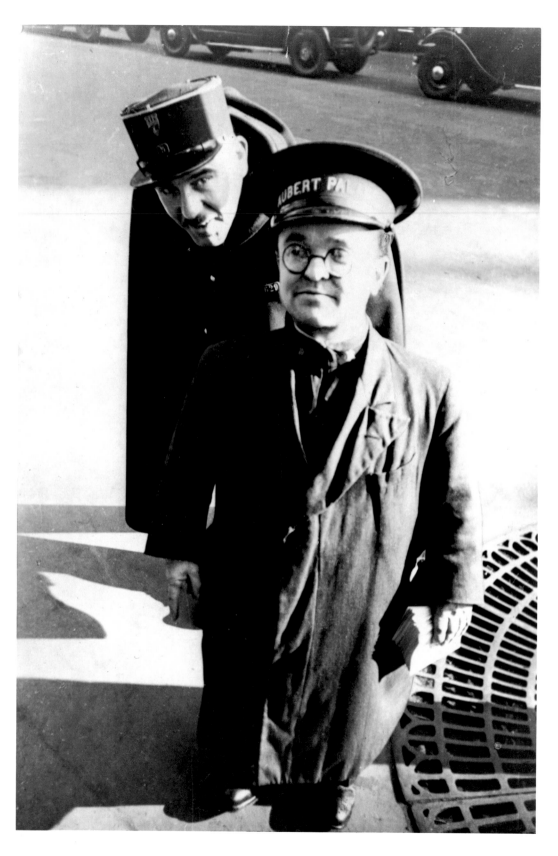

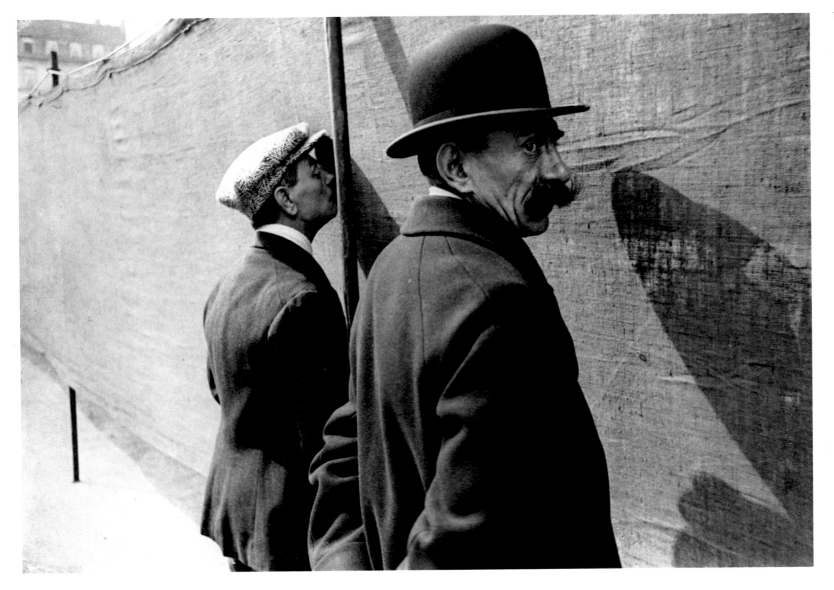

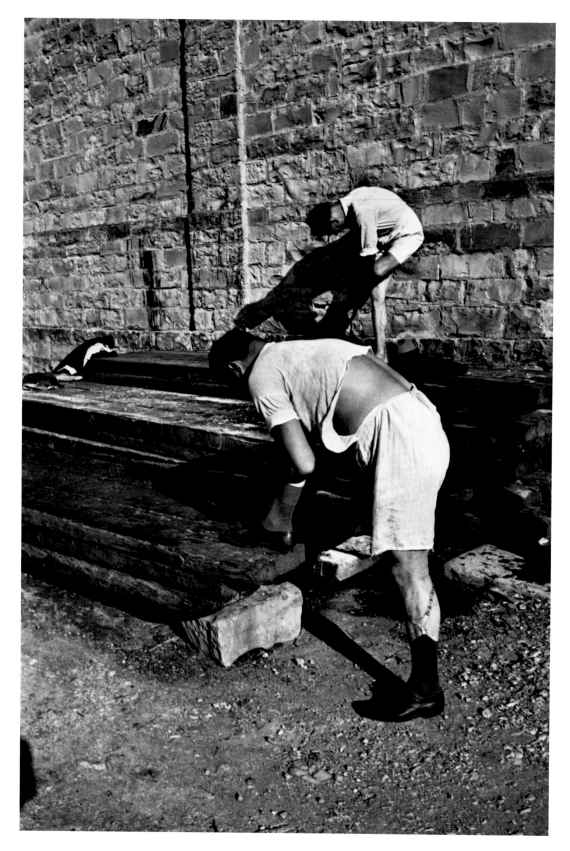

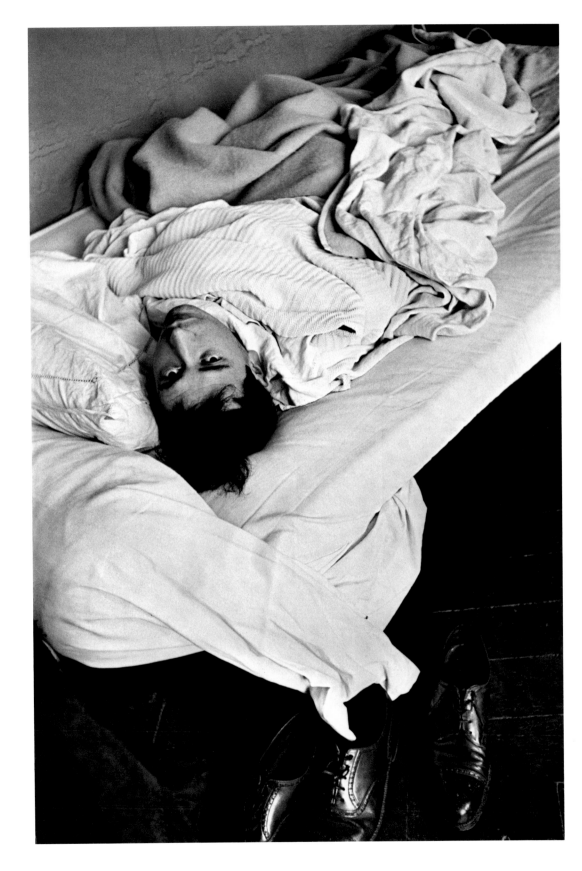

Pierre Colle, Paris. 1932

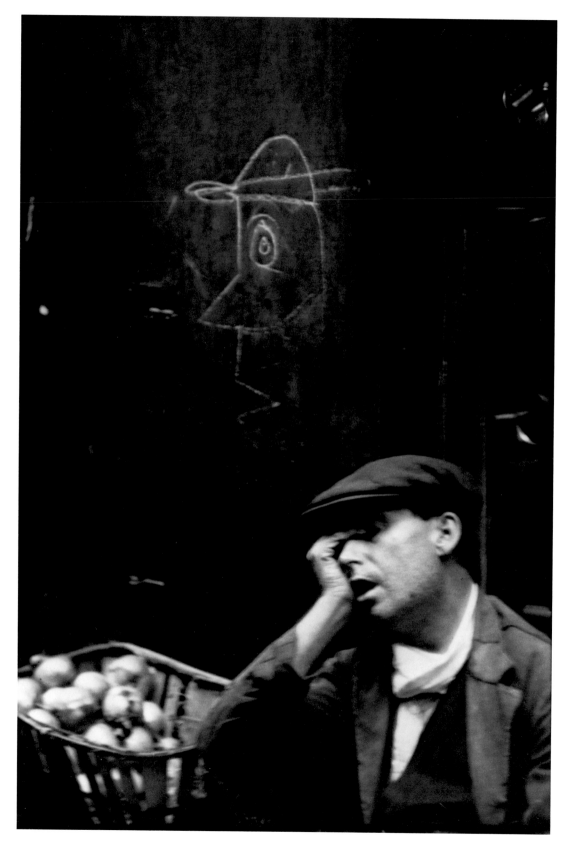

Barrio Chino, Barcelona. 1933

Christian Bérard, Paris. 1932

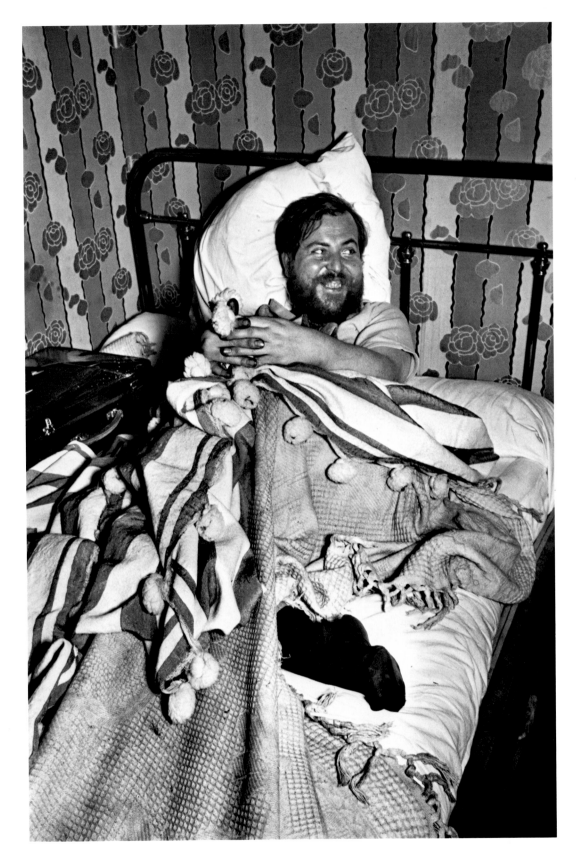

82

La Villette, near Paris. 1932

Allée du Prado, Marseille. 1932

90

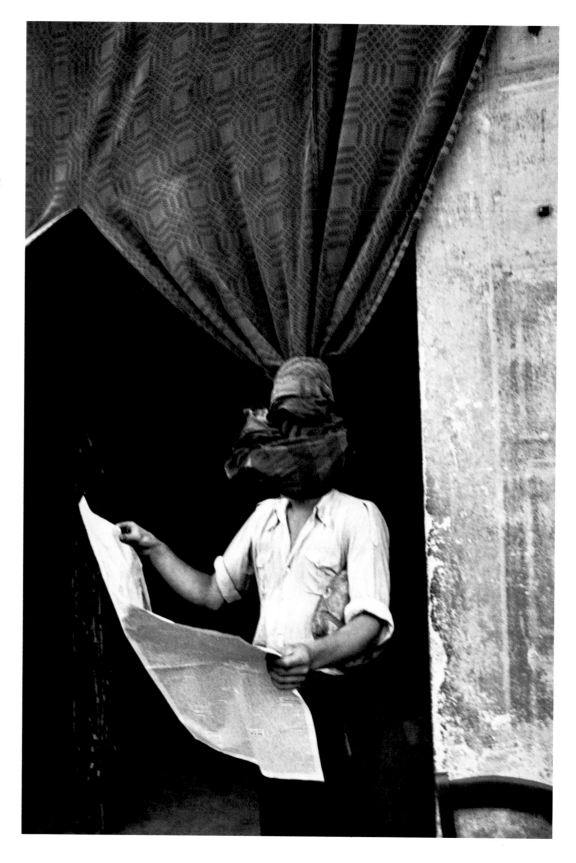

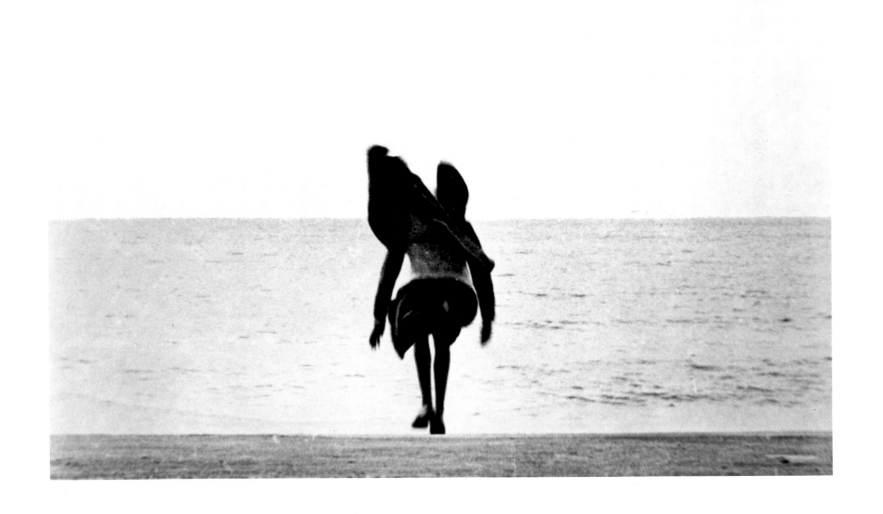

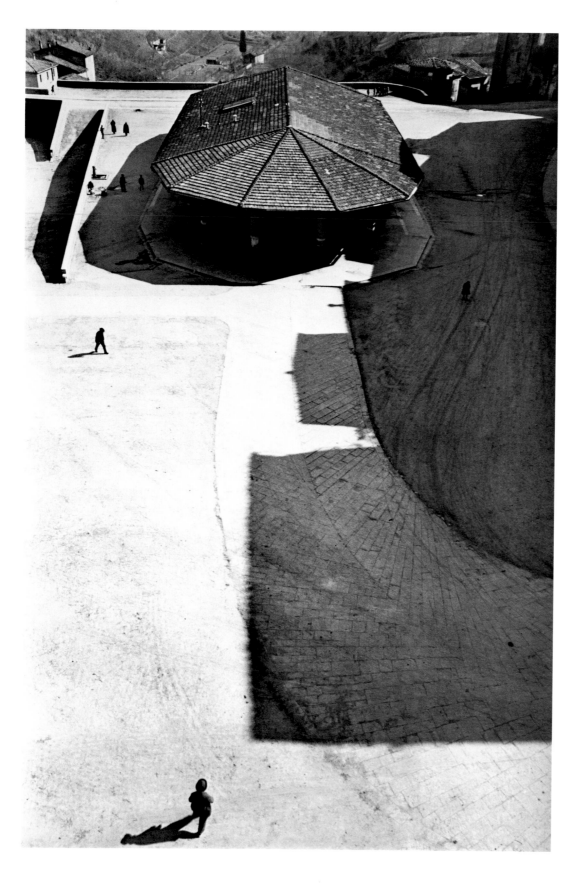

Siena. 1933

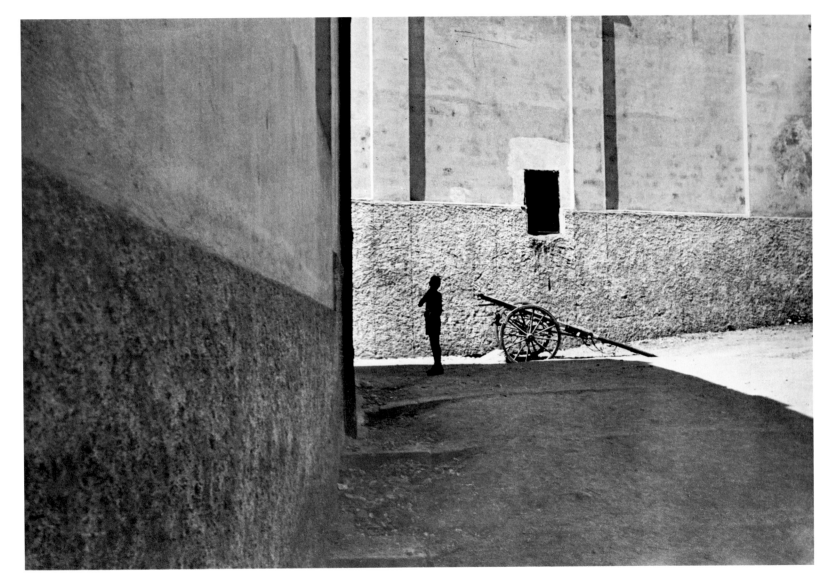

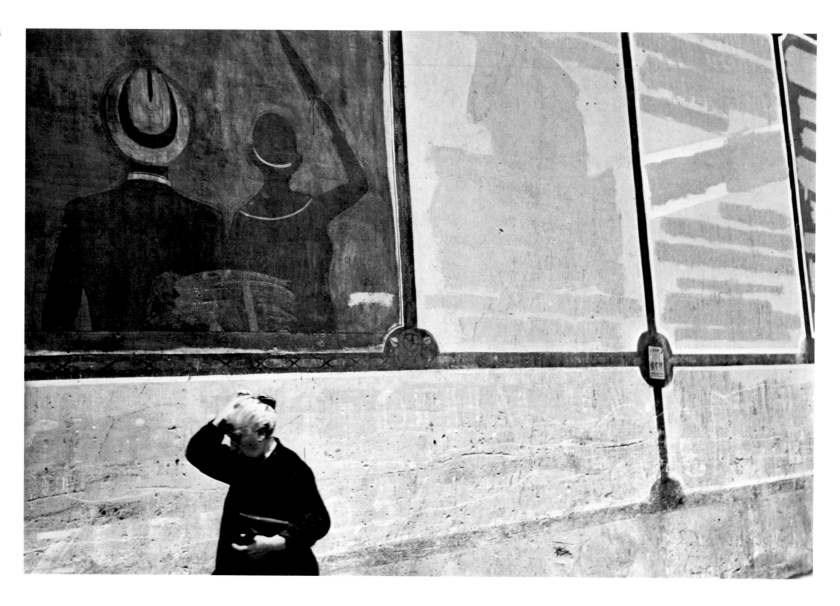

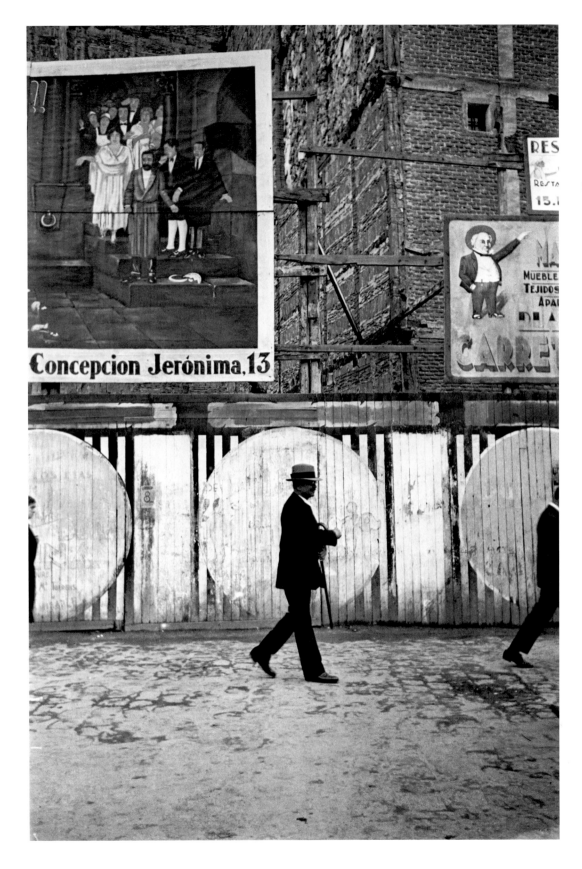

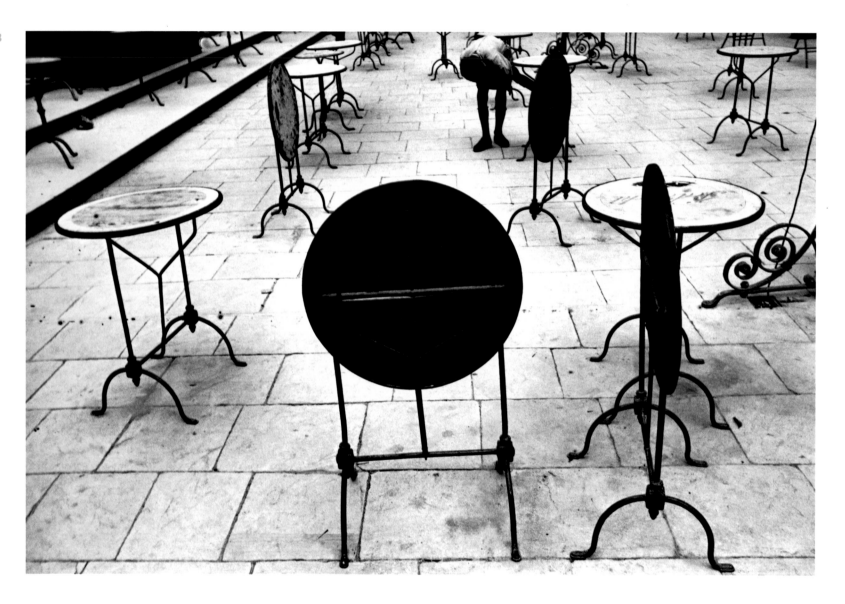

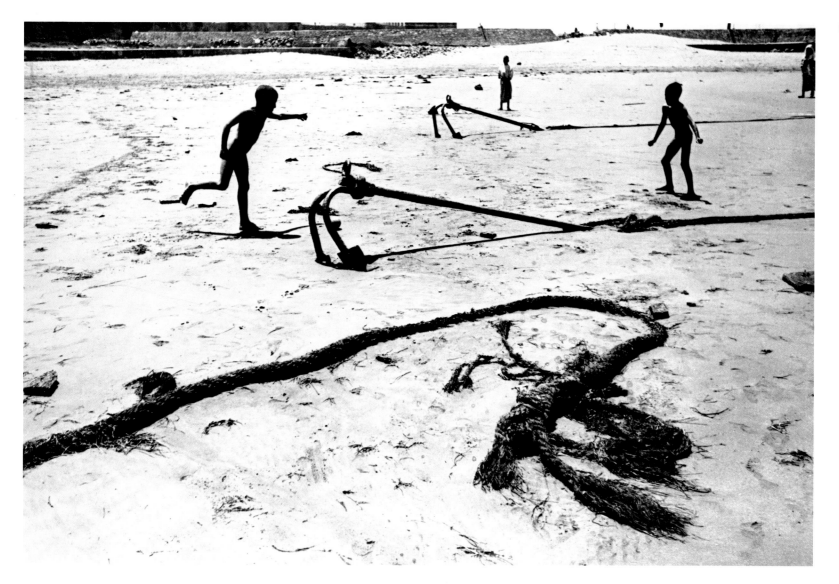

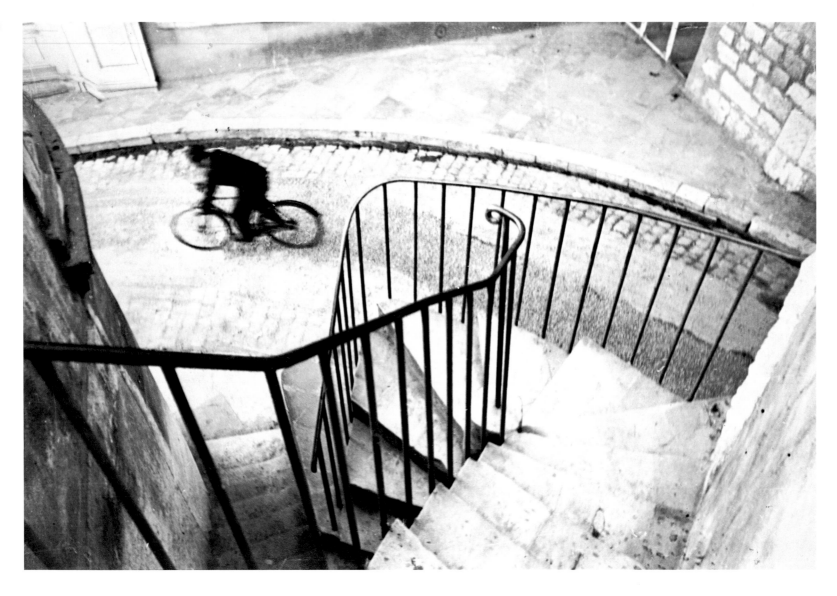

Behind the Gare St.-Lazare, Paris. 1932

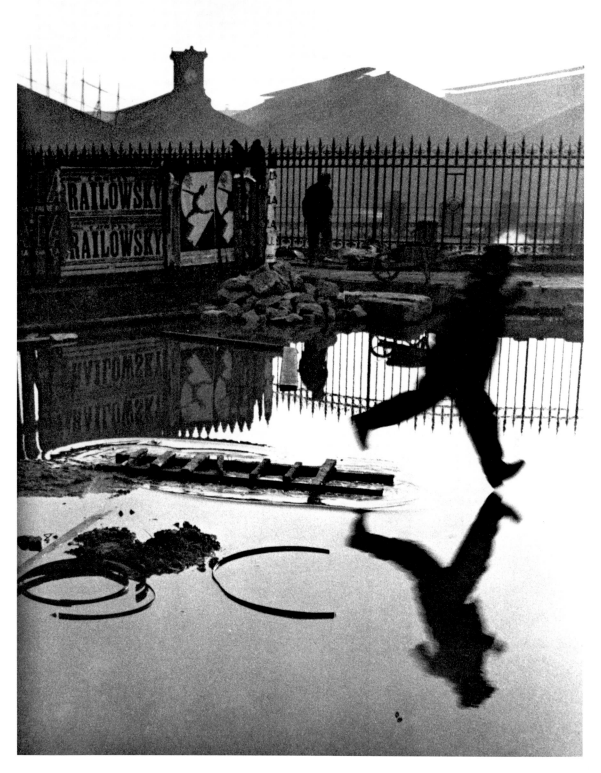

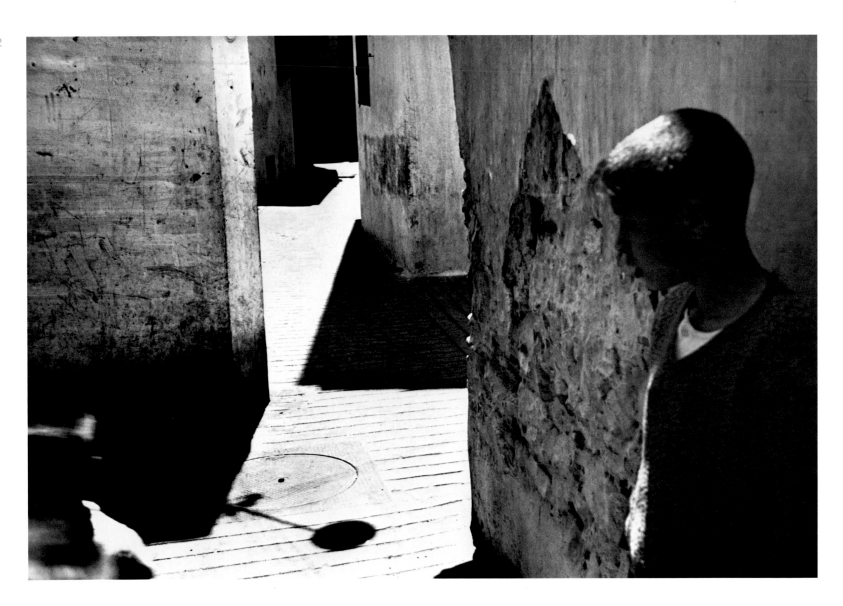

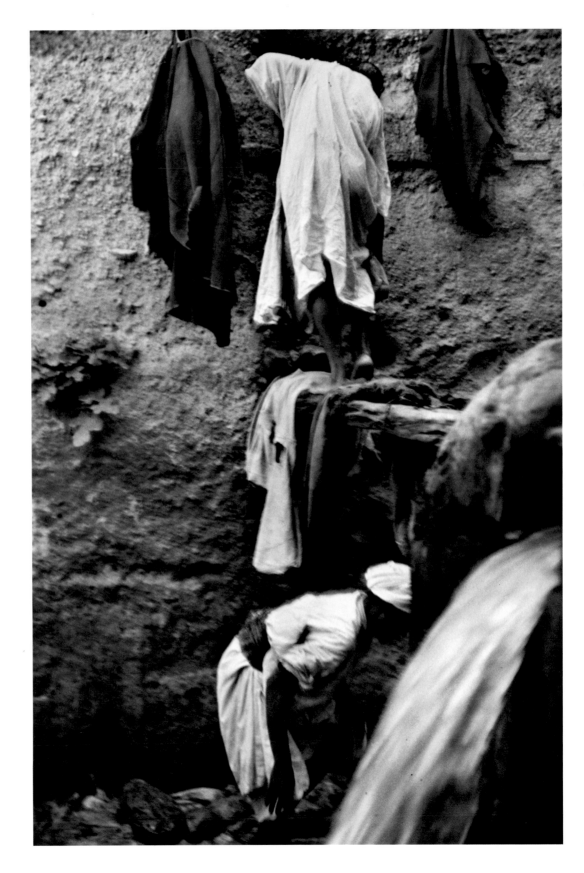

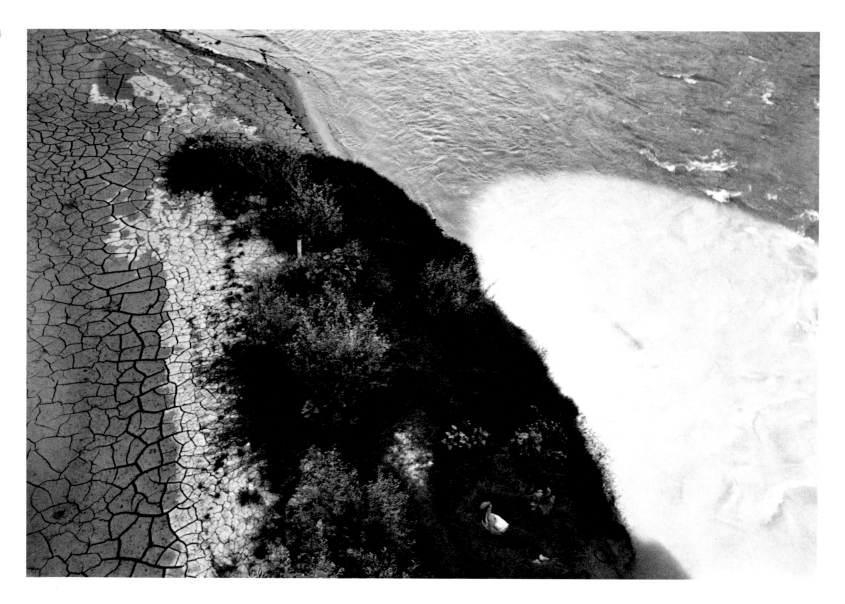

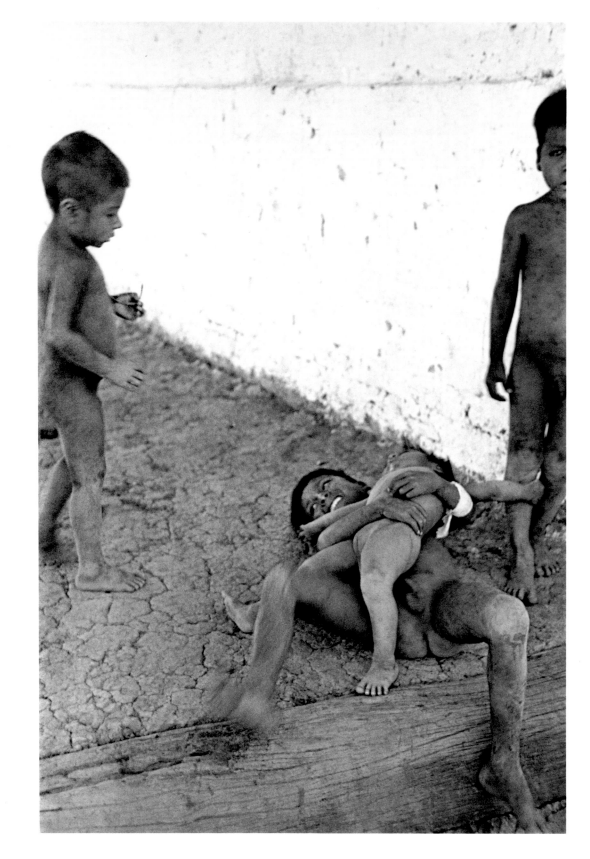

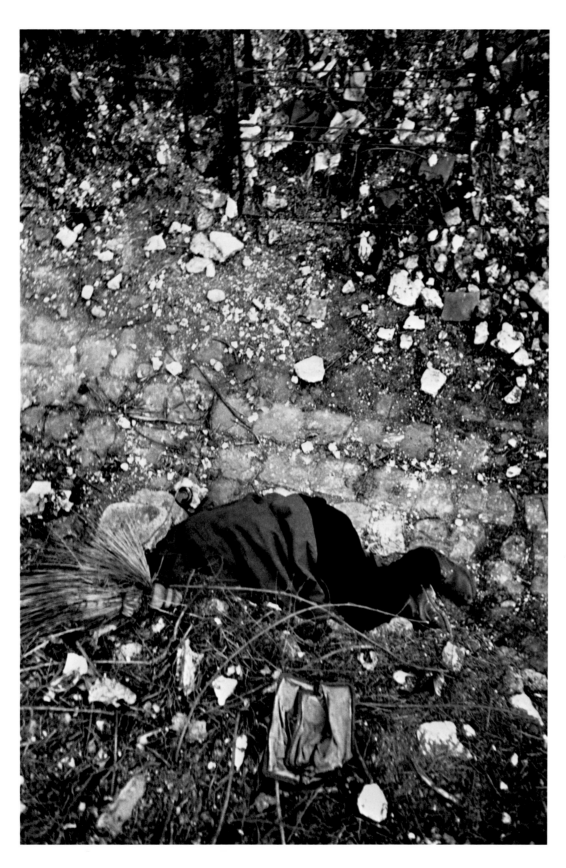

Marseille. 1932

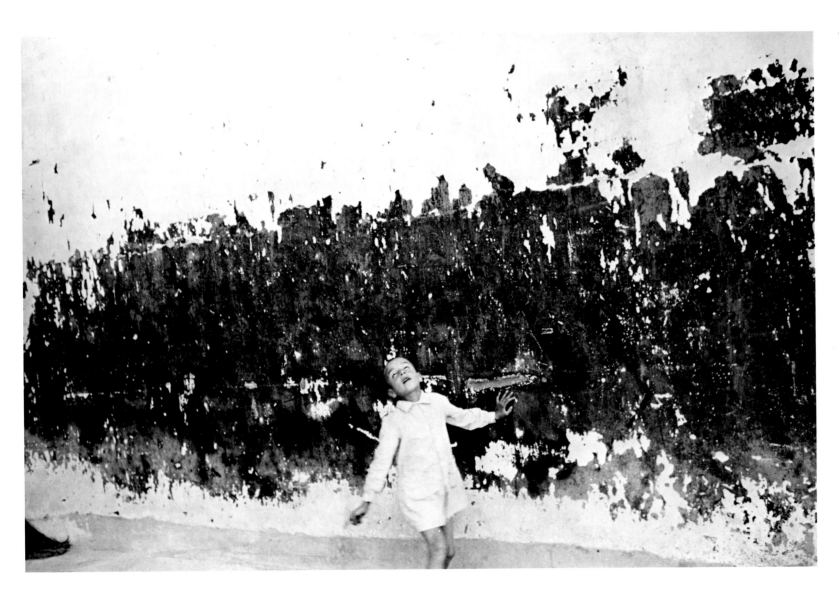

108

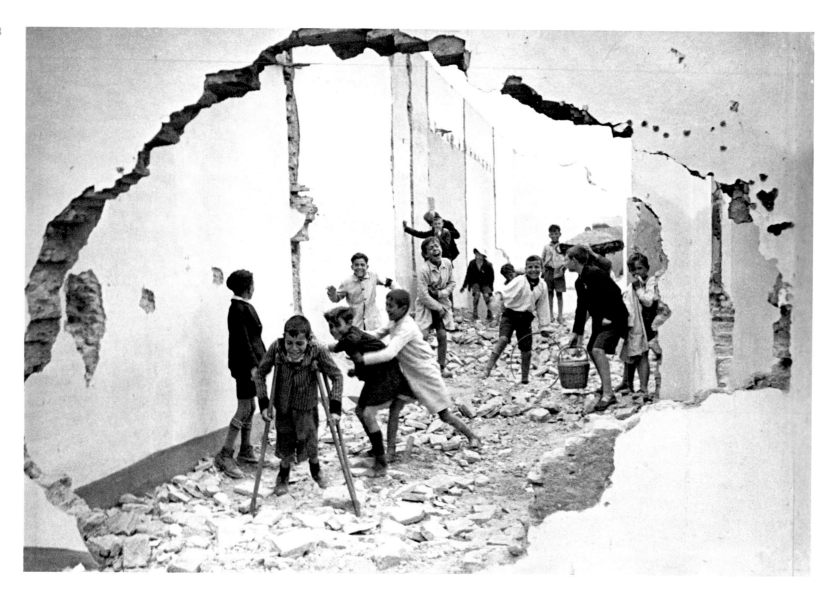

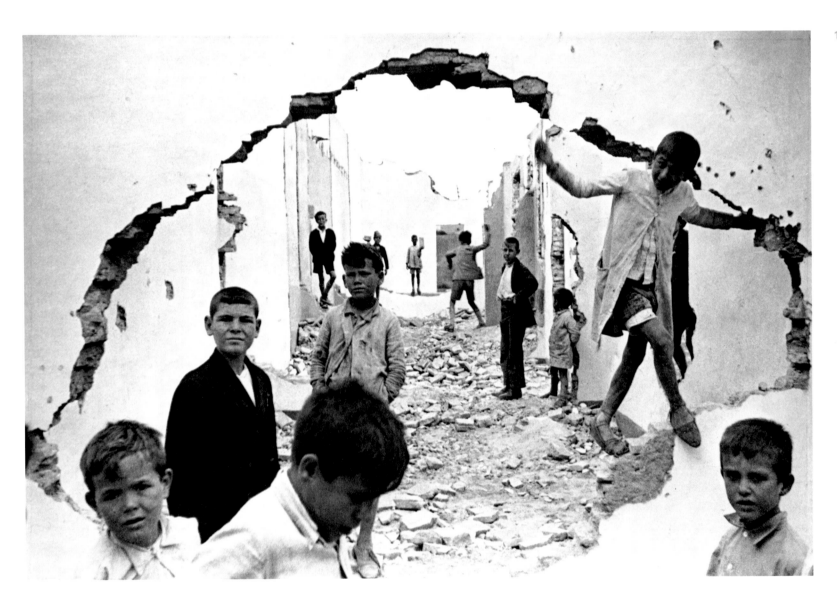

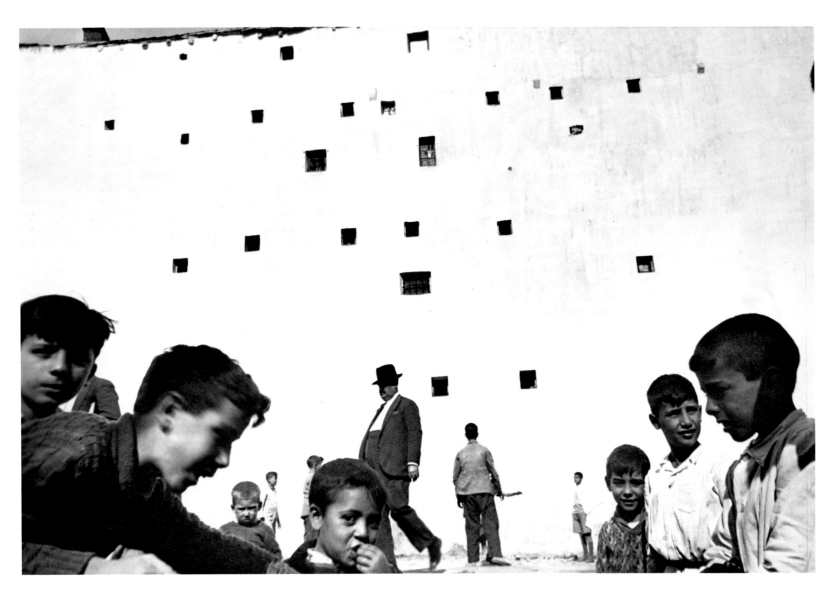

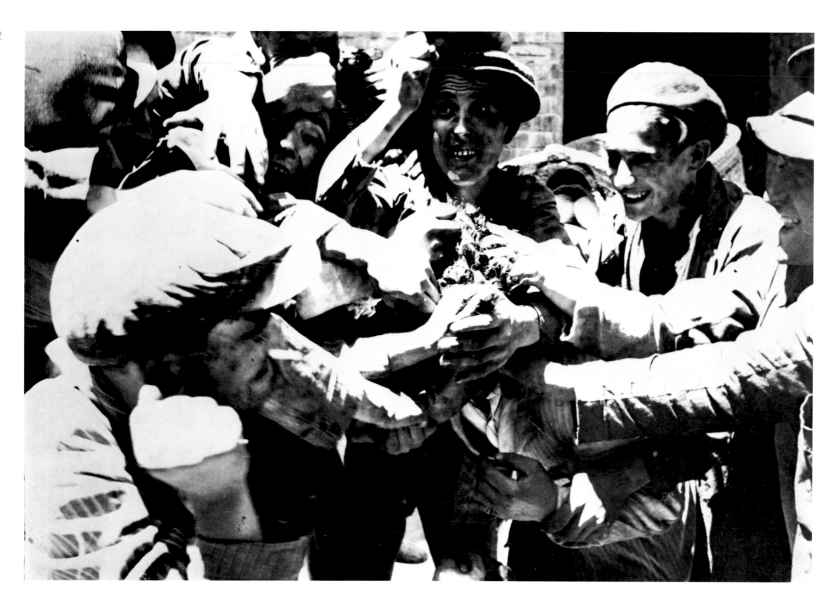

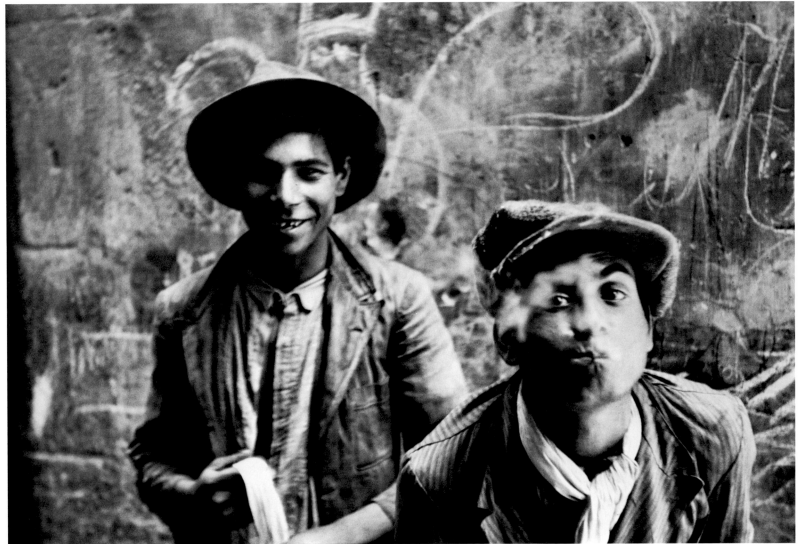

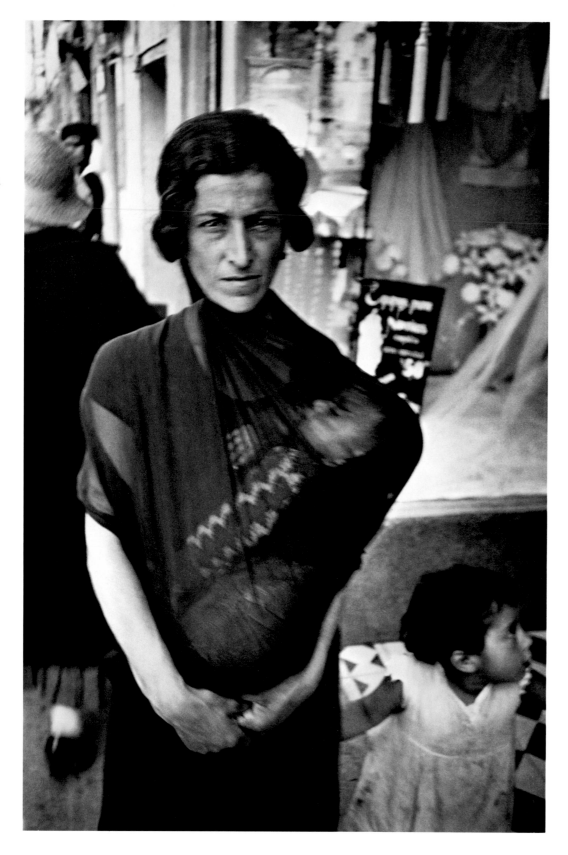

Mexico City. 1934

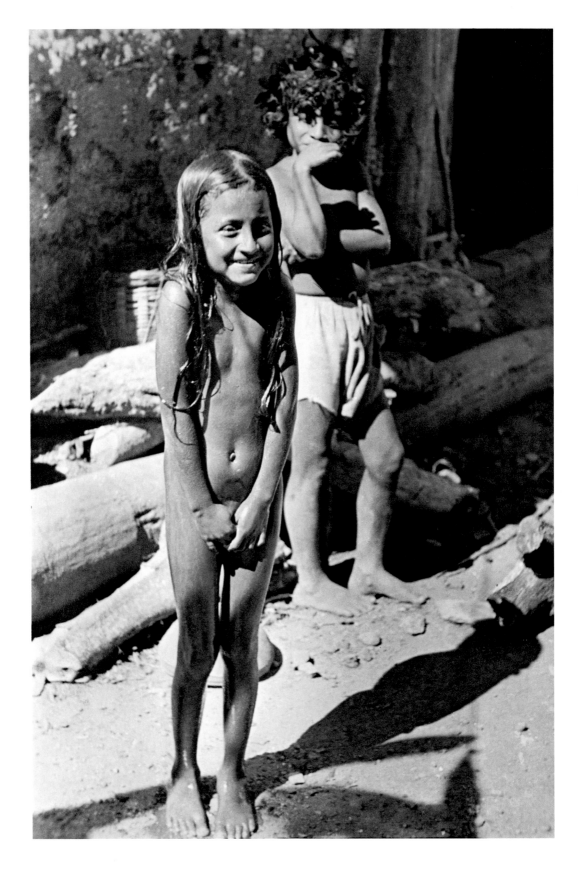

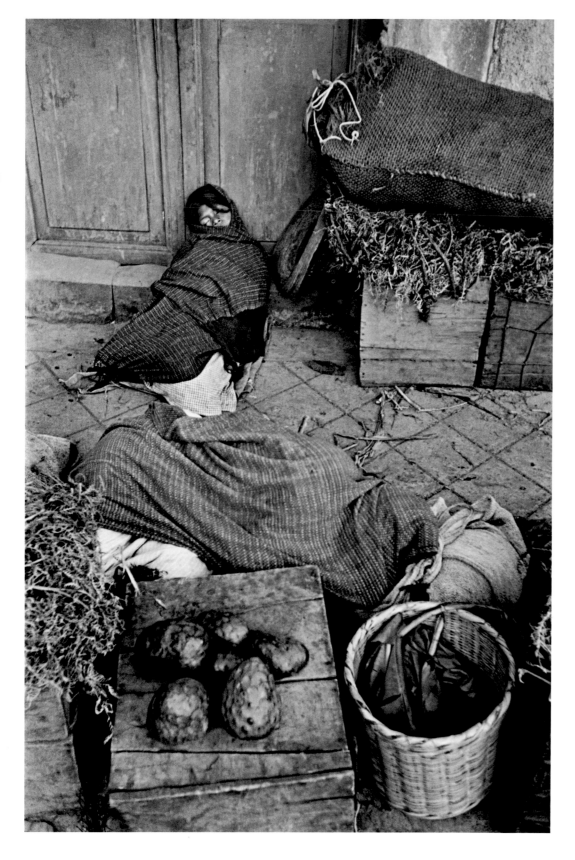

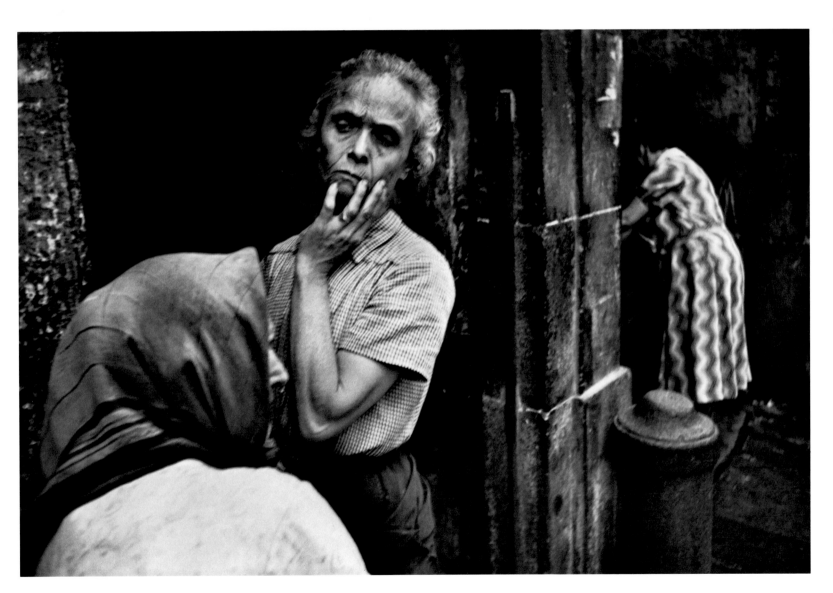

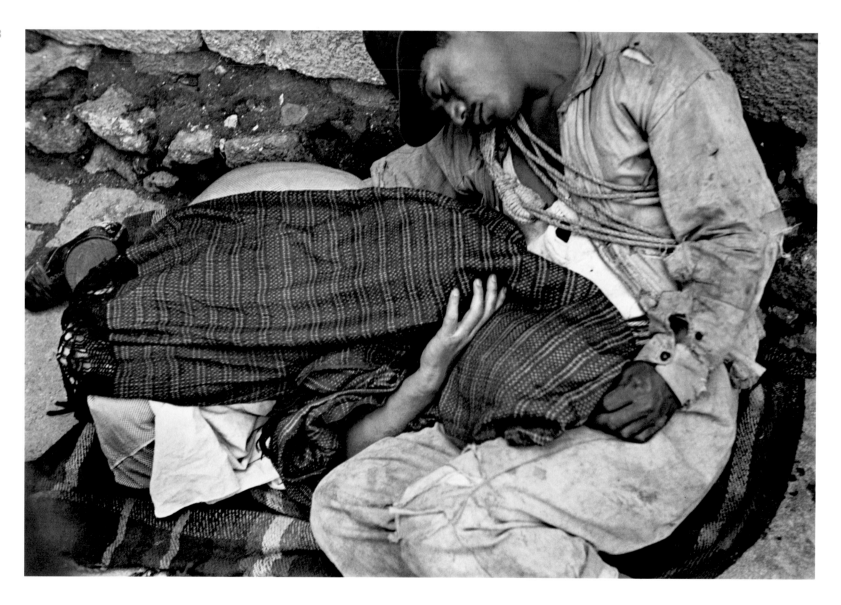

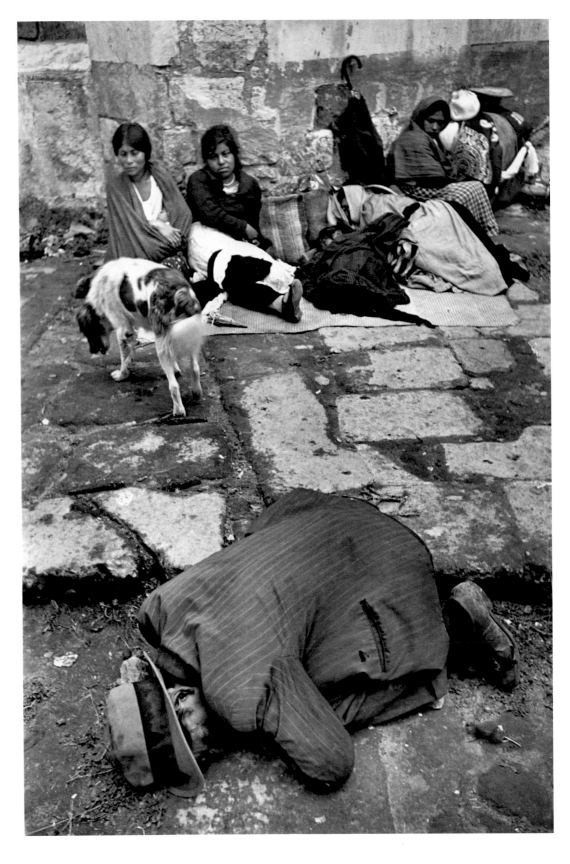

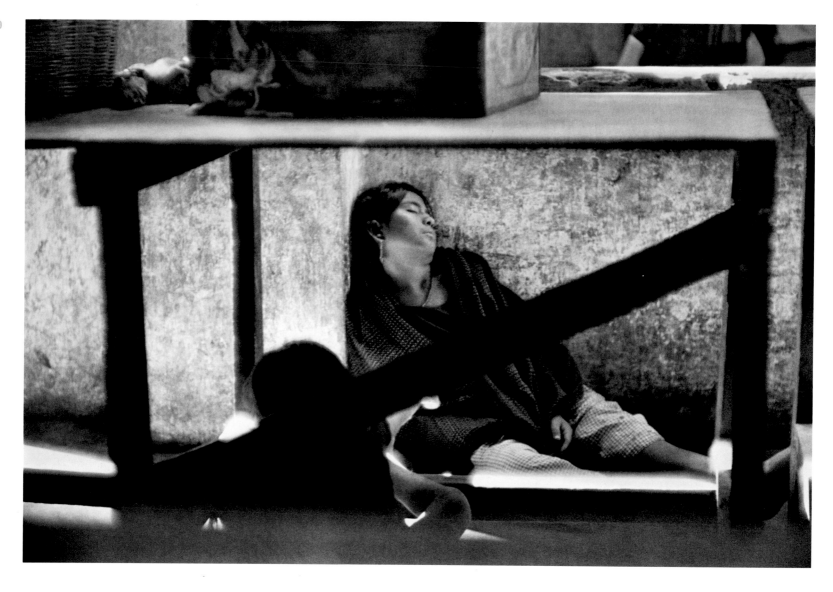

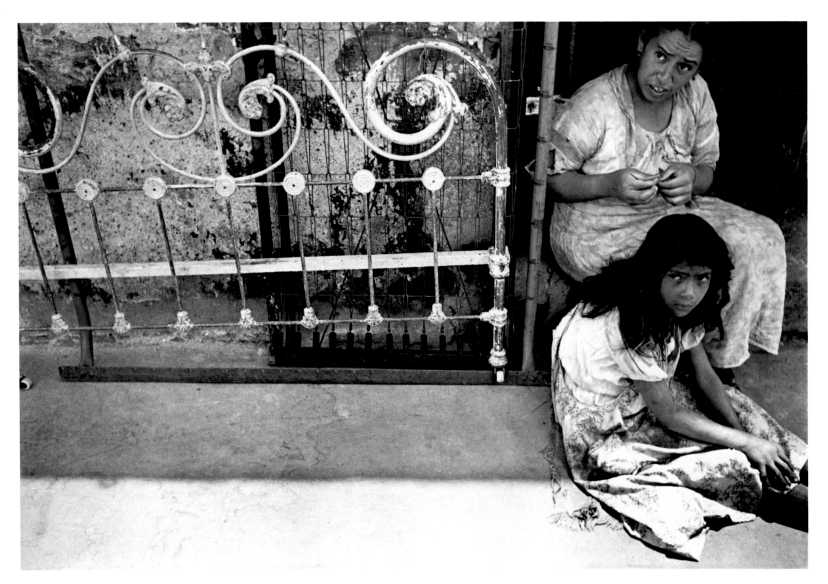

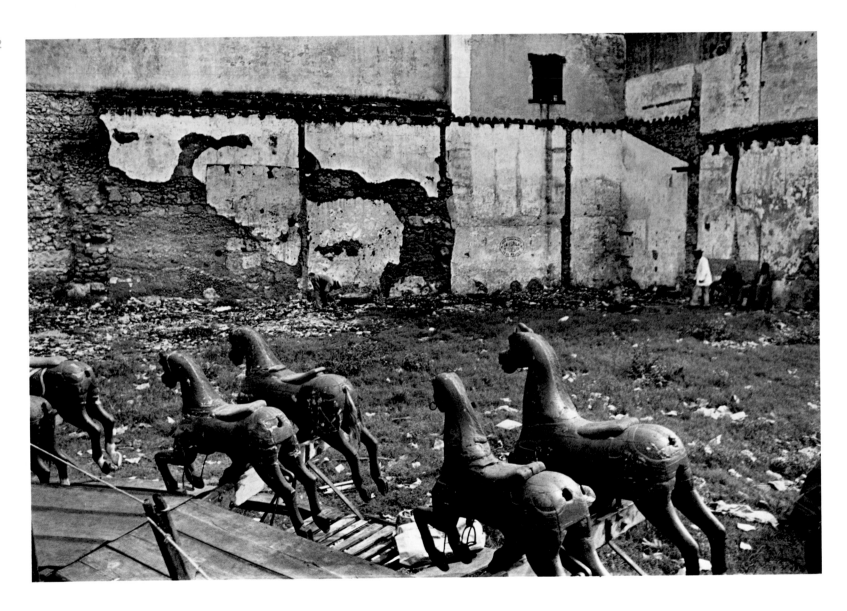

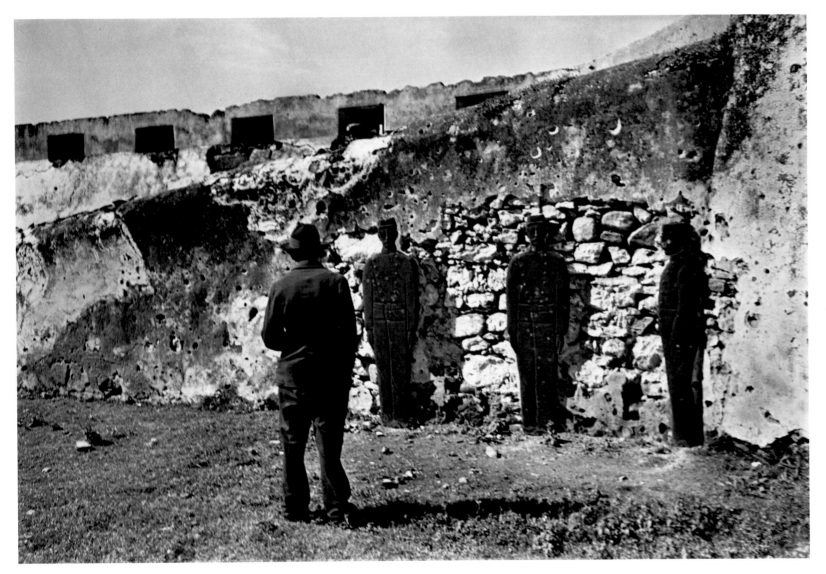

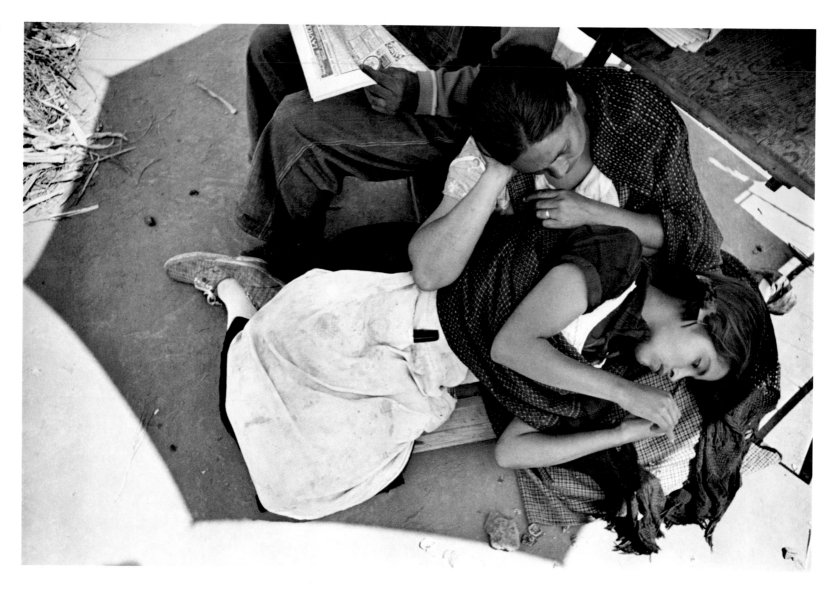

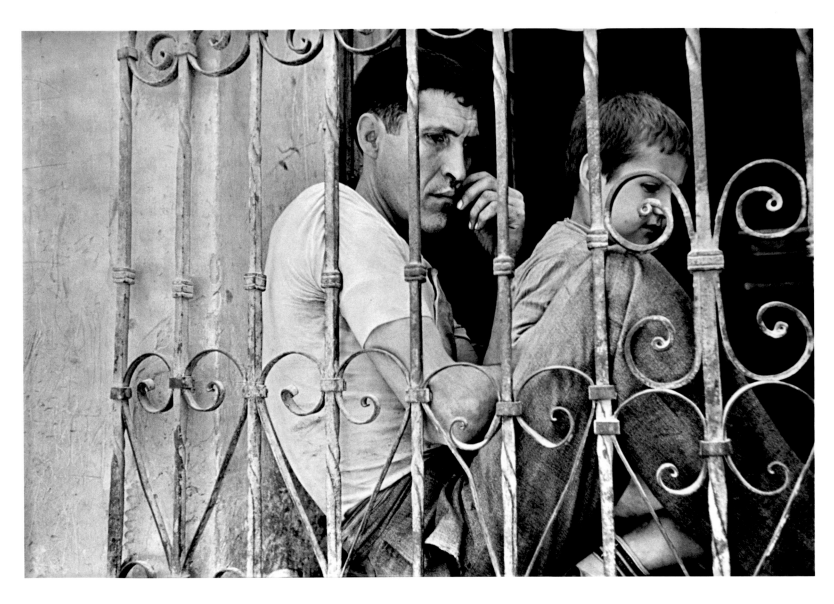

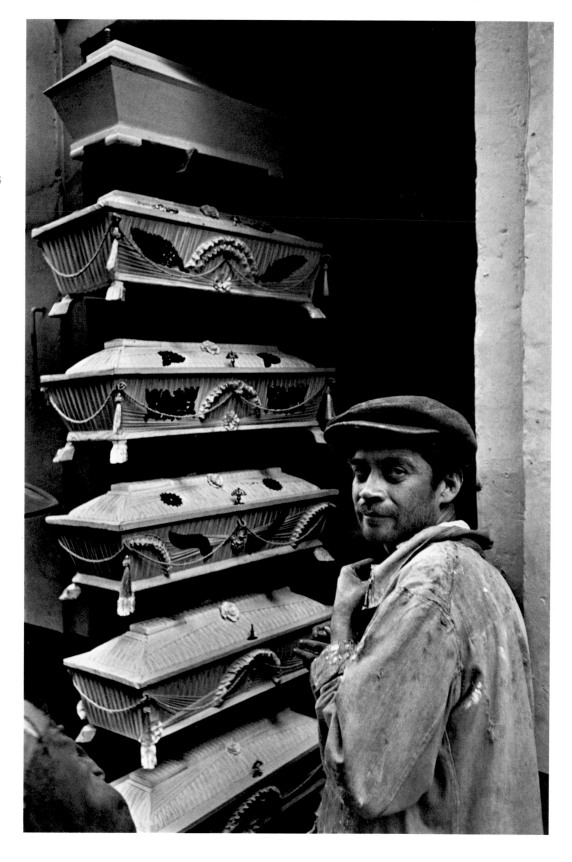

Mexico City. 1934

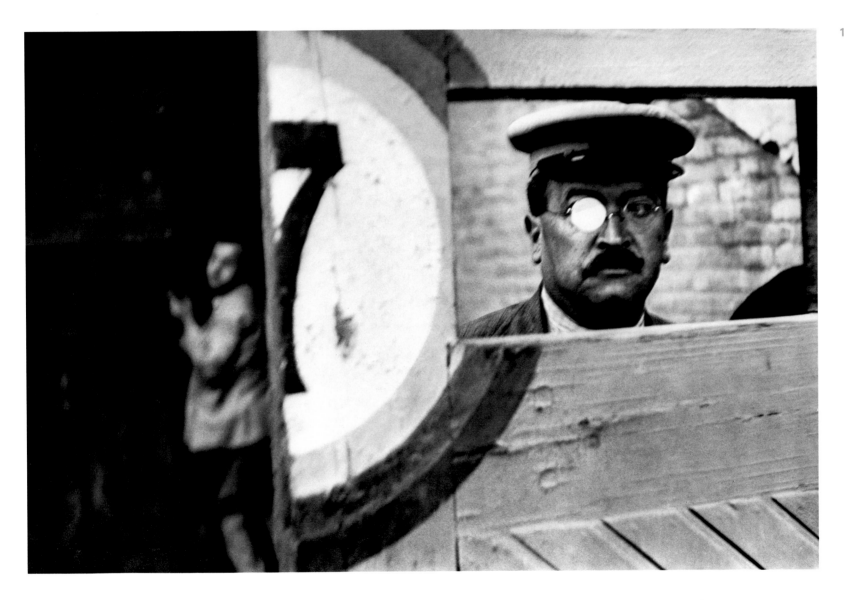

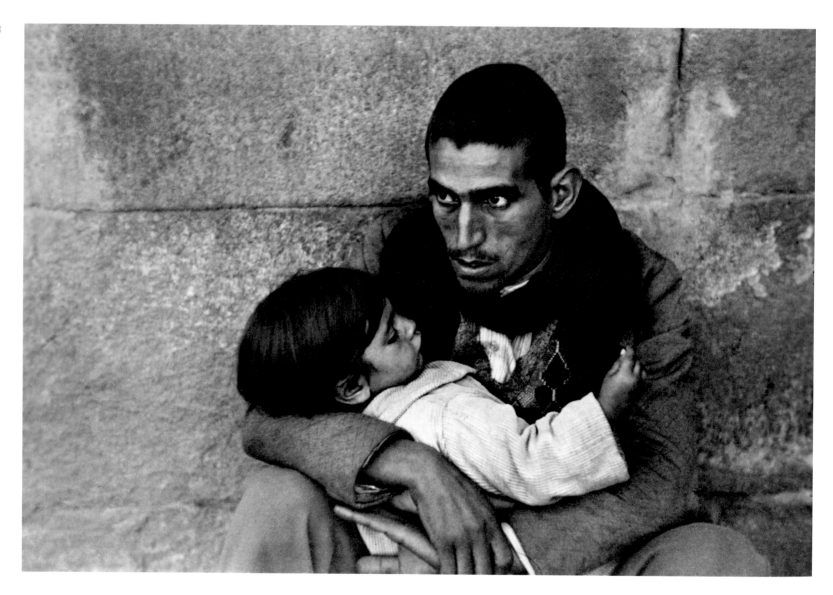

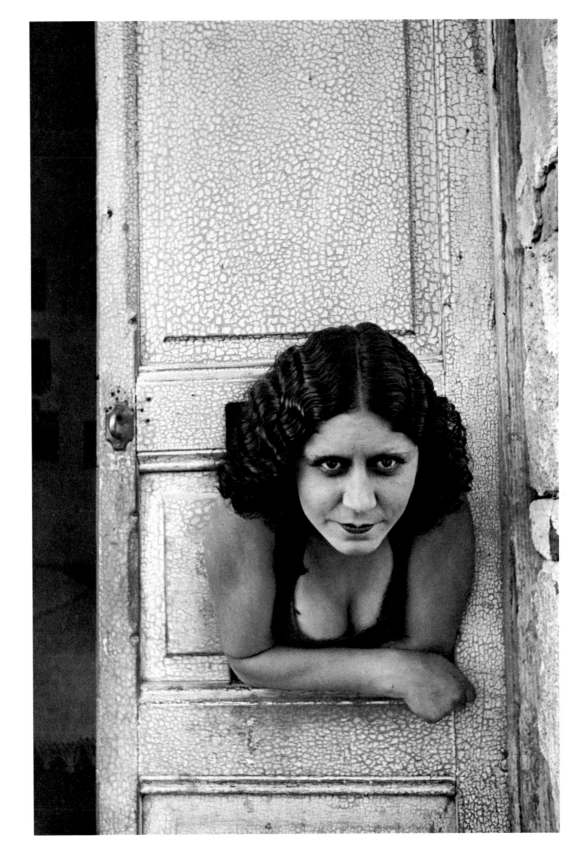

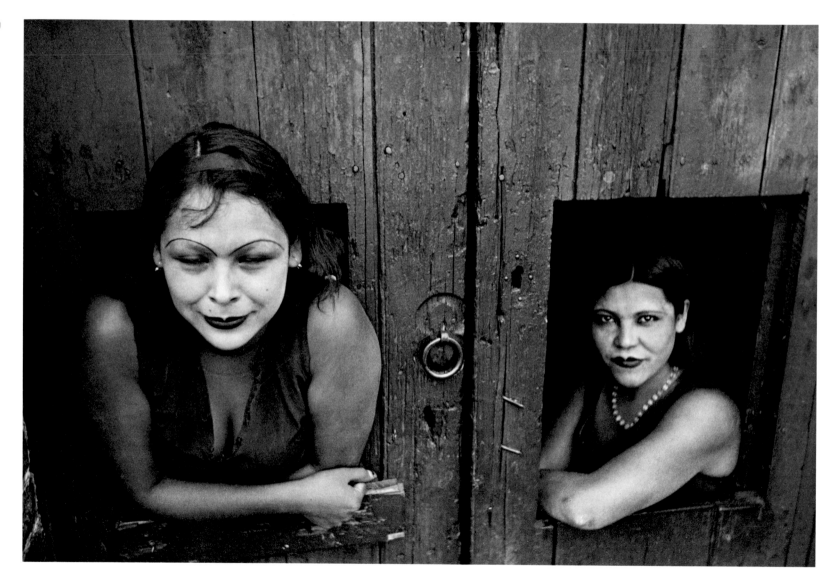

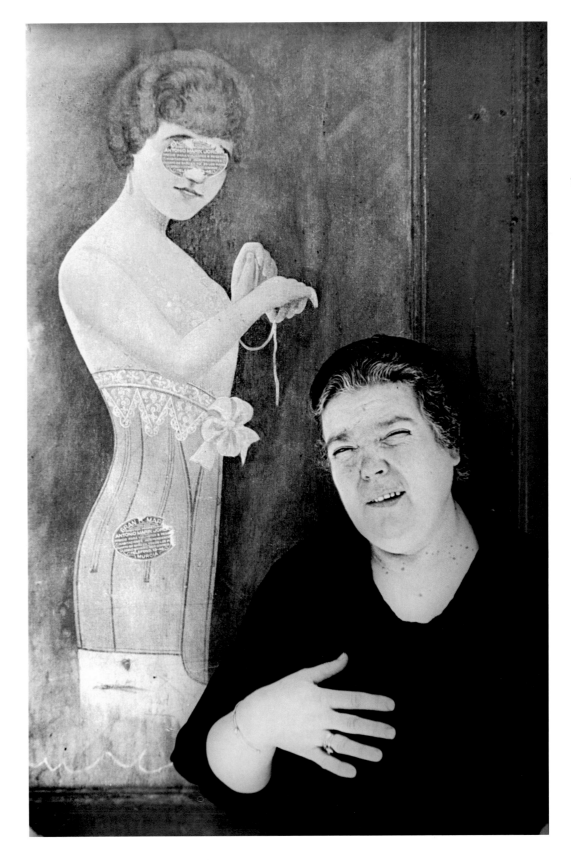

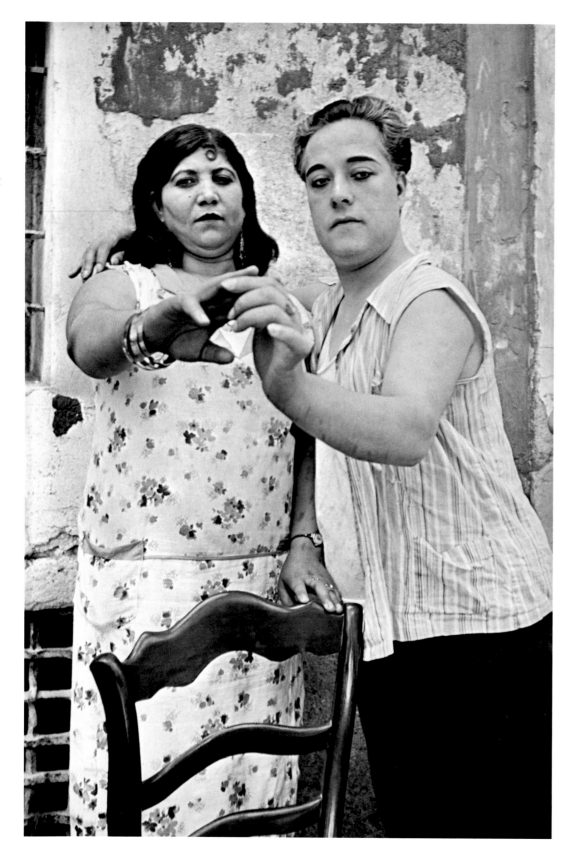

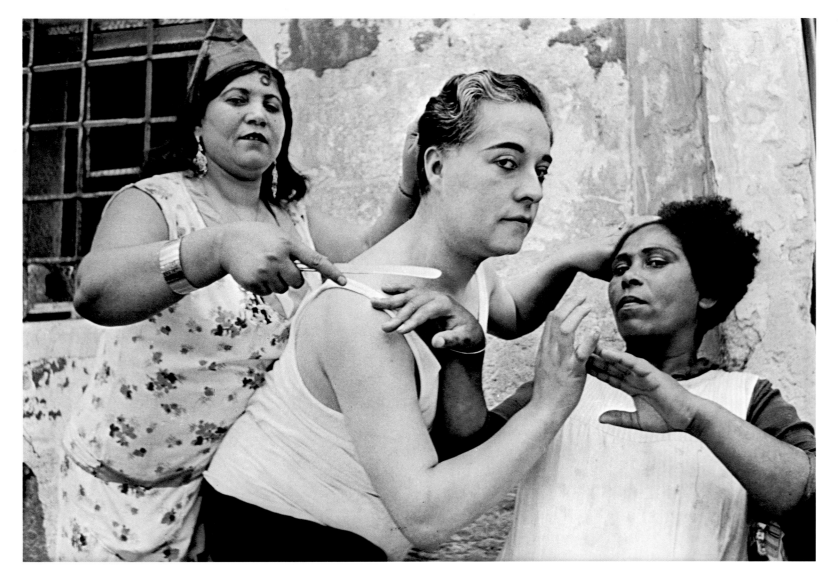

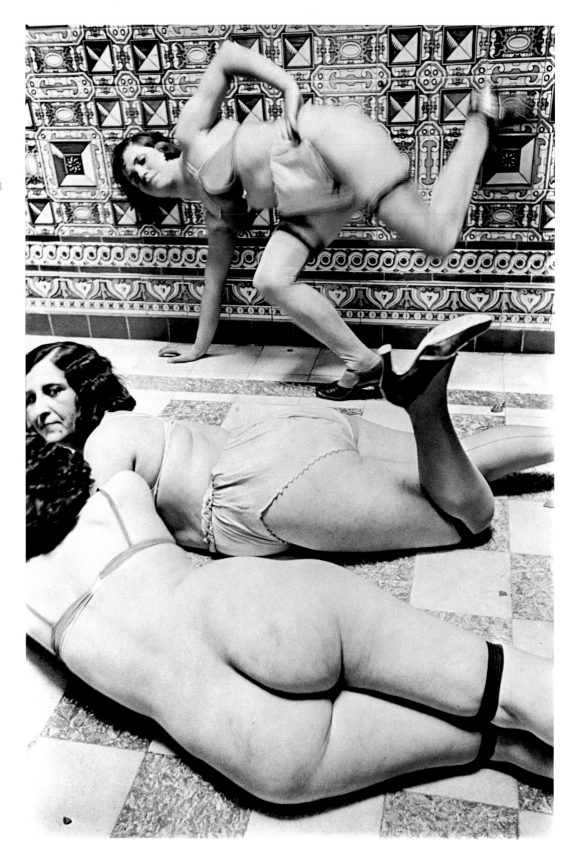

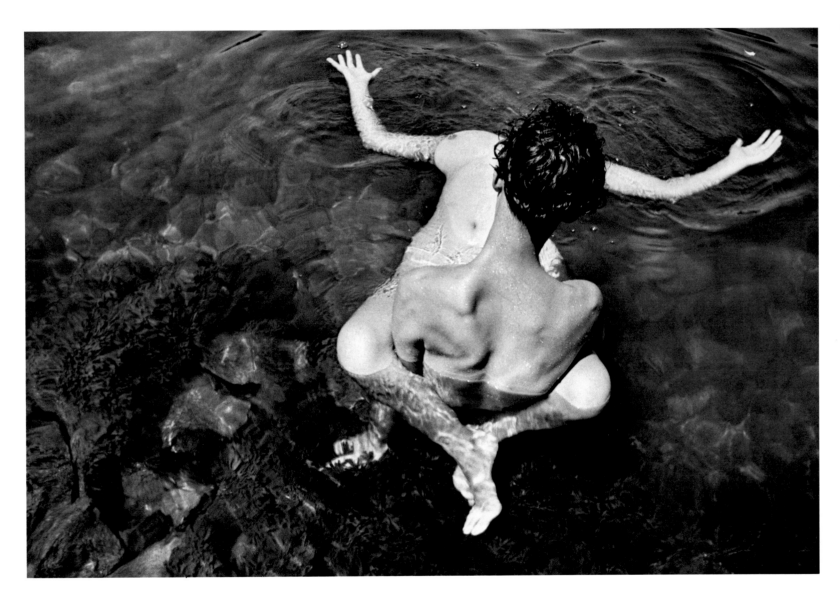

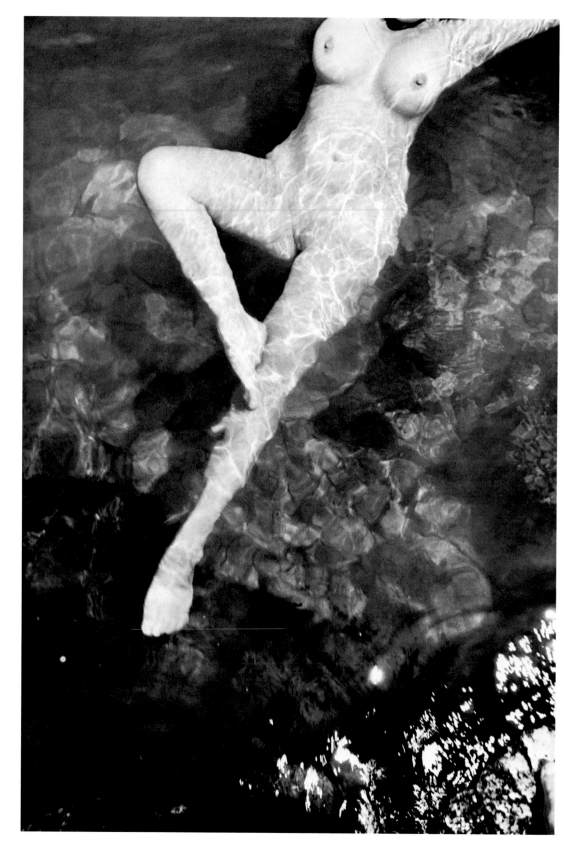

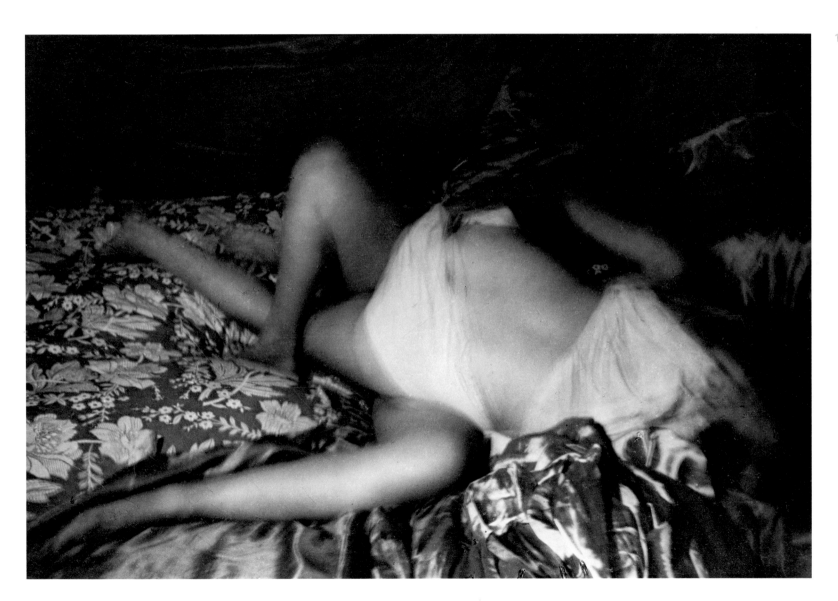

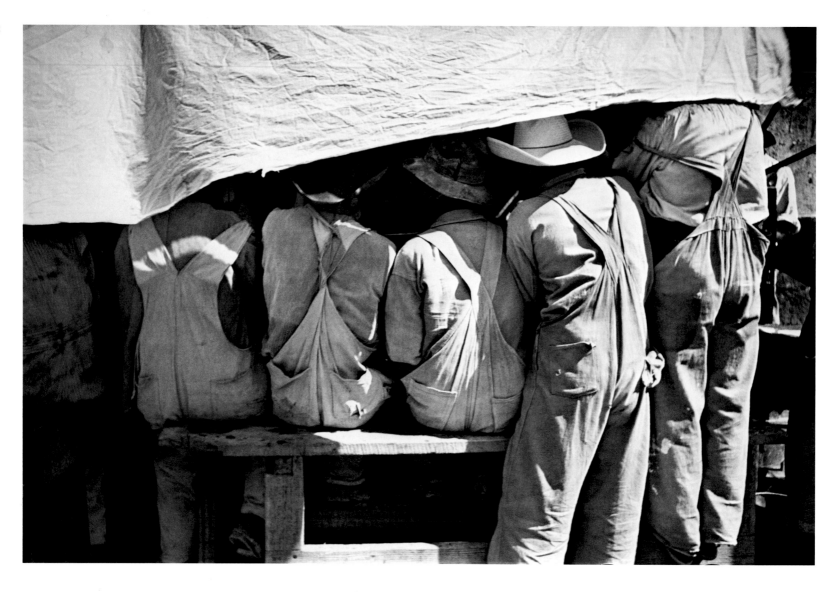

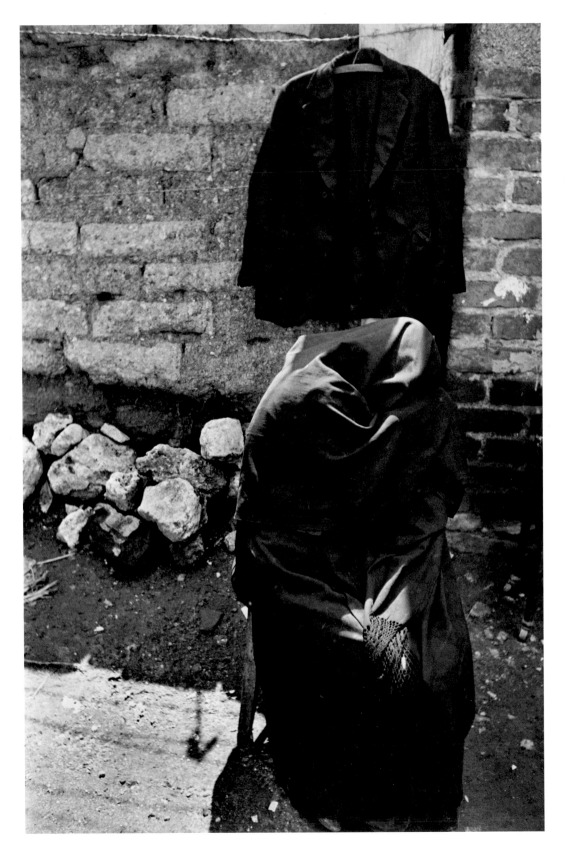

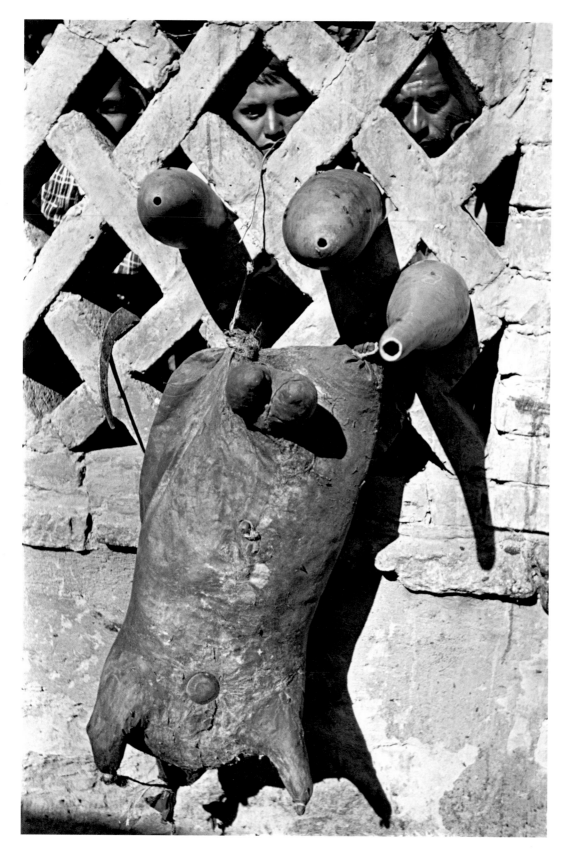

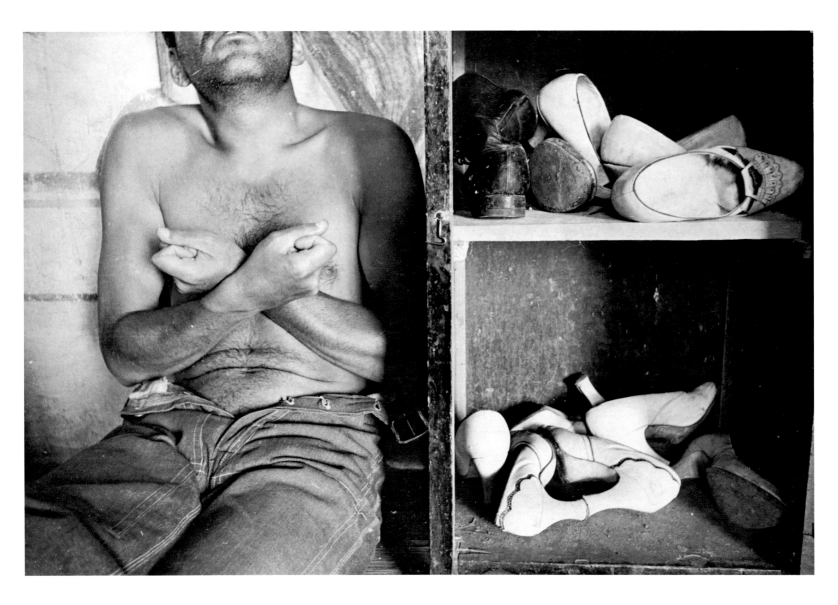

# Catalogue

In the following catalogue, the photographs are listed in the order of their appearance in the plate section. All of the prints are gelatin-silver prints. In the dimensions, height precedes width.

### A NOTE ON THE PRINTS

In the early 1930s, Henri Cartier-Bresson made his own prints but he did not make a great many, since his audience at that time was very small. The great majority of surviving prints from the period were made for exhibition at the Julien Levy Gallery; a few others were gifts to friends. Levy sold relatively few prints at the time (several to The Museum of Modern Art). Later, over the years, he sold a number more, some of which are currently located. The bulk of Levy's remaining holdings (twenty-one prints) is now in The Julien Levy Collection at The Art Institute of Chicago.

Numbers inscribed on the backs of several prints in The Julien Levy Collection and elsewhere suggest that for one exhibition at Levy's gallery Cartier-Bresson made prints from at least sixty-nine different negatives. The majority of these prints have disappeared. Although from time to time previously unknown prints come to light, somewhat less than half of the eighty-seven pictures presented here are known in the form of prints made in the thirties. Yet even if it were possible to assemble the present selection from prints made in that period, it would not necessarily be desirable to do so. Especially in the early thirties Cartier-Bresson was impatient with the very idea of professional craft. Although some of the prints he made then are very beautiful, the others vary widely in character and quality. Often, prints of the thirties are inferior to those made around 1950 or later. In cases where The Museum of Modern Art owns more

than one print from a single negative, the earliest print has not always been chosen for the present exhibition and book.

After World War II Cartier-Bresson, who has always preferred shooting to printing, was rescued from the darkroom by his friend Pierre Gassmann. Under the photographer's supervision, Gassmann's lab, Pictorial Service, in Paris has made virtually all of Cartier-Bresson's prints since the late 1940s, including all of the prints presented here that are dated 1947 or later. The new prints made in 1986 and 1987 for the present exhibition are the work of Georges Fèvre, Catherine Guilbaud, Marc Hervé, Marie-Pierre Jorre, and Vojin Mitrovic. For most of the new prints no corresponding print of the thirties is known. In several cases the negative had not been printed before.

At the end of the thirties, at the outbreak of World War II, Cartier-Bresson cut his negatives into individual frames and discarded those that did not please him. Presumably a number of prints perished as well. In at least several cases Cartier-Bresson destroyed negatives that he had printed earlier, with the result that a small number of excellent pictures are now known only in prints that had left the photographer's hands before 1939. Such is the case for the pictures reproduced here on pages 53, 57, 63, 68, 72, 83, 93, and 112. Good as they are, however, none of these is a match for the greatest of the early pictures. It appears that Cartier-Bresson was a very good, if severe editor of his own work.

Cartier-Bresson's housecleaning of the late thirties was not as radical as it might have been. He retained several hundred negatives, which provide clues to his working method, and which include more than a few superb pictures that apparently were not printed in the thirties. A dozen or more of these were published for the first time in *Henri Cartier-Bresson, Photographer* (Boston: Little, Brown, 1979). Several more make their first appearance here.

144

p. 75 *Pierre Colle, Paris.* 1932 (printed 1986)
14 × 9⅜″ (35.6 × 23.8 cm)
Lent by the photographer

p. 76 *Barrio Chino, Barcelona.* 1933 (printed 1968)
15³⁄₁₆ × 10³⁄₁₆″ (38.6 × 25.9 cm)
The Museum of Modern Art, New York
Gift of the photographer

p. 77 *Antonio Salazar, Mexico.* 1934 (printed 1986)
9⁷⁄₁₆ × 14″ (24 × 35.6 cm)
Lent by the photographer

p. 78 *Tivoli, Italy.* 1933 (printed 1947)
13¾ × 9⅛″ (34.9 × 23.4 cm)
The Museum of Modern Art, New York
Gift of the photographer

p. 79 *Christian Bérard, Paris.* 1932 (printed 1986)
14 × 9⅜″ (35.6 × 23.8 cm)
Lent by the photographer

p. 80 *Paris.* 1932 (printed 1986)
9⁵⁄₁₆ × 13⅞″ (23.7 × 35.3 cm)
Lent by the photographer

p. 81 *Funeral of Aristide Briand, Paris.* 1932 (printed 1930s)
7¾ × 11⅝″ (19.8 × 29.5 cm)
The Museum of Modern Art, New York
Gift of Willard Van Dyke

p. 82 *Quai St.-Bernard, Paris.* 1932 (printed 1986)
9⁵⁄₁₆ × 13¹⁵⁄₁₆″ (23.7 × 35.4 cm)
Lent by the photographer

p. 83 *Paris.* 1932–33 (printed 1930s)
7¾ × 11⁹⁄₁₆″ (19.6 × 29.3 cm)
The Art Institute of Chicago
The Julien Levy Collection. Gift of Jean and
Julien Levy

p. 84 *La Villette, near Paris.* 1932 (printed 1986)
14 × 9⅜″ (35.6 × 23.8 cm)
Lent by the photographer

p. 85 *Paris.* 1932 (printed 1930s)
7⅞ × 11¹¹⁄₁₆″ (20 × 29.7 cm)
The Art Institute of Chicago
The Julien Levy Collection. Gift of Jean and
Julien Levy

p. 86 *André Pieyre de Mandiargues, Italy.* 1932–33
(printed 1986)
9⁷⁄₁₆ × 14″ (24 × 35.6 cm)
Lent by the photographer

p. 87 *Martigues, France.* 1932–33 (printed 1930s)
9¾ × 6⅝″ (24.8 × 16.9 cm)
The Museum of Modern Art, New York
Promised gift of Paul F. Walter

p. 89 *Allée du Prado, Marseille.* 1932 (printed 1964)
13⅝ × 9¼″ (34.8 × 23.5 cm)
The Museum of Modern Art, New York
Gift of the photographer

p. 90 *André Pieyre de Mandiargues and Léonor Fini, Trieste.*
1933 (printed 1986)
14 × 9⅜″ (35.6 × 23.9 cm)
Lent by the photographer

p. 91 *Trieste.* 1933 (printed 1986)
9⁷⁄₁₆ × 14″ (24 × 35.6 cm)
Lent by the photographer

p. 92 *Livorno, Italy.* 1932 (printed 1986)
13¹⁵⁄₁₆ × 9⅜″ (35.4 × 23.8 cm)
The Museum of Modern Art, New York
Purchased as the gift of Lily Auchincloss

p. 93 *Hyères, France.* 1932 (printed 1930s)
6¹⁄₁₆ × 9⁵⁄₁₆″ (15.4 × 23.7 cm)
The J. Paul Getty Museum, Malibu, California

p. 94 *Siena.* 1933 (printed 1986)
14 × 9⅜″ (35.6 × 23.8 cm)
Lent by the photographer

p. 95 *Salerno.* 1933 (printed 1947)
13¼ × 19⁹⁄₁₆″ (33.7 × 49.8 cm)
The Museum of Modern Art, New York
Gift of the photographer

p. 96 *Barcelona.* 1933 (printed 1968)
15½ × 23⅛″ (39.5 × 58.7 cm)
The Museum of Modern Art, New York
Gift of the photographer

p. 97 *Madrid.* 1933 (printed 1968)
23⅛ × 15⁹⁄₁₆″ (58.7 × 39.5 cm)
The Museum of Modern Art, New York
Gift of the photographer

p. 98  *Florence.* 1933 (printed 1986)
9⅜ × 14″ (23.8 × 35.6 cm)
Lent by the photographer

p. 99  *Arsila, Spanish Morocco.* 1933 (printed 1947)
9⅛ × 13¹¹⁄₁₆″ (23.2 × 34.7 cm)
The Museum of Modern Art, New York
Gift of the photographer

p. 100  *Hyères, France.* 1932 (printed 1930s)
7¾ × 11⁷⁄₁₆″ (19.6 × 29.1 cm)
The Museum of Modern Art, New York
Purchase

p. 101  *Behind the Gare St.-Lazare, Paris.* 1932 (printed 1964)
19½ × 14⅛″ (49.7 × 35.7 cm)
The Museum of Modern Art, New York
Gift of the photographer

p. 102  *Seville.* 1933 (printed 1986)
9⅜ × 14″ (23.8 × 35.6 cm)
The Museum of Modern Art, New York
Purchased as the gift of Harriette and Noel Levine

p. 103  *Arsila, Spanish Morocco.* 1933 (printed 1986)
13¹⁵⁄₁₆ × 9⅜″ (35.4 × 23.8 cm)
Lent by the photographer

p. 104  *Italy.* 1932–33 (printed 1986)
9⅜ × 13¹⁵⁄₁₆″ (23.8 × 35.4 cm)
Lent by the photographer

p. 105  *Juchitán, Mexico.* 1934 (printed 1986)
13¹⁵⁄₁₆ × 9⅜″ (35.4 × 23.8 cm)
Lent by the photographer

p. 106  *Marseille.* 1932 (printed 1986)
13¹⁵⁄₁₆ × 9⅜″ (35.4 × 23.8 cm)
Lent by the photographer

p. 107  *Valencia.* 1933 (printed 1947)
12⅞ × 19⁹⁄₁₆″ (32.6 × 49.8 cm)
The Museum of Modern Art, New York
Gift of the photographer

p. 108  *Seville.* 1933 (printed c. 1950)
9¹⁵⁄₁₆ × 14¹³⁄₁₆″ (25.2 × 37.6 cm)
The Museum of Modern Art, New York
Lois and Bruce Zenkel Fund

p. 109  *Seville.* 1933 (printed 1947)
9³⁄₁₆ × 13⁹⁄₁₆″ (23.3 × 34.4 cm)
The Museum of Modern Art, New York
Gift of the photographer

p. 111  *Madrid.* 1933 (printed 1947)
9⅛ × 13⁹⁄₁₆″ (23.2 × 34.6 cm)
The Museum of Modern Art, New York
Gift of the photographer

p. 112  *Spain.* 1933 (printed 1930s)
6⅛ × 9⅛″ (15.6 × 23.2 cm)
The Art Institute of Chicago
The Julien Levy Collection

p. 113  *Andalusia.* 1933 (printed 1986)
9⅜ × 14″ (23.8 × 35.6 cm)
Lent by the photographer

p. 114  *Mexico City.* 1934 (printed 1968)
15⅛ × 10³⁄₁₆″ (38.6 × 26 cm)
The Museum of Modern Art, New York
Gift of the photographer

p. 115  *Juchitán, Mexico.* 1934 (printed 1947)
13¹¹⁄₁₆ × 9⅛″ (34.7 × 23.1 cm)
The Museum of Modern Art, New York
Gift of the photographer

p. 116  *Mexico.* 1934 (printed 1986)
13¹⁵⁄₁₆ × 9⅜″ (35.4 × 23.8 cm)
Lent by the photographer

p. 117  *Spain.* 1932–33 (printed 1986)
9⅜ × 13¹⁵⁄₁₆″ (23.8 × 35.4 cm)
Lent by the photographer

p. 118  *Mexico.* 1934 (printed 1986)
9⅜ × 13¹⁵⁄₁₆″ (23.8 × 35.4 cm)
Lent by the photographer

p. 119  *Mexico.* 1934 (printed 1986)
14 × 9⅜″ (35.6 × 23.8 cm)
Lent by the photographer

p. 120  *Juchitán, Mexico.* 1934 (printed 1986)
9⁵⁄₁₆ × 13¹⁵⁄₁₆″ (23.7 × 35.4 cm)
Lent by the photographer

p. 121 *Mexico City.* 1934 (printed 1986)
9⁵⁄₁₆ × 13⁷⁄₈″ (23.7 × 35.2 cm)
Lent by the photographer

p. 122 *Cuba.* 1934 (printed 1986)
9³⁄₈ × 14″ (23.8 × 35.6 cm)
Lent by the photographer

p. 123 *Puebla, Mexico.* 1934 (printed 1986)
9³⁄₈ × 14″ (23.8 × 35.6 cm)
Lent by the photographer

p. 124 *Mexico City.* 1934 (printed 1987)
9⁷⁄₁₆ × 14¹⁄₈″ (24 × 35.8 cm)
Lent by the photographer

p. 125 *Spain.* 1933 (printed 1986)
9³⁄₈ × 13¹⁵⁄₁₆″ (23.8 × 35.4 cm)
Lent by the photographer

p. 126 *Mexico City.* 1934 (printed 1986)
14 × 9⁵⁄₁₆″ (35.5 × 23.7 cm)
The Museum of Modern Art, New York
Robert and Joyce Menschel Fund

p. 127 *Valencia.* 1933 (printed 1964)
12¹⁵⁄₁₆ × 19⁷⁄₁₆″ (33 × 49.3 cm)
The Museum of Modern Art, New York
Gift of the photographer

p. 128 *Madrid.* 1933 (printed 1947)
9¹⁄₄ × 13¹¹⁄₁₆″ (23.5 × 34.8 cm)
The Museum of Modern Art, New York
Gift of the photographer

p. 129 *Calle Cuauhtemoctzin, Mexico City.* 1934
(printed 1947)
13⁵⁄₈ × 9¹⁄₈″ (34.7 × 23.2 cm)
The Museum of Modern Art, New York
Gift of the photographer

p. 130 *Calle Cuauhtemoctzin, Mexico City.* 1934
(printed 1968)
10³⁄₁₆ × 15³⁄₁₆″ (25.9 × 38.6 cm)
The Museum of Modern Art, New York
Gift of the photographer

p. 131 *Córdoba, Spain.* 1933 (printed 1968)
13¹⁵⁄₁₆ × 9³⁄₁₆″ (35.5 × 23.3 cm)
The Museum of Modern Art, New York
Gift of the photographer

p. 132 *Alicante, Spain.* 1933 (printed 1986)
13¹⁵⁄₁₆ × 9⁵⁄₁₆″ (35.4 × 23.7 cm)
Lent by the photographer

p. 133 *Alicante, Spain.* 1933 (printed 1968)
10¹⁄₄ × 15³⁄₁₆″ (26 × 38.6 cm)
The Museum of Modern Art, New York
Gift of the photographer

p. 134 *Alicante, Spain.* 1933 (printed 1986)
13¹⁵⁄₁₆ × 9⁵⁄₁₆″ (35.4 × 23.6 cm)
The Museum of Modern Art, New York
Purchased as the gift of Shirley C. Burden

p. 135 *Italy.* 1933 (printed 1986)
9⁷⁄₁₆ × 14″ (24 × 35.6 cm)
The Museum of Modern Art, New York
Lois and Bruce Zenkel Fund

p. 136 *Italy.* 1933 (printed 1986)
14 × 9³⁄₈″ (35.6 × 23.9 cm)
Lent by the photographer

p. 137 *Mexico.* 1934 (printed c. 1950)
9¹⁄₄ × 13⁵⁄₈″ (23.5 × 34.6 cm)
The Museum of Modern Art, New York
Gift of Monroe Wheeler

p. 138 *Mexico.* 1934 (printed 1986)
9⁷⁄₁₆ × 14″ (24 × 35.7 cm)
Lent by the photographer

p. 139 *Mexico.* 1934 (printed 1968)
15¹⁄₈ × 10³⁄₁₆″ (38.5 × 25.9 cm)
The Museum of Modern Art, New York
Gift of the photographer

p. 140 *Mexico.* 1934 (printed 1986)
13¹⁵⁄₁₆ × 9³⁄₈″ (35.4 × 23.8 cm)
Lent by the photographer

p. 141 *Santa Clara, Mexico.* 1934 (printed 1930s)
6⁵⁄₈ × 9⁷⁄₈″ (16.8 × 25.1 cm)
The Museum of Modern Art, New York
Gift of Willard Van Dyke

# Bibliography

The bibliography includes only works that present or discuss Cartier-Bresson's early photographs or that were consulted in preparing this catalogue. Where possible, English-language editions are cited. Books of Cartier-Bresson's photographs and exhibition catalogues are listed chronologically.

## BOOKS OF CARTIER-BRESSON'S PHOTOGRAPHS

*Images à la sauvette*. Introduction by Henri Cartier-Bresson. Paris: Éditions Verve, 1952. American ed., *The Decisive Moment*. New York: Simon & Schuster, 1952.

*Henri Cartier-Bresson: Fotografie*. Introduction by Anna Fárová. Prague: SNKLHU, 1958.

*Photographs by Henri Cartier-Bresson*. Essays by Lincoln Kirstein and Beaumont Newhall. New York: Grossman, 1963.

*The World of Henri Cartier-Bresson*. Introduction by Henri Cartier-Bresson. New York: Viking, 1968.

*Henri Cartier-Bresson, Photographer*. Foreword by Yves Bonnefoy. Boston: Little, Brown, 1979.

*Henri Cartier-Bresson*. Introduction by Jean Clair. Paris: Centre national de la photographie, 1982.

*Henri Cartier-Bresson*. Introduction by Michael Brenson. New York: Pantheon, 1982.

*Henri Cartier-Bresson: Photoportraits*. Preface by André Pieyre de Mandiargues. London and New York: Thames & Hudson, 1985.

## EXHIBITION CATALOGUES

*The Photographs of Henri Cartier-Bresson*. Essays by Lincoln Kirstein and Beaumont Newhall. New York: The Museum of Modern Art, 1947.

*Henri Cartier-Bresson*. Texts by Henri Cartier-Bresson and Claude Roy. Cologne: Kunsthalle, 1967.

*Henri Cartier-Bresson*. Essay by Sir Ernst Gombrich. Edinburgh: Scottish Arts Council, 1978.

*L'Imaginaire d'après nature: Disegni, dipinti, fotografie di Henri Cartier-Bresson*. Edited by Giuliana Scimé. Milan: Padiglione d'arte contemporanea, 1983.

*Henri Cartier-Bresson: Carnet de notes sur le Mexique*. Essay by Juan Rulfo. Paris: Centre culturel du Mexique, 1984.

*Photographs by Henri Cartier-Bresson from Mexico, 1934 and 1963*. Essay by Amy Conger. Corpus Christi, Tex.: Art Museum of South Texas, 1984.

*Henri Cartier-Bresson: Paris à vue d'oeil*. Texts by André Pieyre de Mandiargues and Vera Feyder. Paris: Musée Carnavalet in association with Paris-Audiovisuel, 1985.

## INTERVIEWS

Baby, Yvonne. "Henri Cartier-Bresson on the Art of Photography." *Harper's Magazine* (New York), November 1961, pp. 72–78.

Bourde, Yves. "Un Entretien avec Henri Cartier-Bresson." *Le Monde* (Paris), September 5, 1974.

Desvergnes, Alain. "Une Interview de Henri Cartier-Bresson." *Photo* (Paris), September 1979.

Dobell, Byron. "A Conversation with Henri Cartier-Bresson." *Popular Photography* (New York), 41 (September 1957), pp. 130–32.

Guibert, Hervé. "Vive la photo: Rencontre avec Henri Cartier-Bresson." *Le Monde* (Paris), October 30, 1980.

Hill, Paul, and Thomas Cooper. "Henri Cartier-Bresson." In Hill and Cooper, *Dialogue with Photography*. New York: Farrar Straus Giroux, 1979.

Mora, Gilles. "Henri Cartier-Bresson, Gilles Mora: Conversation." In Mora, ed., *Henri Cartier-Bresson*, special issue of *Les Cahiers de la photographie* (Paris), no. 18 (1986), pp. 117–25.

Seed, Sheila Turner. "Henri Cartier-Bresson: Interview." *Popular Photography* (New York), 74 (May 1974), pp. 108 ff.

## ARTICLES

Aragon Leiva, Augustin. "Reflexiónes sobre la fotografía" [c. 1934]. From an unidentified periodical. Photostat in The Museum of Modern Art Library.

Cartier-Bresson, Henri. "Reality Has the Last Word." *The New York Times*, July 8, 1975.

Coleman, A. D. "More Than the Decisive Moment." *The New York Times*, March 29, 1970.

Evans, Walker. "Cartier-Bresson, a True Man of the Eye." *The New York Times Book Review*, October 19, 1952, p. 7.

Galassi, Peter. "An Early Cartier-Bresson." *MoMA* (New York), Winter 1975–76, n.p.

Girod de l'Ain, Bertrand. "Henri Cartier-Bresson au Grand Palais." *Le Monde* (Paris), October 21, 1970.

Goldsmith, Arthur. "Henri Cartier-Bresson Revisited" (1960). Reprinted with minor revisions in Goldsmith, *The Photography Game: What It Is and How to Play It*. New York: Viking, 1971.

————. "Henri Cartier-Bresson: A New Look at an Old Master." *Popular Photography* (New York), 85 (November 1979), pp. 100–07, 149–50.

Greenberg, Clement. "Review of the Whitney Annual and Exhibitions of Picasso and Henri Cartier-Bresson" (1947).

In Greenberg, *The Collected Essays and Criticism*, vol. 2: *1945–49*. Edited by John O'Brian. Chicago: University of Chicago Press, 1986.

Guibert, Hervé. "Cartier-Bresson: 'Photoportraits' sans guillemets." *Le Monde* (Paris), October 10, 1985.

Haas, Ernst. "Henri Cartier-Bresson: A Lyrical View of Life." *Modern Photography* (New York), 35 (November 1971), pp. 88–97, 134, 136.

Holden, Judith. "The Disciplines of Henri Cartier-Bresson." *Infinity* (New York), 10 (February 1961), pp. 3–17.

Hughes, Langston. "Fotografías, mas que fotografías." *Todo* (Mexico City), March 12, 1935.

Kirstein, Lincoln. "A Great Book of Great Photographs." *Infinity* (New York), 1 (November 1952), p. 6.

Leal, Fernando. "La belleza de lo imprevisto." *El Nacional* (Mexico City), [c. 1934–35]. Photostat in The Museum of Modern Art Library.

Lloyd, Peter [pseudonym for Julien Levy]. Letter printed on an announcement for the exhibition "Photographs by Henri Cartier-Bresson and an Exhibition of Anti-Graphic Photography" at the Julien Levy Gallery, New York, October 15–November 16, 1933. Reprinted in Levy, *Surrealism*. New York: Black Sun Press, 1936.

Maddow, Ben. "Surgeon, Poet, Provocateur." *The Photo League Bulletin* (New York), April 1947, p. 2.

Mora, Gilles, ed. *Henri Cartier-Bresson*. Special issue of *Les Cahiers de la photographie* (Paris), no. 18 (1986).

Newhall, Beaumont. "Vision Plus the Camera: Henri Cartier-Bresson" (1946). Reprinted in Newhall, *Photography: Essays and Images*. New York: The Museum of Modern Art, 1980.

Norman, Dorothy. "A Visitor Falls in Love—with Hudson and East Rivers." *The New York Post*, August 26, 1946.

Roegiers, Patrick. "Cartier-Bresson, gentleman-caméléon." *Le Monde aujourd'hui* (Paris), March 16, 1986, p. 12.

Roy, Claude. "Ce Cher Henri." *Photo* (Paris), November 1974.

Schwalberg, Bob, David Vestal, and Michael Korda. "Cartier-Bresson Today: Three Views." *Popular Photography* (New York), 60 (May 1967), pp. 108–09, 138–42.

Soby, James Thrall. "The Art of Poetic Accident: The Photographs of Cartier-Bresson and Helen Levitt." *Minicam* (New York), 6 (March 1943), pp. 28–31, 95.

———. "A New Vision in Photography." *The Saturday Review* (New York), April 5, 1947, pp. 32–34.

Stevens, Nancy. "In Search of the Invisible Man." *American Photographer* (New York), 3 (November 1979), pp. 63–71.

Torre, Guillermo de. "El nuevo arte de la cámara o la fotografía animista." *Luz* (Madrid), January 2, 1934.

Torri, Julio. "Cartier Bresson." One-page essay on the printed announcement for the exhibition "Exposición fotografías: Cartier Bresson, Alvarez Bravo" at Palacio de Bellas Artes, Mexico City, March 11–20, 1935.

Vestal, David. "Cartier-Bresson: Recent Photographs?" *Popular Photography* (New York), 63 (October 1968), p. 115.

White, Minor. "Henri Cartier-Bresson: *The Decisive Moment*." *Aperture* (Rochester, N.Y.), no. 4 (1953), pp. 41–42.

## OTHER REFERENCES

Ades, Dawn. *Photomontage*. London: Thames & Hudson, 1976.

———. *Dada and Surrealism Reviewed* (exhibition catalogue). London: Arts Council of Great Britain, 1978.

Alexander, William. *Film on the Left: American Documentary Film from 1931 to 1942*. Princeton, N.J.: Princeton University Press, 1981.

Aragon, Louis. *Le Paysan de Paris* (1926). English ed., *Nightwalker*. Translated by Frederick Brown. Englewood Cliffs, N.J.: Prentice-Hall, 1970.

———. *La Peinture au défi* (exhibition catalogue). Paris: Galerie Goemans, 1930.

———. *Les Collages*. Paris: Hermann, 1965.

Aranda, Francisco. *Luis Buñuel: A Critical Biography*. Translated by David Robinson. New York: Da Capo, 1976.

*Atelier Man Ray: Berenice Abbott, Jacques-André Boiffard, Bill Brandt, Lee Miller, 1920–1935* (exhibition catalogue). Paris: Centre Georges Pompidou in association with Philippe Sers éditeur, 1982.

Bandy, Mary Lea, ed. *Rediscovering French Film* (exhibition catalogue). New York: The Museum of Modern Art, 1983.

Bertin, Célia. *Jean Renoir*. Paris: Librairie académique Perrin, 1986.

Bouqueret, Christian. *La Nouvelle Photographie en France 1919–1939* (exhibition catalogue). Poitiers: Musée de la Ville, 1986.

Breton, André. *Nadja* (1928). Translated by Richard Howard. New York: Grove Press, 1960.

———. *L'Amour fou*. Paris: Gallimard, 1937.

———. *Manifestoes of Surrealism*. Translated by Richard Seaver and Helen R. Lane. Ann Arbor, Mich.: University of Michigan Press, 1969.

Brinnin, John Malcolm. *Sextet: T. S. Eliot, Truman Capote and Others*. New York: Delacorte Press, 1981.

Buñuel, Luis. *My Last Sigh*. Translated by Abigail Israel. New York: Knopf, 1983.

Campbell, Russell. *Cinema Strikes Back: Radical Filmmaking in the United States, 1930–1942*. Ann Arbor, Mich.: UMI Research Press, 1982.

Capa, Robert, and David Seymour "Chim." *Front populaire*. Text by Georgette Elgey. Paris: Chêne/Magnum, 1976.

Caute, David. *Communism and the French Intellectuals, 1914–1960*. New York: André Deutsch, 1964.

Coke, Van Deren, with Diana C. Du Pont. *Photography: A Facet of Modernism*. New York: Hudson Hills Press in association with the San Francisco Museum of Modern Art, 1986.

Crevel, René. *Le Clavecin de Diderot* (1930). Reprint, Paris: J. J. Pauvert, 1966.

Crosby, Caresse. *The Passionate Years*. New York: Dial Press, 1953.

Dubief, Henri. *Le Déclin de la Troisième République, 1929–1938*. Nouvelle histoire de la France contemporaine, 13. Paris: Éditions du Seuil, 1976.

Ford, Hugh. *Published in Paris: American and British Writers, Printers, and Publishers in Paris, 1920–1939*. Yonkers, N.Y.: Pushcart Press, 1975.

Gidal, Tim N. *Modern Photojournalism: Origin and Evolution, 1910–1933*. Translated by Maureen Oberli-Turner. New York: Collier Books, 1973.

Gräff, Werner. *Es kommt der neue Fotograf!* Berlin: H. Reckendorf, 1929.

Harbison, Robert. *Deliberate Regression*. New York: Knopf, 1980.

Haworth-Booth, Mark, and David Mellor. *Bill Brandt Behind the Camera: Photographs, 1928–1983*. New York: Aperture, 1985.

Johnson, William. *Aigner's Paris*. Stockholm: Fotografiska Museet, 1982.

Krauss, Rosalind, and Jane Livingston, eds. *L'Amour fou: Photography and Surrealism* (exhibition catalogue). Washington, D.C.: The Corcoran Gallery of Art; New York: Abbeville Press, 1985.

Levy, Julien. *Surrealism*. New York: Black Sun Press, 1936.

———. *Memoir of an Art Gallery*. New York: G. P. Putnam's Sons, 1977.

Livingston, Jane. *M. Alvarez Bravo* (exhibition catalogue). Washington, D.C.: The Corcoran Gallery of Art; Boston: Godine, 1978.

Lottmann, Herbert R. *The Left Bank: Writers, Artists, and Politics from the Popular Front to the Cold War*. Boston: Houghton Mifflin, 1982.

*Manuel Alvarez Bravo: 303 Photographies, 1920–1986* (exhibition catalogue). Paris: Musée d'art moderne de la Ville de Paris; Paris-Audiovisuel, 1986.

Moholy-Nagy, László. *Painting, Photography, Film*. Bauhaus Books, 8 (1925). Reprint, Cambridge, Mass.: The MIT Press, 1969.

Mousseigne, Alain. "Situation de la photographie dans les revues des mouvements d'avant-garde artistique en France entre 1918 et 1939." (Mémoire de Maîtrise, Université de Toulouse–Le Mirail, 1974–75).

Nabokov, Nicolas. *Bagázh: Memoirs of a Russian Cosmopolitan*. New York: Atheneum, 1975.

Newhall, Nancy. "Controversy and the Creative Concepts." *Aperture* (Rochester, N.Y.), 2 (July 1953), pp. 3–13.

Ozenfant, Amédée. *Foundations of Modern Art* (1928). Translated by John Rodker. Revised ed., New York: Dover, 1952.

Phillips, Sandra S. "The Photographic Work of André Kertész in France, 1925–1936: A Critical Essay and Catalogue." (Ph.D. dissertation, The City University of New York, 1985).

Phillips, Sandra S., David Travis, and Weston J. Naef. *André Kertész: Of Paris and New York* (exhibition catalogue). Chicago: The Art Institute of Chicago; New York: The Metropolitan Museum of Art, 1985.

Pieyre de Mandiargues, André. *Le Désordre de la mémoire: Entretiens avec Francine Mallet*. Paris: Gallimard, 1975.

*Les Réalismes, 1919–1939* (exhibition catalogue). Paris: Centre Georges Pompidou, 1980.

Renoir, Jean. *My Life and My Films*. Translated by Norman Denny. New York: Atheneum, 1974.

Reymond, Nathalie. "Le Rappel à l'ordre d'André Lhote." In *Le Retour à l'ordre dans les arts plastiques et l'architecture, 1919–1925*. Actes du second colloque d'histoire de l'art contemporain. Saint-Étienne: Musée d'art et d'industrie, 1974.

Rosenblum, Robert. *Cubism and Twentieth-Century Art*. New York: Abrams, 1960.

Rubin, William. *Dada and Surrealist Art*. New York: Abrams, 1969.

———, ed. *"Primitivism" in 20th Century Art: Affinity of the Tribal and the Modern* (exhibition catalogue). 2 vols. New York: The Museum of Modern Art, 1984.

Sesonske, Alexander. *Jean Renoir: The French Films, 1924–1939*. Cambridge, Mass.: Harvard University Press, 1980.

Shattuck, Roger. "Having Congress: The Shame of the Thirties." In Shattuck, *The Innocent Eye: On Modern Literature and the Arts*. New York: Farrar Strauss Giroux, 1984.

Soby, James Thrall. *After Picasso*. Hartford: Edwin Valentine Mitchell; New York: Dodd, Mead, 1935.

Szarkowski, John. *André Kertész, Photographer* (exhibition catalogue). New York: The Museum of Modern Art, 1964.

———. *Looking at Photographs: 100 Pictures from the Collection of The Museum of Modern Art*. New York: The Museum of Modern Art, 1973.

———. "Understandings of Atget." In John Szarkowski and Maria Morris Hambourg, *The Work of Atget*, vol. 4: *Modern Times* (exhibition catalogue). New York: The Museum of Modern Art, 1985.

Thirion, André. *Revolutionaries Without Revolution*. Translated by Joachim Neugroschel. New York: Macmillan, 1975.

Travis, David. *Photographs from the Julien Levy Collection, Starting with Atget* (exhibition catalogue). Chicago: The Art Institute of Chicago, 1976.

Whelan, Richard. *Robert Capa: A Biography*. New York: Knopf, 1985.

Wolff, Geoffrey. *Black Sun: The Brief Transit and Violent Eclipse of Harry Crosby*. New York: Vintage, 1977.